On the cover: Pictured are Detroit's Penobscot and Guardian Buildings, taken on May 30, 1937, by *Detroit Free Press* photographer Joe Kalec for the Rotogravure section. (Courtesy Burton Historical Collection of the Detroit Public Library.)

IMAGES of America
ART DECO IN DETROIT

Rebecca Binno Savage and Greg Kowalski

ARCADIA
PUBLISHING

Copyright © 2004 by Rebecca Binno Savage and Greg Kowalski
ISBN 978-1-5316-1813-1

Published by Arcadia Publishing
Charleston, South Carolina

Library of Congress Catalog Card Number: 2003114741

For all general information contact Arcadia Publishing at:
Telephone 843-853-2070
Fax 843-853-0044
E-mail sales@arcadiapublishing.com
For customer service and orders:
Toll-Free 1-888-313-2665

Visit us on the Internet at www.arcadiapublishing.com

CONTENTS

Acknowledgments		6
Introduction		7
1.	Exceptional Examples	9
2.	Art Deco Building Materials	35
3.	Doing Business: Industrial, Retail, Post Offices, Clinics, and Communications	41
4.	By the Side of the Road: Roadside Architecture	63
5.	Apartments and Homes	69
6.	Details above the Door	81
7.	Theaters and a Ballroom	87
8.	Lessons Learned	105
9.	Religious and Educational Buildings	119
Index		128

ACKNOWLEDGMENTS

We now have the opportunity to formally thank the people who volunteered to do the work of photography, documentation, and research for the initial survey in 1993. Some of them have moved on to other cities, and some even into careers in historic preservation: Audra Bartley, Mel Batch, David Blalock, Jacques Pierre Caussin, Dan Drotar, Ann Duke, Jeff Garland, Janice Milhem, Carl Parks, Gary Spondike, Dennis Standhart, and Sandra Taranto.

In creating this book, we must acknowledge the assistance of: Kathryn B. Eckert, Michael Hauser, Thomas J. Holleman, Chris Mead, and Alyn Thomas. Also, special thanks to Suzy Parker Sherman for her endless patience and priceless friendship.

And finally, thank you to Hal Savage for his love and support.

Introduction

Detroit may have a reputation as a rust belt city, but it is also home to some of the most elegant and exotic Art Deco structures in the United States. Detroiters take it for granted, and don't always think of their city as being on the cutting edge of design . . . but in the late 1920s it was. Detroit's downtown skyscrapers stand up as some of the most significant Art Deco buildings in the United States. But that's not all, because Art Deco designs were applied to factories of the automotive suppliers, and to the new construction that was creating neighborhoods out of the green fields surrounding Detroit. The Art Deco style and Detroit grew at the same time.

Defining Art Deco has always been a little tricky, and some architectural scholars still debate the category and subsets. We use the term Art Deco in a very broad sense and include Streamline, Art Moderne, and ZigZag Moderne in our classification. Art Deco is a style stimulated by the 1925 Exposition Internationale des Arts Decoratifs et Industriels Modernes held in Paris. Sometimes referred to as French Art Deco, it was characterized by sharp angular forms combined with floral motifs. Later designs in the 1930s evolved into the sleek streamline curving lines which gave a sense of motion to a static building. By the early 1940s, the Art Deco style looked toward geometric cubism. At the time, it was known as variously as the Modern Style, Jazz Moderne, or Industrial Modern. It wasn't until the mid-1960s that it was tagged Art Deco.

In 1993 the Board of Directors of the Detroit Area Art Deco Society decided that they needed to assemble a comprehensive survey of the Detroit area's Art Deco architecture. Former president Ann Duke organized a meeting of Deco Society members who were interested in helping document and photograph buildings for the survey. They took a map of the metropolitan area and carved it up into different sections and assigned Deco Society members to shoot slides of various areas of metro Detroit. It was decided to organize the slide presentation into topics determined by building type—not by geographic location. After many hours of review, re-shooting, and prioritizing, the slide presentation was finally presentable.

This book was created from the slides assembled for the survey and organized into a presentation. The slide presentation was titled "Detroit's Art Deco Architecture" and had two goals: to explain what Art Deco architecture looks like and encompasses, and to prove that Detroit's collection of Art Deco architecture is nationally significant and worthy of recognition. We begin with Detroit's most significant buildings that immediately come to mind:

the Fisher Building, the Guardian Building, and the Penobscot Building. Next, the materials used in Art Deco architecture are presented: Vitrolite and Carrara glass, terra cotta, brick, and porcelain enameled steel. Then we highlight the many types of buildings that utilized Art Deco architecture: industrial, communications (including the WJR Transmitter, the WWJ Broadcast Station, and Michigan Bell Building), roadside architecture (gas stations and diners), religious buildings, post offices, apartments, clinics, homes, schools, and theaters. Finally, some beautiful Art Deco buildings that have recently been demolished are given as lessons: the Sears Building in Highland Park, as well as the Mercury Theater. By the end of this book the point is proven—there is a significant collection of Art Deco architecture in our metropolitan area that is worthy of preservation and recognition.

Over the years, the slide presentation has been given to many different groups and university classes. The most memorable presentation was for the Art Deco Society of New York in the "Cloud Club" on the top floor of the Chrysler Building. The Detroit Area Art Deco Society continues to update the slide presentation and shoot new slides of the buildings—as well as discover a few new ones now and then. Unfortunately, its task is also to document structures lost to demolition.

Creating a book from the slide survey and presentation was one of the Detroit Area Art Deco Society's original long-term objectives. Finally realized, we hope that the reader agrees with our finding: Detroit's collection of Art Deco architecture is one of the country's most significant.

One
Exceptional Examples

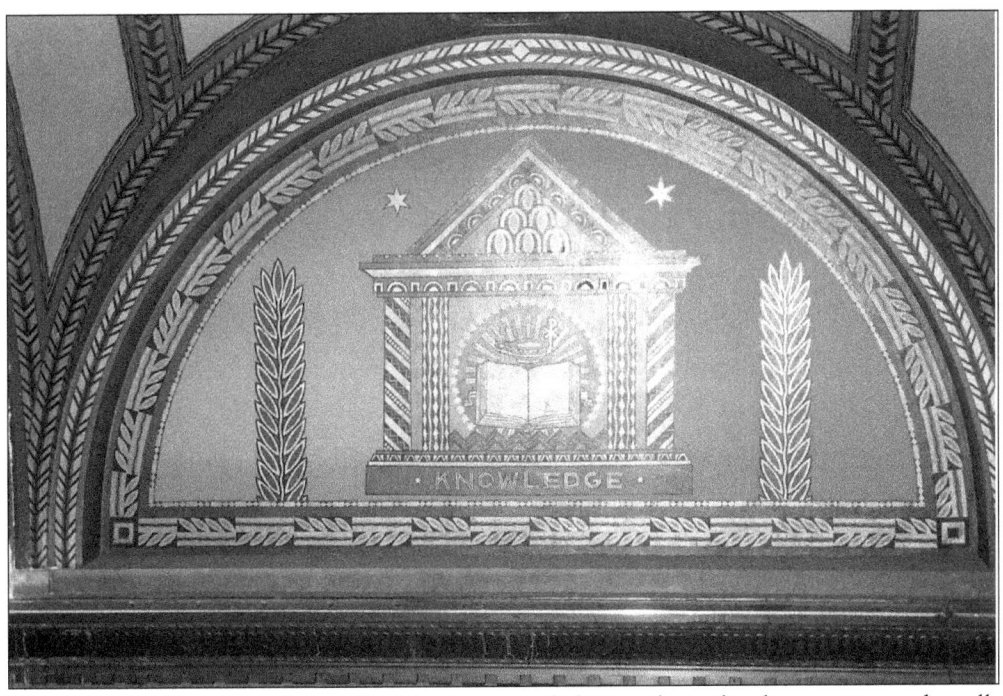

The Fisher Building is replete with elaborate stenciled artwork on the three-story arcade walls and ceilings. This image of knowledge and reading was meant to inspire visitors and workers on the building's third floor.

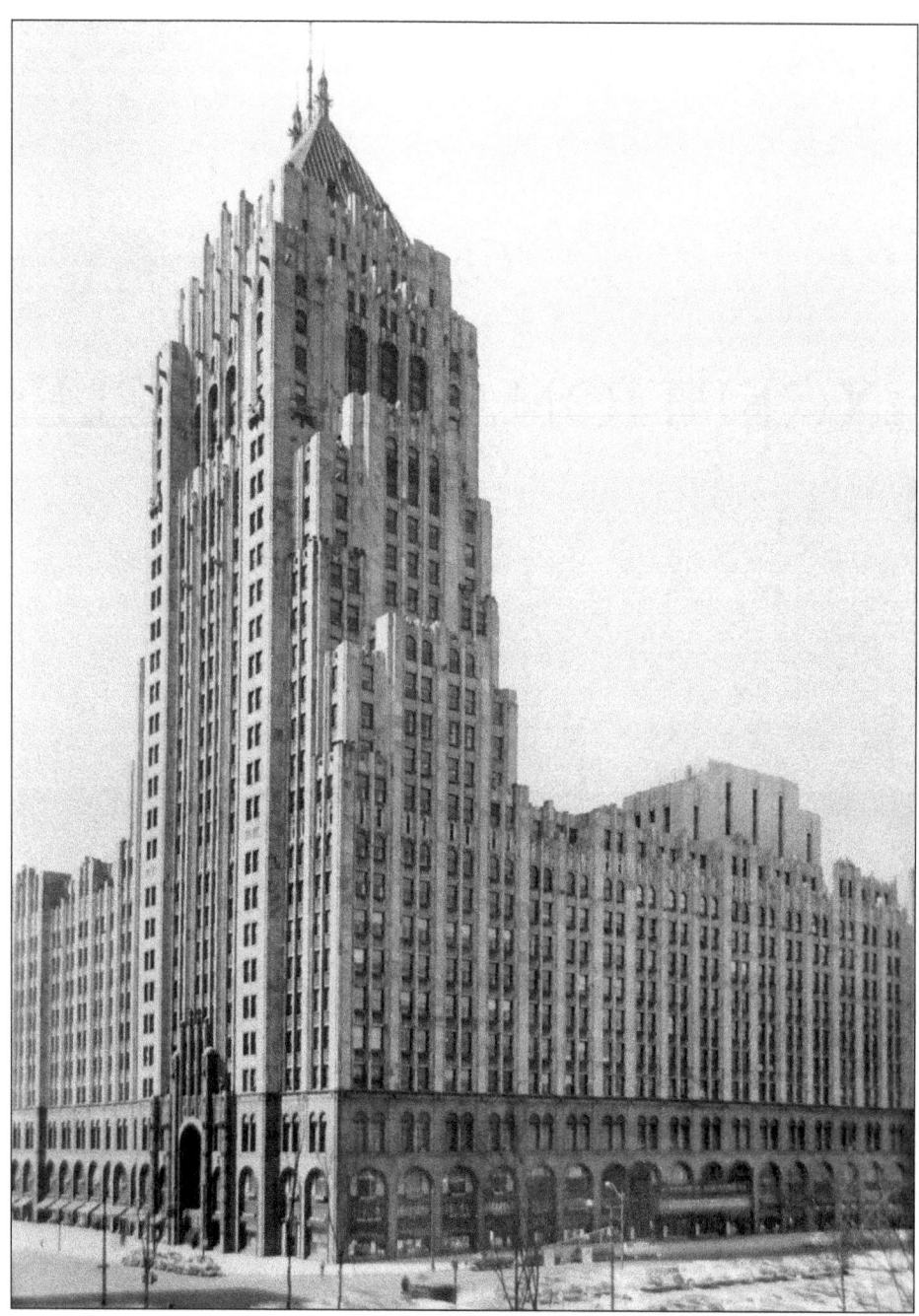

The Fisher Building is a masterpiece of architecture in Detroit. Designed in 1928, it is 28 stories tall, with two 11-story wings extending along Grand Boulevard and Second Avenue. Meant to be a city within a city, it was a place where one could park his or her car, drop the children off at the nursery, conduct business, bank, shop, dine, and see a movie. Built by the seven industrialist Fisher brothers as a home for their automotive company, they gave the architect an unlimited budget. That meant no expense was spared in using the best materials available and an army of itinerant European artisans to create a stunning skyscraper. (Courtesy Burton Historical Collection.)

Albert Kahn (1862–1942) was the architect of the Fisher Building, and he was the most prominent industrial architect of the 20th century. Kahn was born in Germany, the eldest son of a rabbi, and worked his way up through one of Detroit's early architectural firms. His own firm initially specialized in reinforced concrete automotive factories and became internationally acclaimed. The Albert Kahn offices later output hospitals, government buildings, university libraries, mansions, and skyscrapers. Among Kahn's most notable structures are the General Motors Building, the Ford Motor Company Model T Plant, and the Belle Isle Conservatory. Detroit would not have been the same without him. (Courtesy AIA Detroit.)

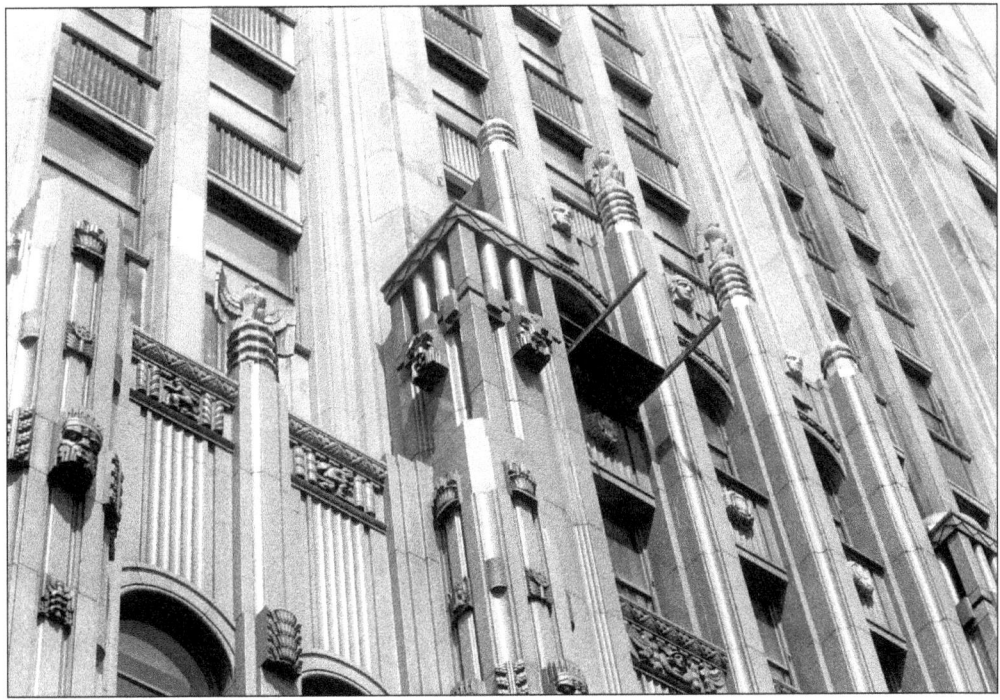

The Fisher Building's first three floors are clad in Minnesota granite and the upper stories in Maryland marble—this photo taken over the main entrance depicts both. The entrance piers are ornamented with stylized eagles on an industrialized perch. Kahn designed strong vertical piers on the tower's exterior to give it the illusion of greater height.

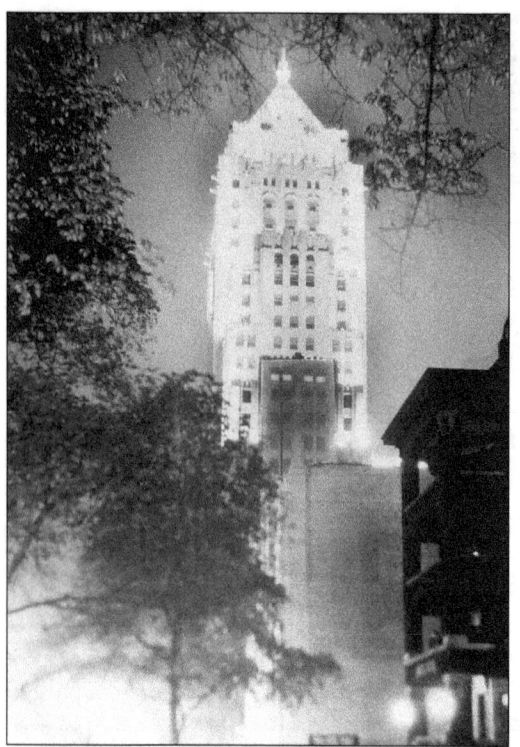

The "Golden Tower of the Fisher Building" brightens the skyline of Detroit. The sloped roof was originally covered with gold-leafed tile, but now green tile tops the structure. WJR radio station has been housed in the tower for decades. For the year 1929, the building was honored by the Architectural League of New York as the most beautiful commercial structure in the United States. (Courtesy Burton Historical Collection.)

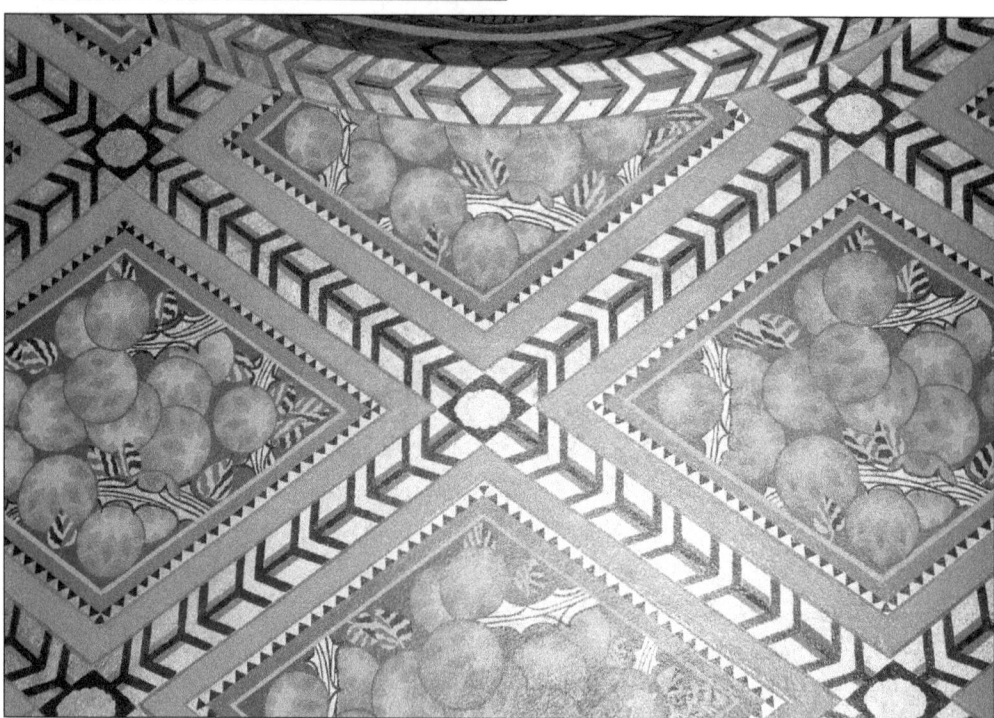

Geza Maroti, a Hungarian-born artist, designed the elaborate frescoes, lunettes, plaques, and mosaics of the Fisher Building's interior. The ceiling stencil work shown here is a representation of oranges in an angular Art Deco pattern.

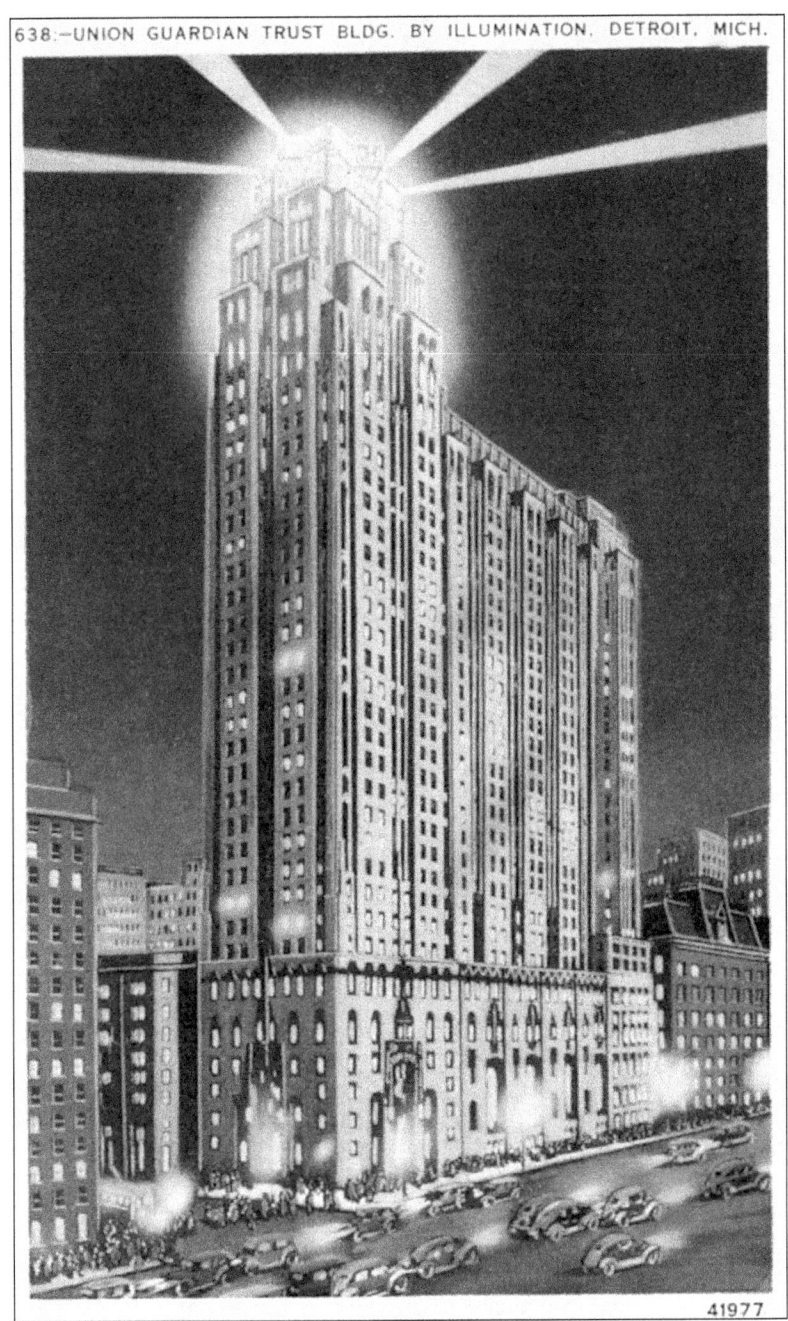

This vintage postcard depicts the Union Guardian Trust Building—one of the most exuberant Art Deco skyscrapers built in America. It was designed in 1929 as a flagship headquarters for the Union Trust Company. Now known as the Guardian Building, it is 36 stories tall and a National Historic Landmark. The Guardian Building stands on an entire block of Griswold in the financial district downtown. The taller north tower and the smaller octagonal south tower are connected with a nave-like block resembling a cathedral. In fact, the Guardian Building was once promoted "the Cathedral of Finance." As shown in this postcard, the tower once had high-powered beams of light streaming in all directions.

Architect Wirt C. Rowland (1878–1946) designed the Guardian Building while he was working for the firm Smith, Hinchman & Grylls. Rowland was born in Clinton, Michigan, and moved to Detroit to pursue his architectural career. He studied at Harvard, went to work in numerous Detroit architectural firms, and truly redefined Detroit's skyline. The Buhl Building, Penobscot Building, and Guardian Building are all from Wirt Rowland's drawing table.

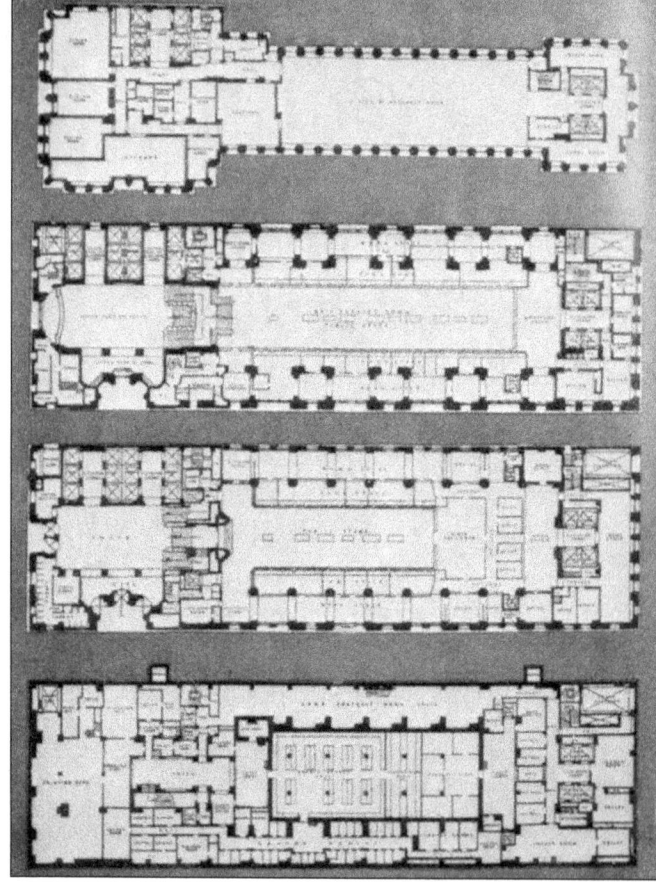

These plans of the Guardian Building show the basement level, the first and second floor lobby and banking hall, and the 32nd floor dining room where every item of furniture and tableware was designed by Wirt Rowland.

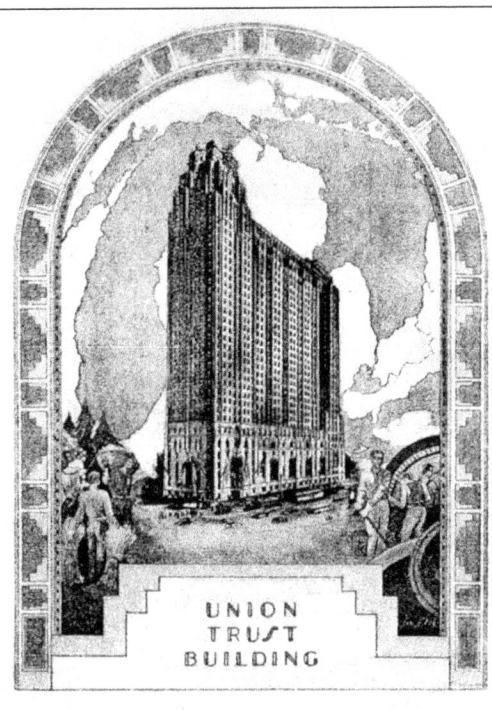

UNION TRUST COMPANY AND
THE NATIONAL BANK OF COMMERCE
OF DETROIT
ANNOUNCE THE OPENING OF
THEIR NEW BUILDING AT
GRISWOLD AND CONGRESS STREETS
AND REQUEST THE PLEASURE
OF YOUR COMPANY ON
TUESDAY · APRIL SECOND
NINETEEN HUNDRED TWENTY · NINE

The Union Trust Company's grand opening invitation featured a typeface that itself was appropriately Art Deco. Just one year later, the Union Trust Company was one of the many banks to fail in the Great Depression of the 1930s. (Courtesy Burton Historical Collection.)

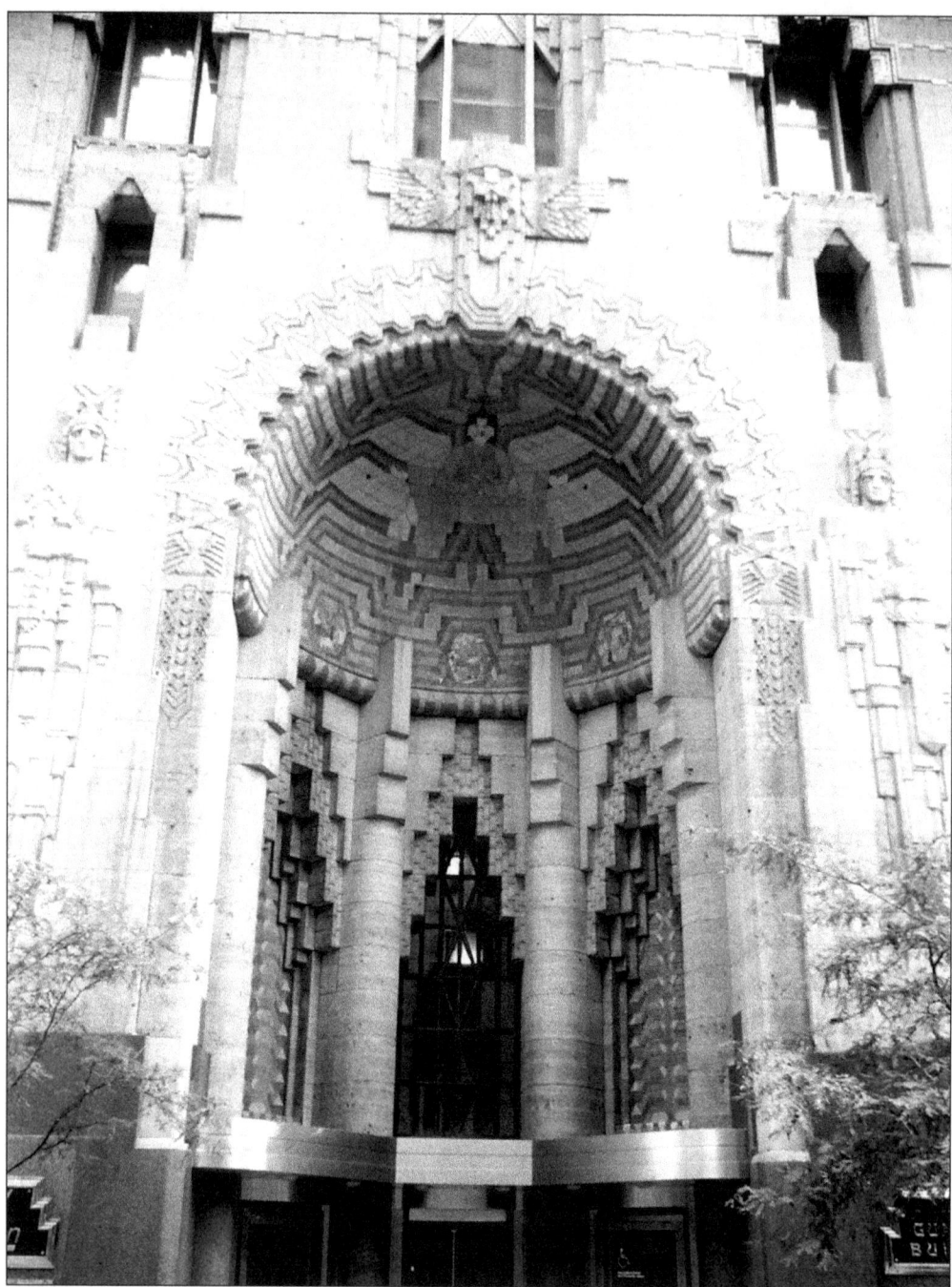

The main entrance to the Guardian Building is flanked by reliefs of "Safety" and "Security" by Detroit sculptor Carrardo Parducci. The semi-circular dome's tiles were executed by Mary C. Perry Stratton of Pewabic Pottery. She worked closely with the architect, Wirt Rowland, on the design and symbolism of the tiles. Rowland created a new skyscraper style by combining Art Deco angles and Mayan/Aztec details. The exterior of the Guardian Building is faced with granite on the first two stories, and custom-colored orange brick, glazed tile, and terra cotta above. Rowland developed a specific brick color, which was later marketed as "Guardian Brick."

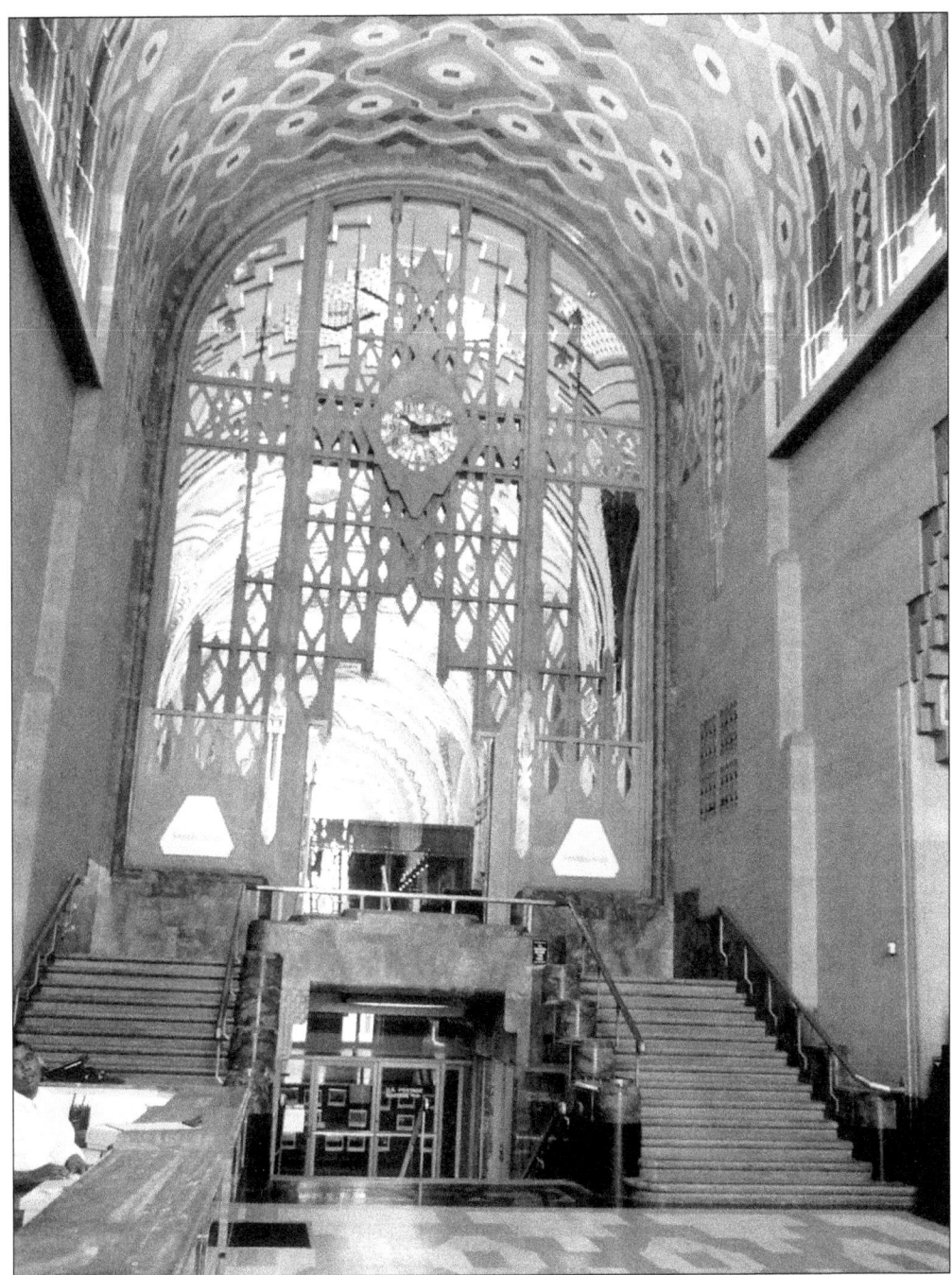

The Guardian Building's lobby is one of the most spectacular Art Deco interiors in the United States. Dividing the lobby from the banking hall on the second floor is a Monel metal screen containing a clock that was executed by Tiffany Studios of New York. The ceiling tiles were produced by Rookwood Pottery of Cincinnati and are designed in a pattern of interlocking hexagons. Note that the same pattern is repeated on the travertine floor. The pair of marble grand stairs led up to what was originally the banking hall. The Guardian is an unequaled skyscraper, which recalls the spirit of the Roaring Twenties.

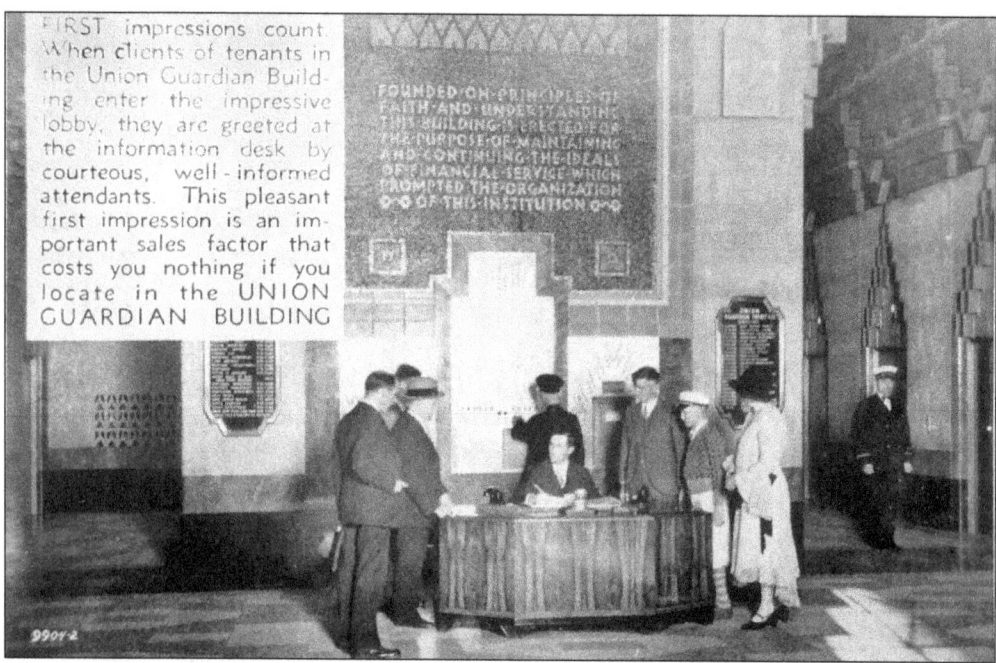

This image is from a promotional brochure published when the building first opened in 1929. The mosaic above the security desk was designed by New York artist Ezra Winter. (Courtesy Burton Historical Collection.)

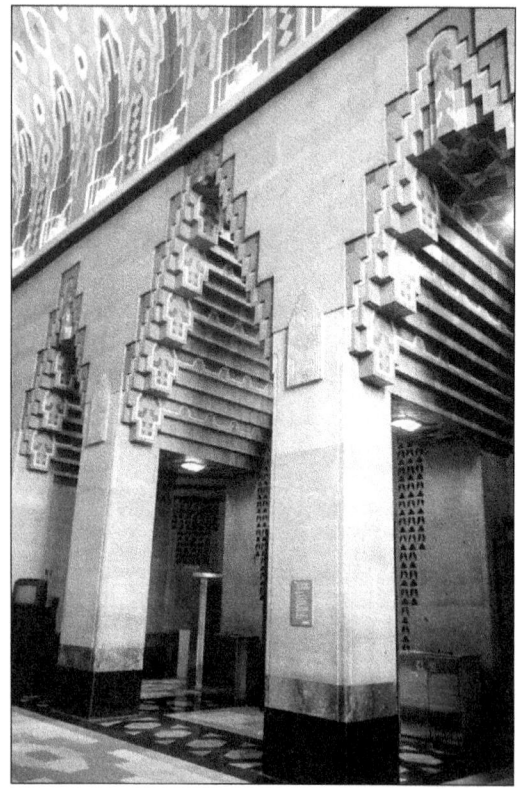

The stepped arch used in the Guardian Building's lobby is a recurring theme on the building's exterior and interior. The stepped arch was frequently used in the Art Deco style—it was derived from the Mayan ruins being excavated in Central America at that time. The building fell on hard times after the Depression, but fortunately the Michigan Consolidated Gas Company (Michcon) completely restored the lobbies and exterior when it occupied the building.

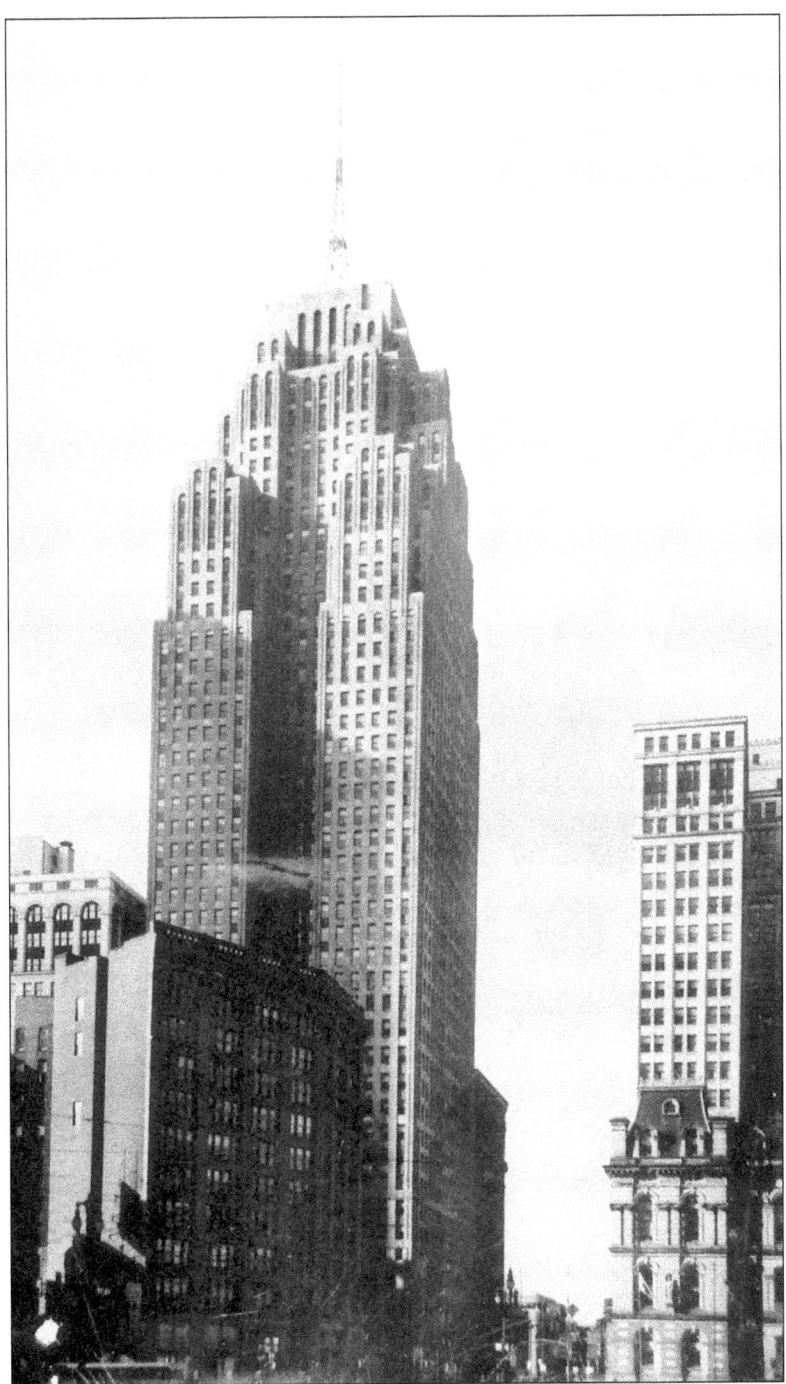

The Penobscot Building was designed by Wirt C. Rowland while he worked for Smith, Hinchman & Grylls in 1927. Here he used the setback skyscraper form to construct an icon that is 47 stories tall—the fifth highest building in the world when it was completed. The Penobscot Building was Detroit's image-defining skyscraper, one which brought the city's architecture into the modern age. It was also Detroit's tallest structure for 50 years, until the Renaissance Center surpassed it in 1977. (Courtesy Burton Historical Collection.)

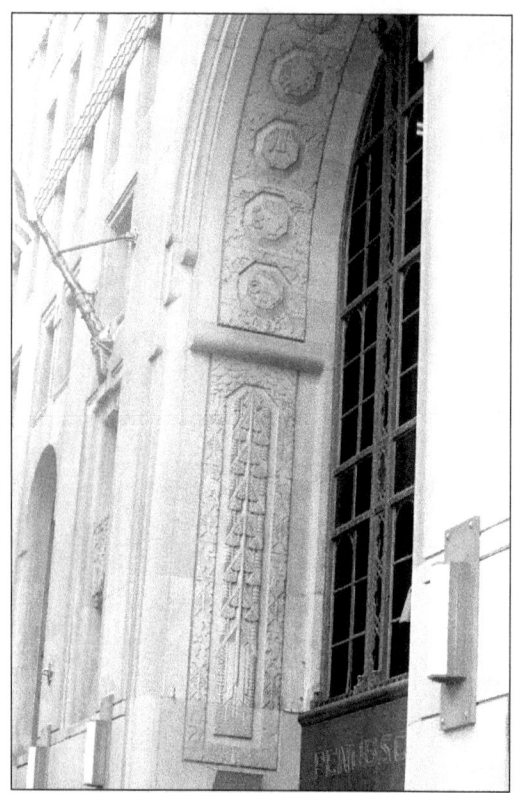

Standing on Griswold in downtown's financial district, the entrance of the Penobscot Building is dramatically marked by a three-story window inset with Art Deco detailing. The Penobscot is faced with mahogany-colored granite on the first three stories, and gray limestone above. A cleaning and restoration of the façade in 2000 brought a new appreciation for the building.

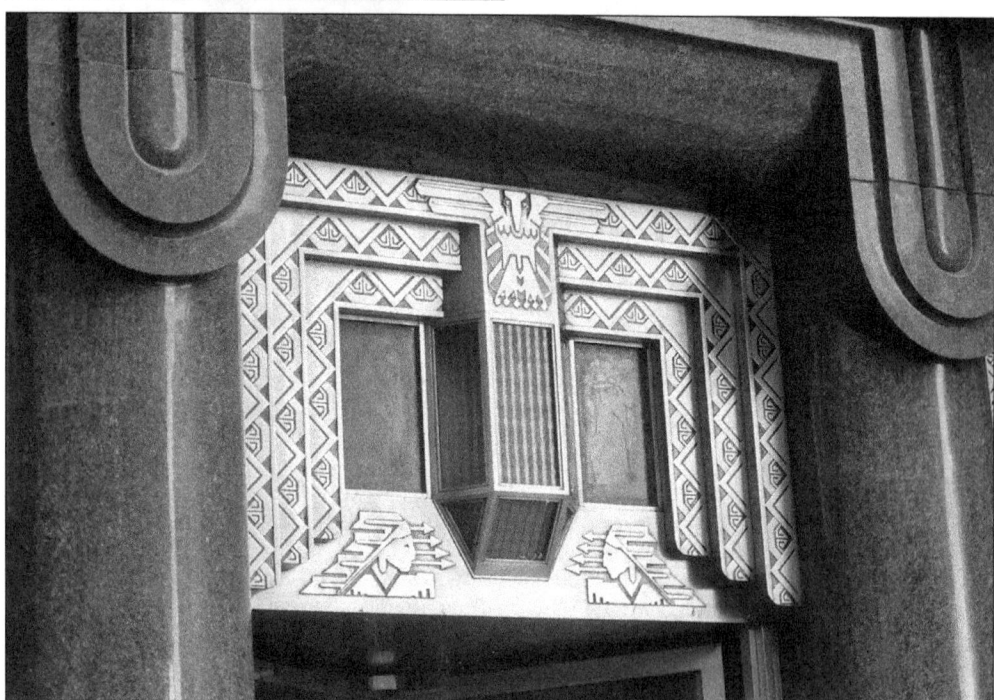

Brass insets over the entrance of the Penobscot Building use a decorative motif now called "zigzag deco." Even the representations of Native American Indians have an Art Deco style.

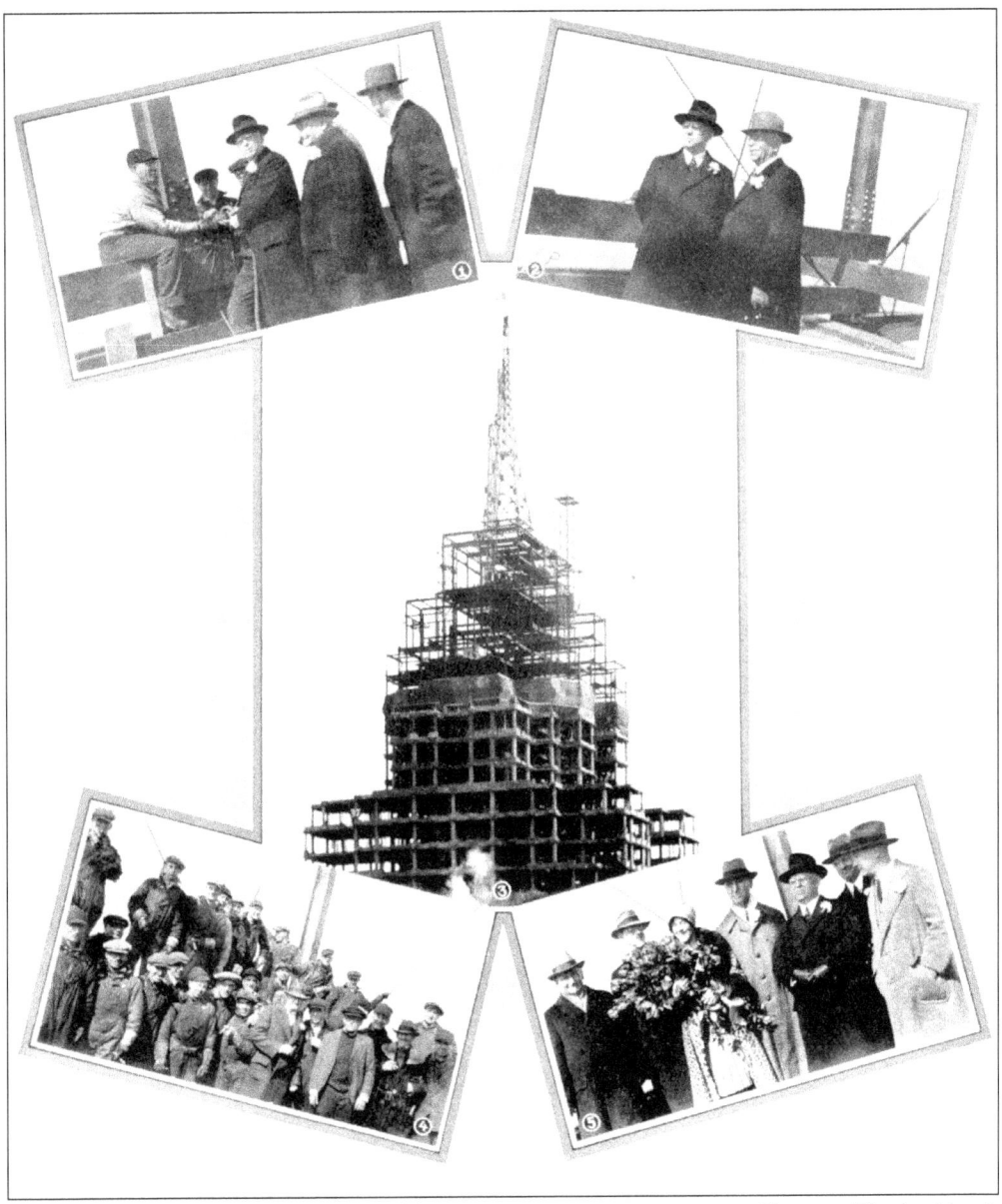

The dedication of the Penobscot Building was a momentous event in Detroit. The building's owner, William H. Murphy, posed for a photo by driving home the last rivet in the steel structure of the tower (photo 1). Because it was dedicated during Prohibition, the Penobscot was christened with a "highly decorated bottle of ginger ale." The woman in the photos is Jean McLachlan, daughter of the manager of the Murphy estate. (Courtesy Detroit Regional Chamber.)

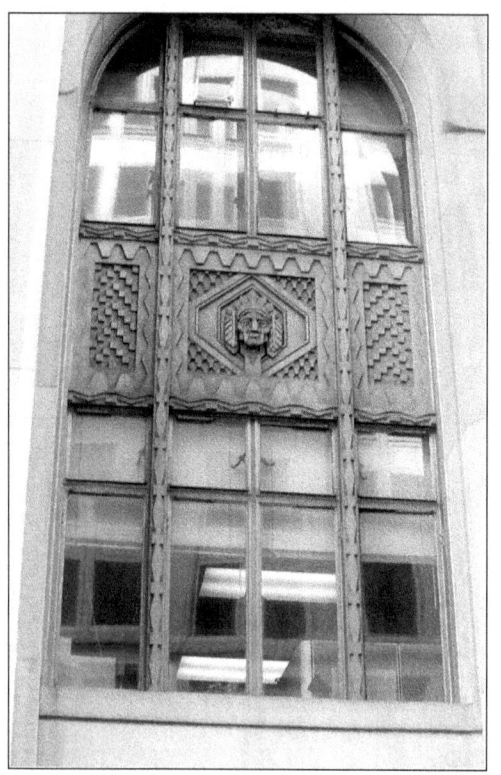

The second floor of the Penobscot Building originally contained a large three-story banking hall. These windows to the banking hall featured spandrels with a depiction of Penobscot Indians. An interesting note is that the Penobscot Indians are not native to Michigan, but to the state of Maine, where the Murphy family originated.

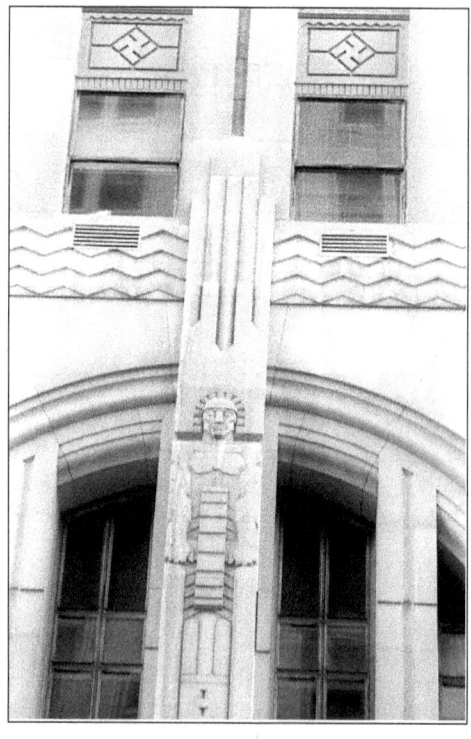

Other window spandrels in the Penobscot Building contain a right-angled cross now known as the swastika. They were actually created as a reference to the Native American symbol and face the opposite direction of the Nazi swastika.

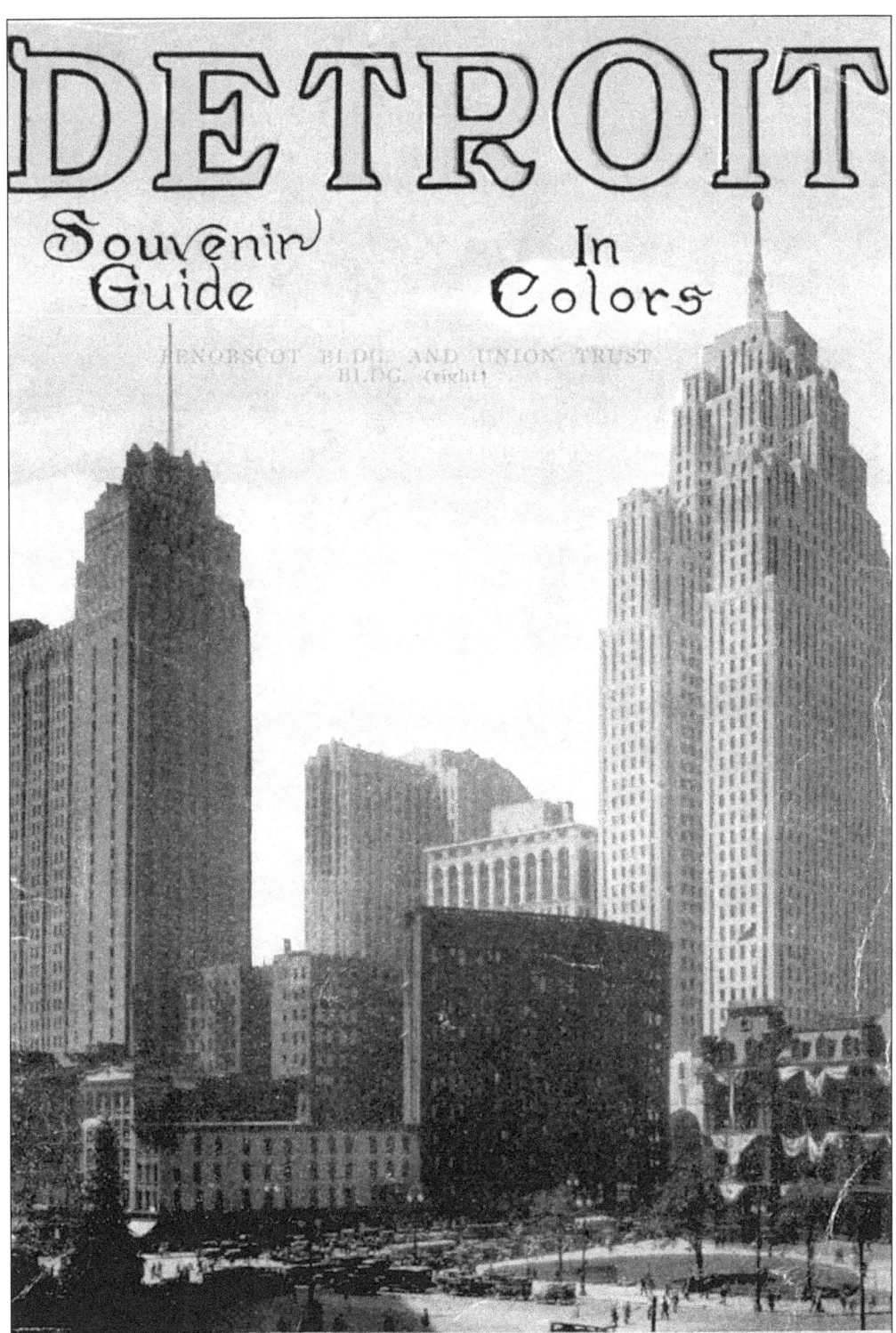

Detroit's skyline was defined by these two Art Deco skyscrapers for half a century. The cover to a 1920s souvenir guide depicts Detroit as a contemporary metropolis.

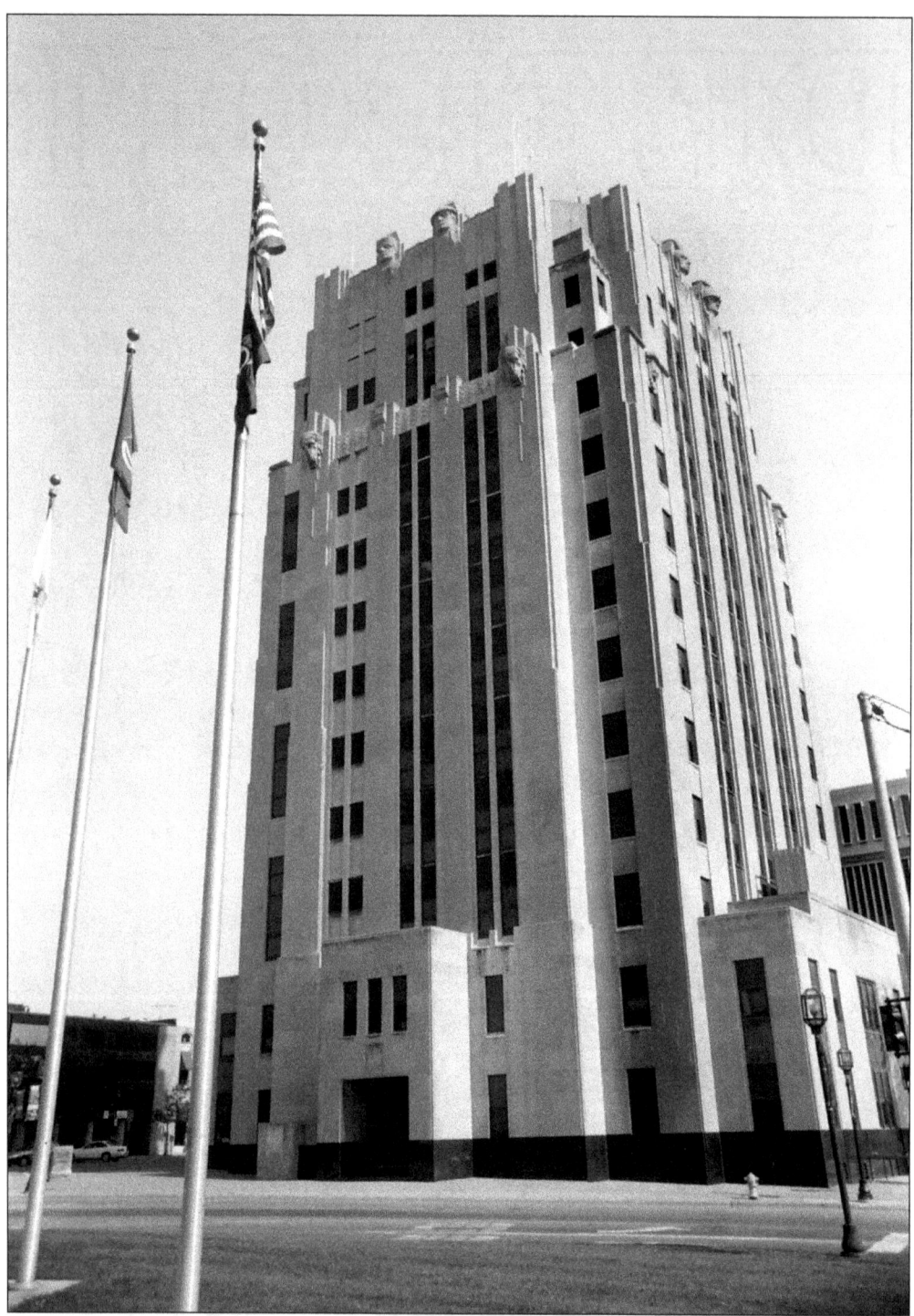

The Macomb County Building in Mt. Clemens is a 12-story skyscraper designed in 1931. The architect, George J. Haas of St. Clair Shores, created a contemporary skyscraper for what was then a relatively rural county. The skyscraper design was to reinforce the concept that Macomb County was a forward-thinking community.

The Macomb County Building features symbols of the branches of the United States military and a Native American. The military figures were created in reference to the nearby Selfridge Army Air Field.

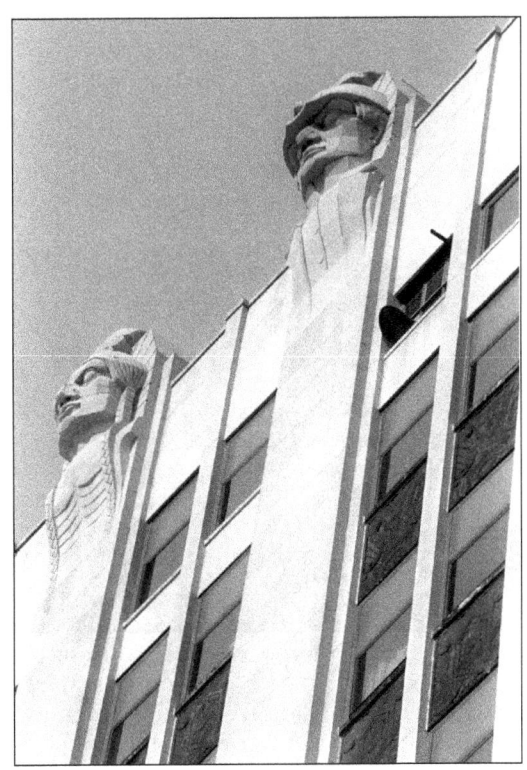

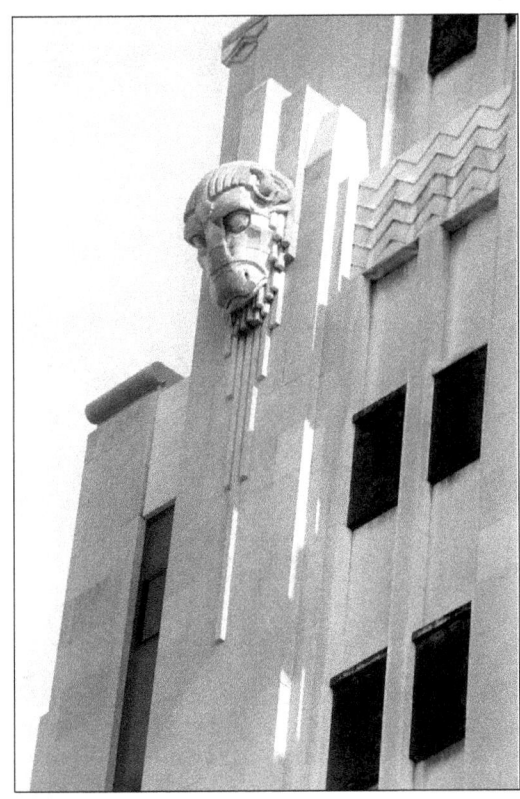

The building also includes representations of rams' heads—an ancient symbol of power.

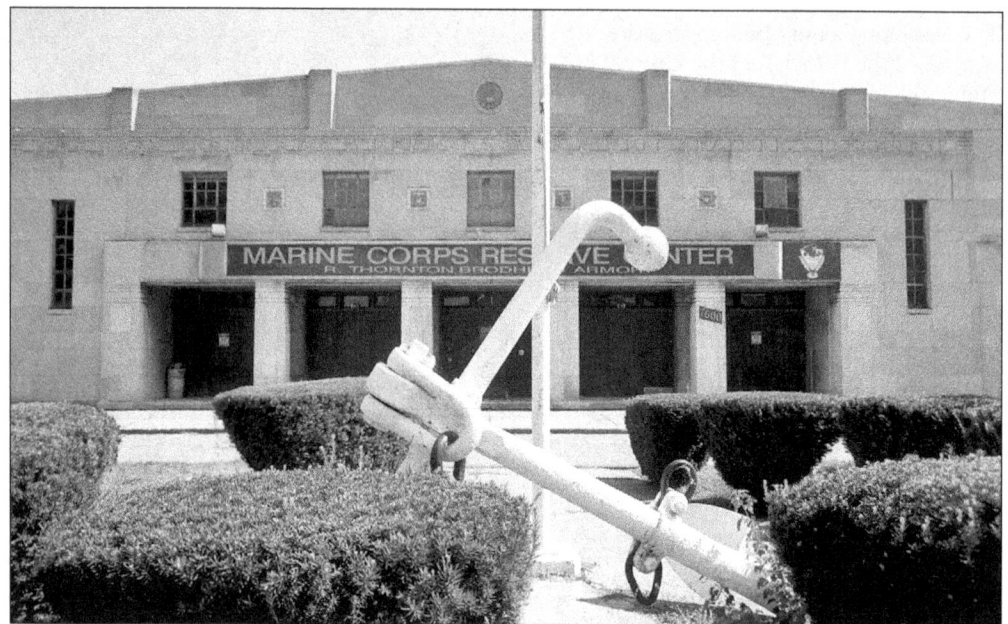

The Brodhead Armory was initially constructed as the Detroit Naval Armory in 1930 by the architectural firm Stratton & Hyde. Now the Marine Corps Reserve Center, it is home to the 1st Battalion 24th Marines. While the horizontal, minimalist design of the building is not one of the most significant in Detroit, the building's interior holds Michigan's largest collection of Works Progress Administration artwork.

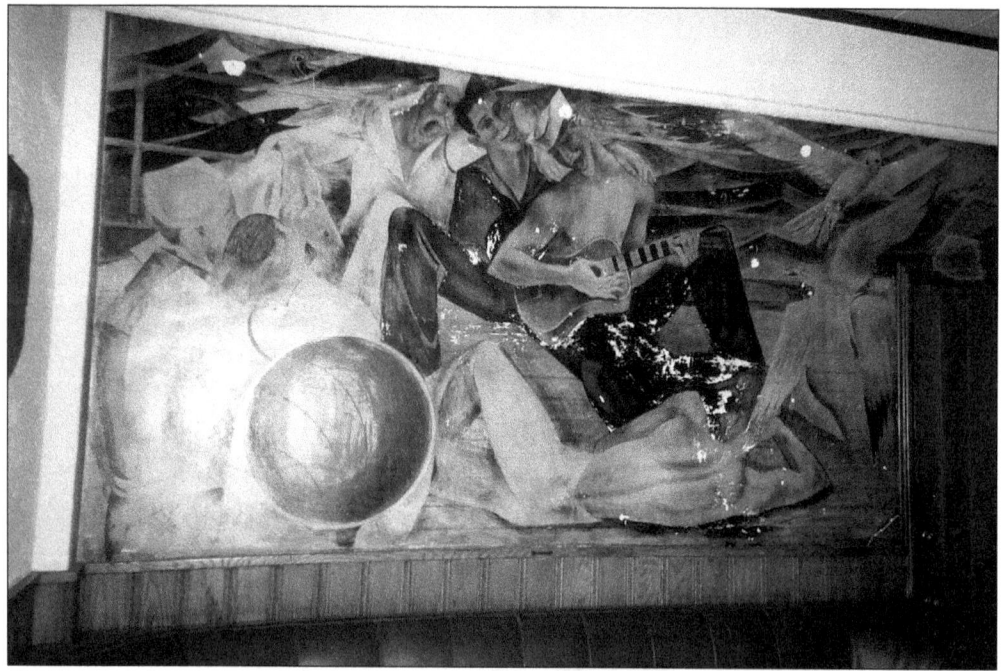

Captain R. Thronton Brodhead took advantage of Franklin Roosevelt's federal relief program called the Works Progress Administration (WPA), and its Federal Art Program. In 1936, this paid for frescoes to be done by artist David Fredenthal in the Mar Bar and Ward Room.

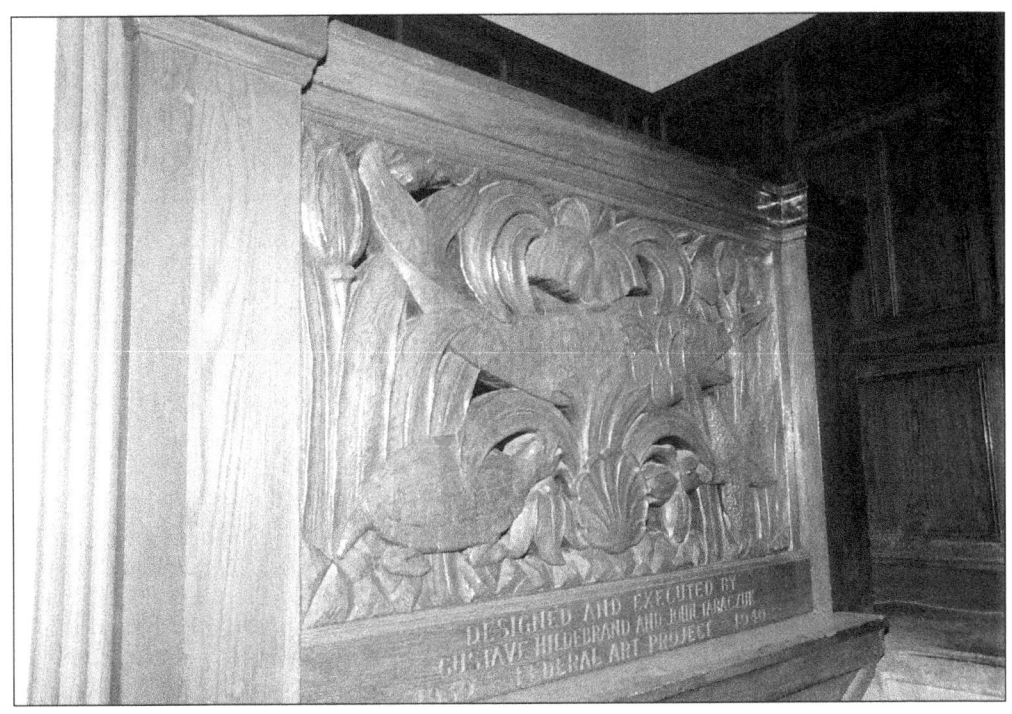

The Brodhead Armory holds many woodcarvings by artists John Tabaczuk and Gustave Hildebrand on the doorways, staircases, fireplace, and benches. The most spectacular WPA art in the building depicts an aquatic fantasy on the officers' banister.

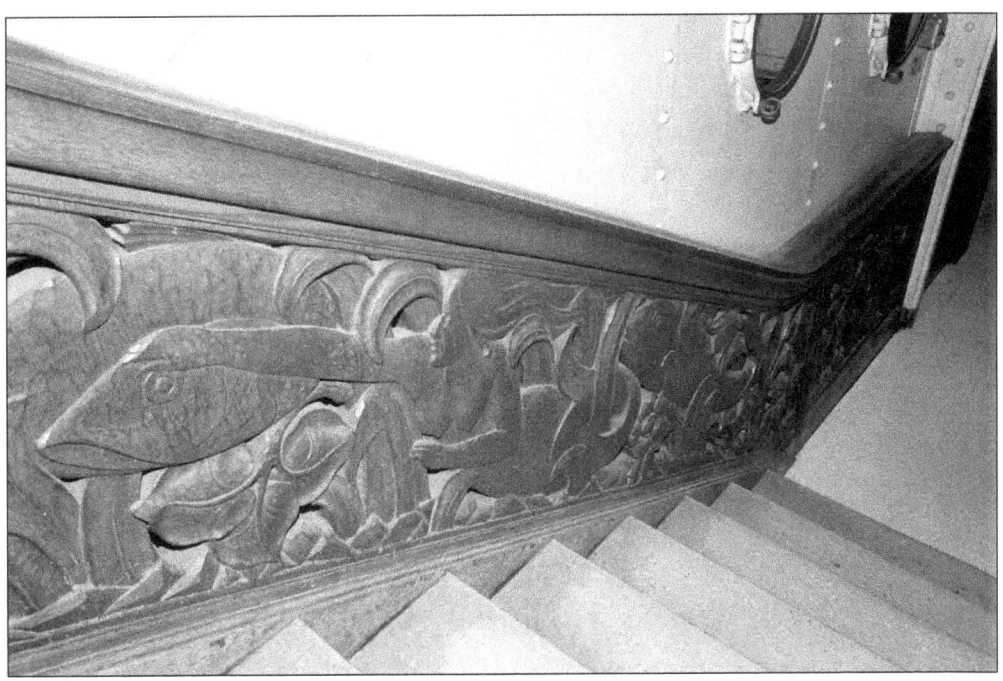

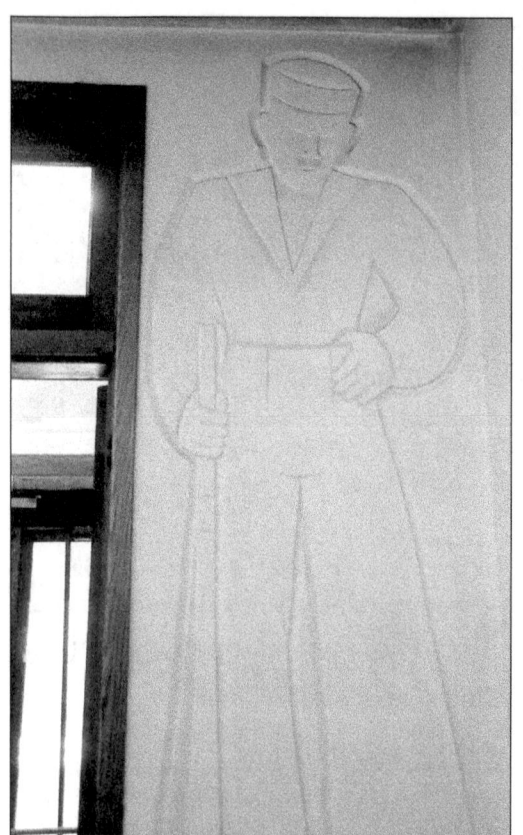

Artist Gustave Hildebrand carved into wet plaster for these very stylized Art Deco depictions of sailors in the building's first floor east entrance hall. The Brodhead Armory is located on East Jefferson just past the Belle Isle Bridge. It is situated on the Detroit River and once had a slip where naval ships were able to dock. Hildebrand's carvings depict the sailors performing tasks on board a ship docked at the slip behind the Armory.

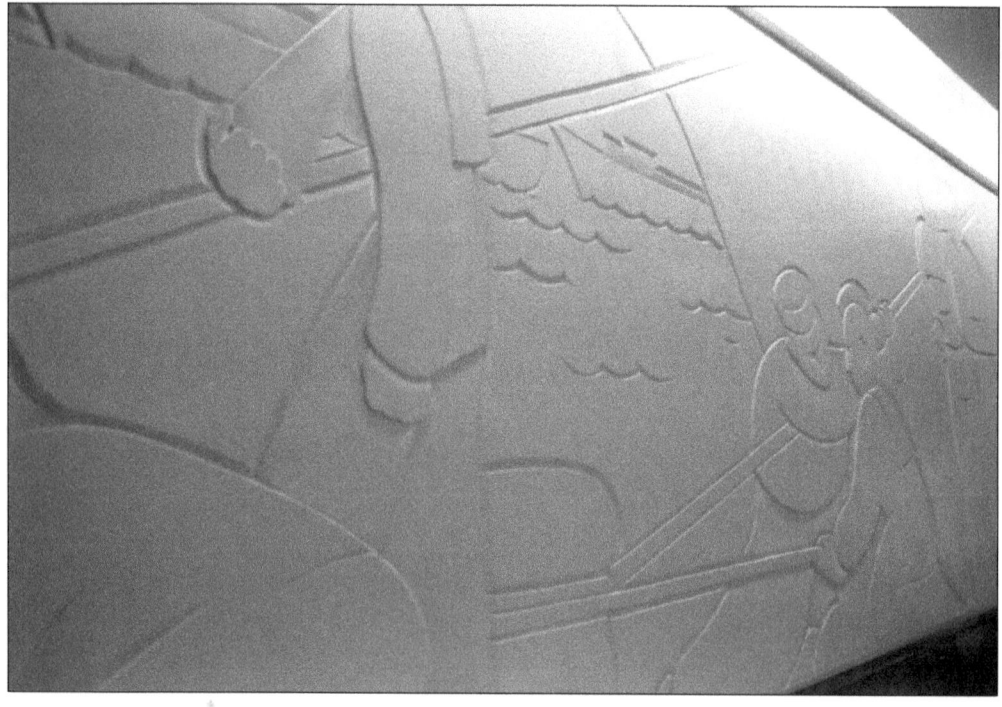

This monumental door features the Presidential seal above deep sea divers and sea life.

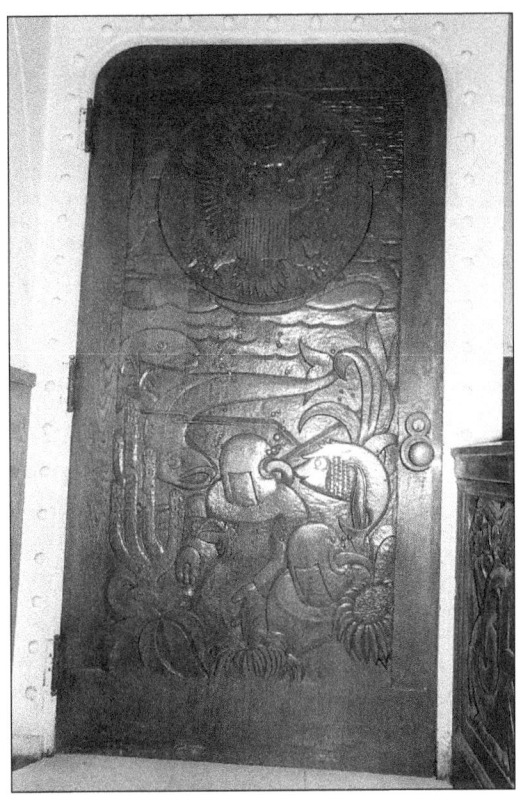

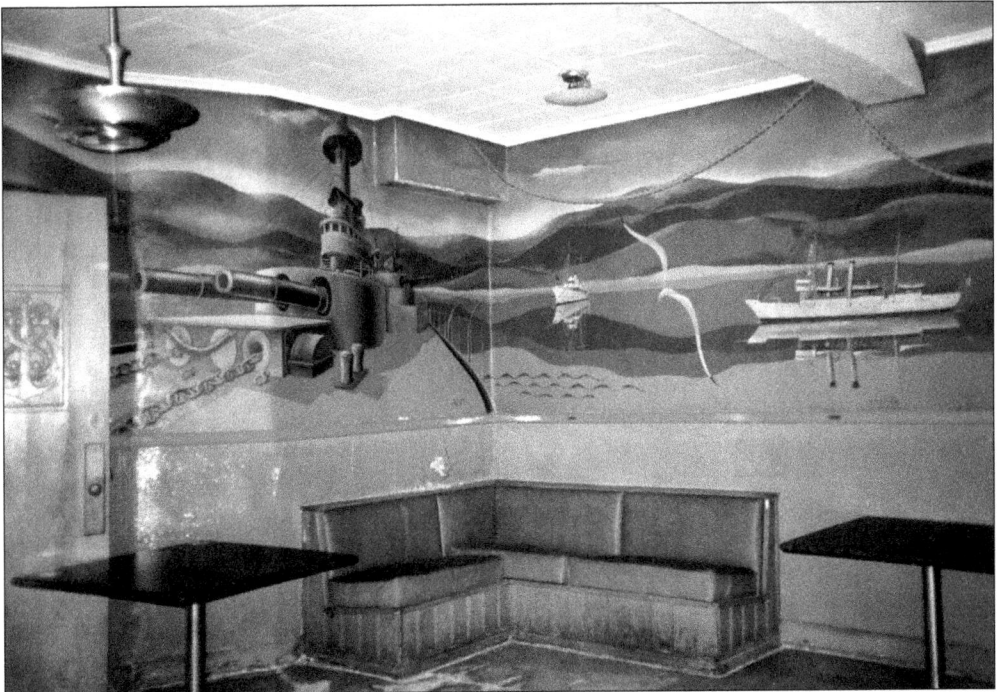

Detroit artist Edgar Yaeger executed the frescoes in the officers' mess. These murals depict ships related to the Spanish-American War and the Great Lakes.

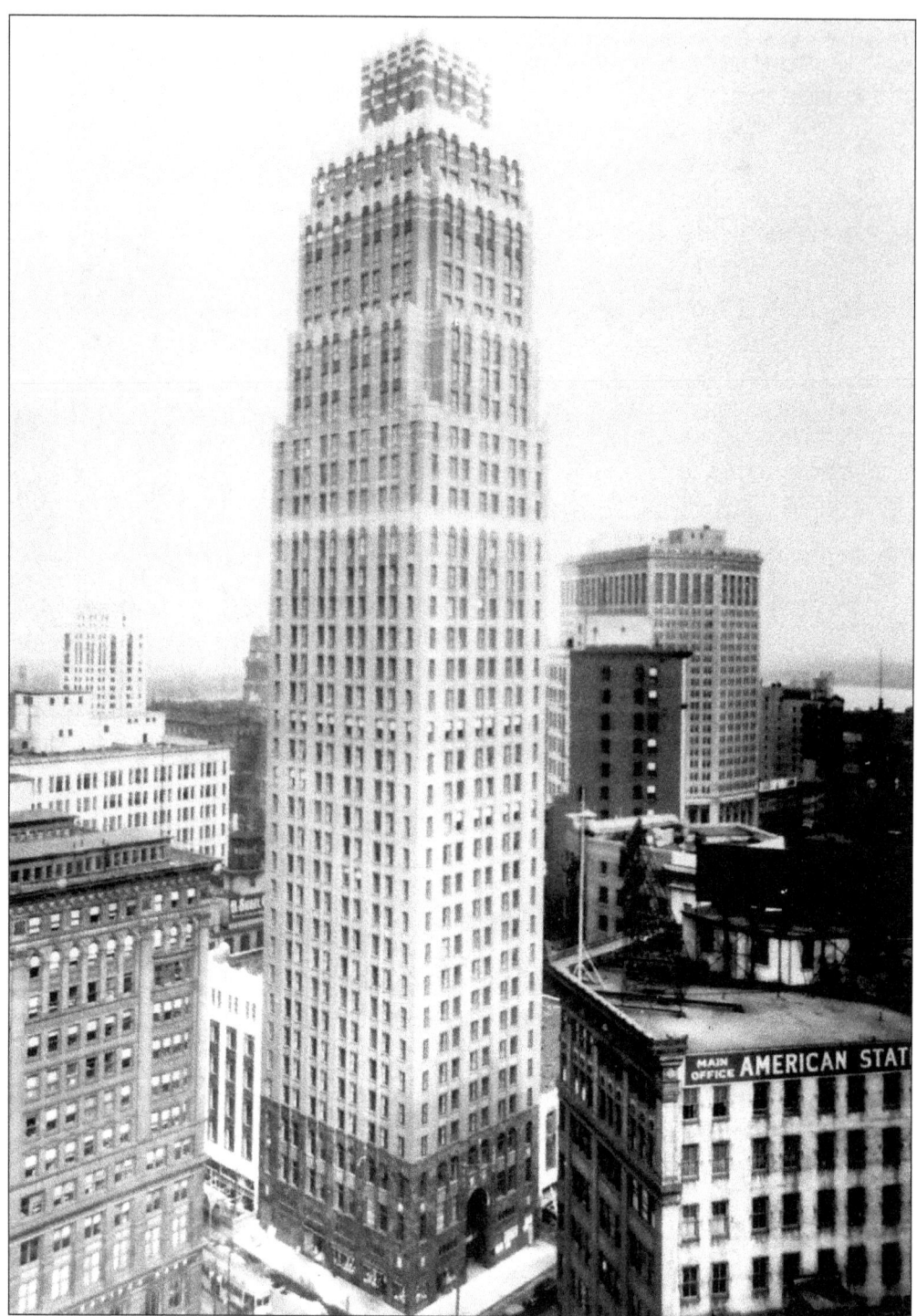

The David Stott Building was designed in 1929 by the firm Donaldson & Meier. They created a custom tan-orange colored brick for this 37-story structure. It is capped with terra cotta detailing at the upper set-back floors. This slim, modern skyscraper is a defining exclamation point to Griswold's downtown financial district. (Courtesy Burton Historical Collection.)

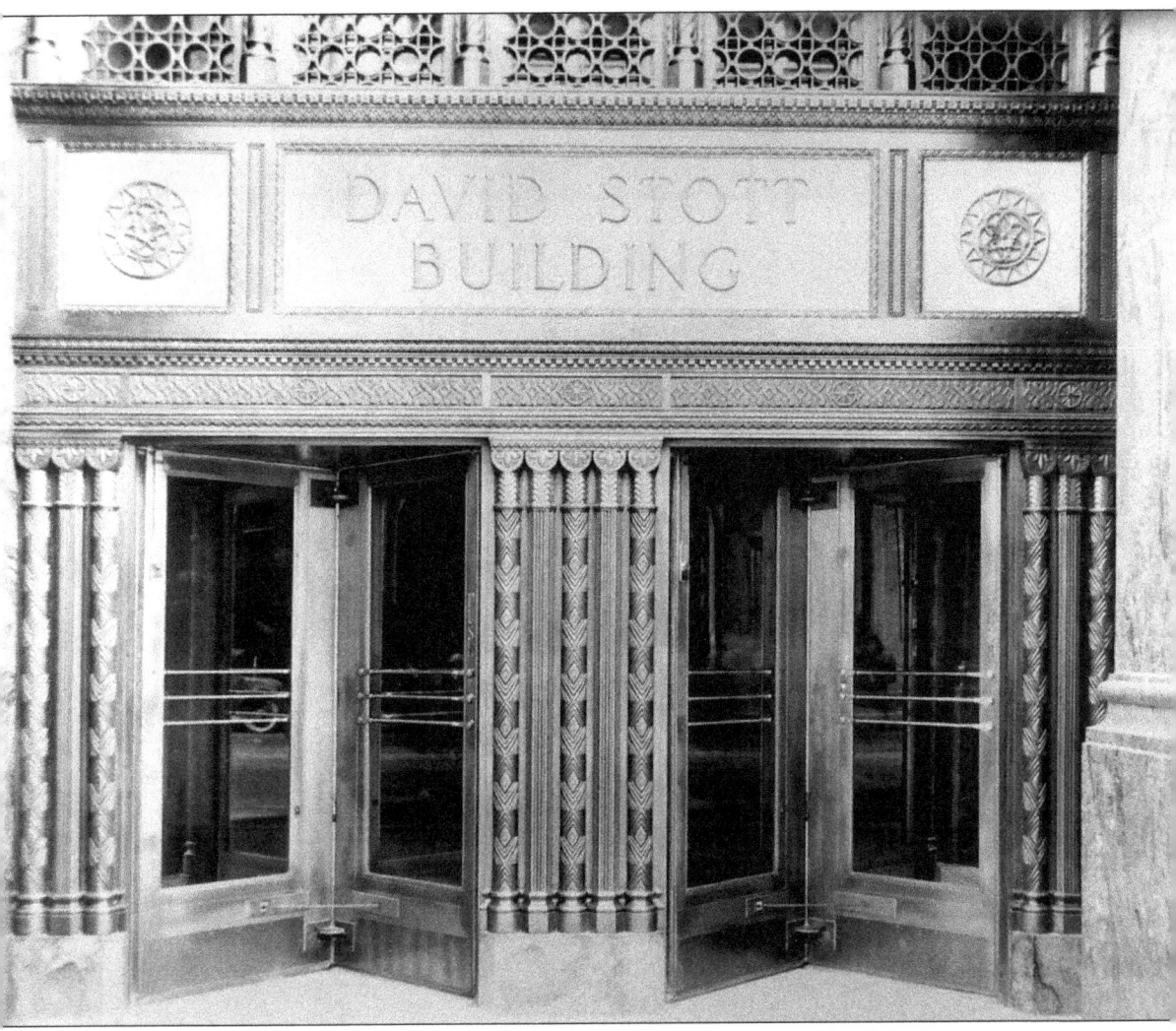

The front entrance of the David Stott Building is another fabulous example of Art Deco patterns applied to a commercial office structure in downtown Detroit. This skyscraper is now taken for granted in Detroit, and it is waiting for restoration. (Courtesy Burton Historical Collection.)

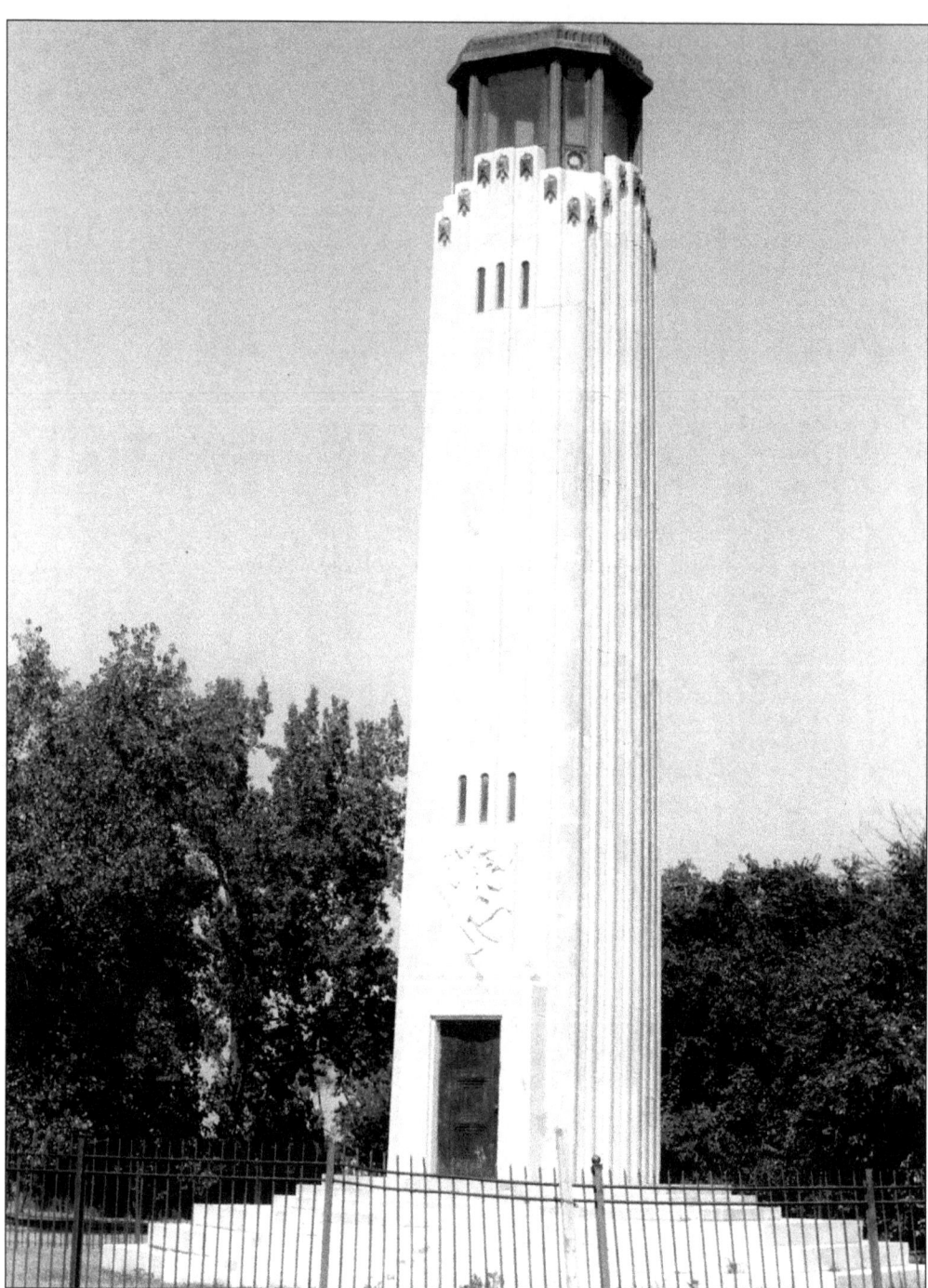

The William Livingstone Lighthouse on Belle Isle is the only Art Deco lighthouse in the United States. It was designed in 1929 by Albert Kahn's firm as a tribute to Livingstone, president of the Lake Carriers Association. Sheathed in white Georgia marble, the lighthouse is not round, but square, its façade flattened into four two-dimensional faces. The vertical fluting of the shaft is a reference to the classical column, and draws the eye rapidly upward to the zigzag at the top of the shaft.

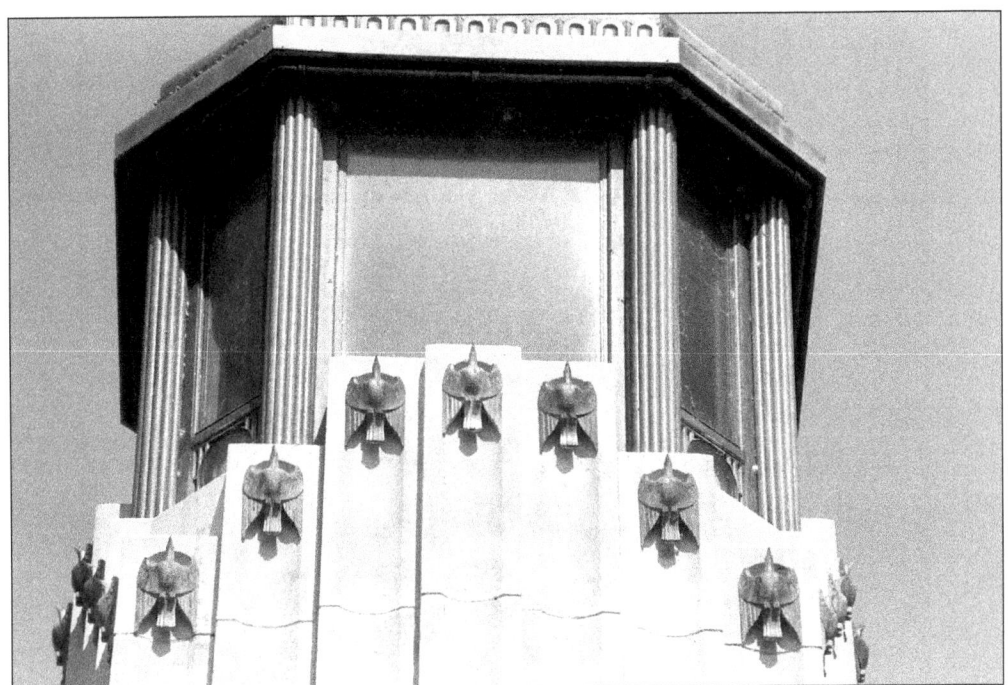

At the top of the lighthouse are bronze soaring eagles that seem to be pulling the shaft of the lighthouse ever higher.

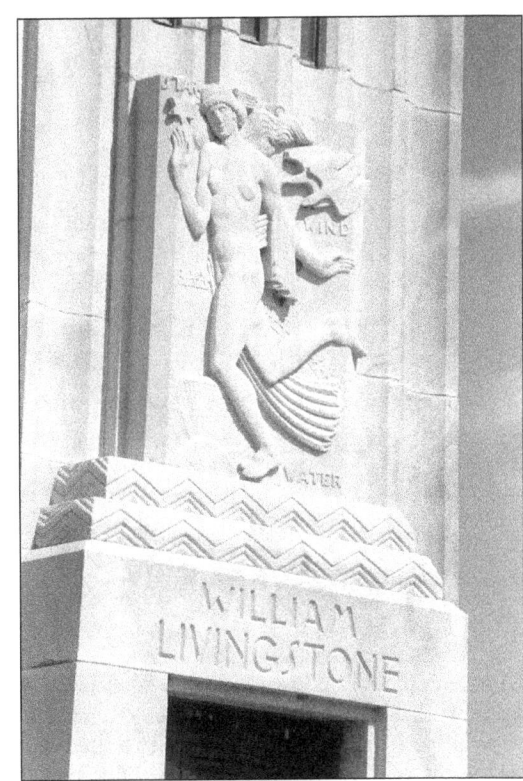

A stylized Art Deco woman symbolizes humanity overcoming nature, the "star, wind and water" used by navigators who see the lighthouse. Hungarian artist Geza Maroti sculpted this relief.

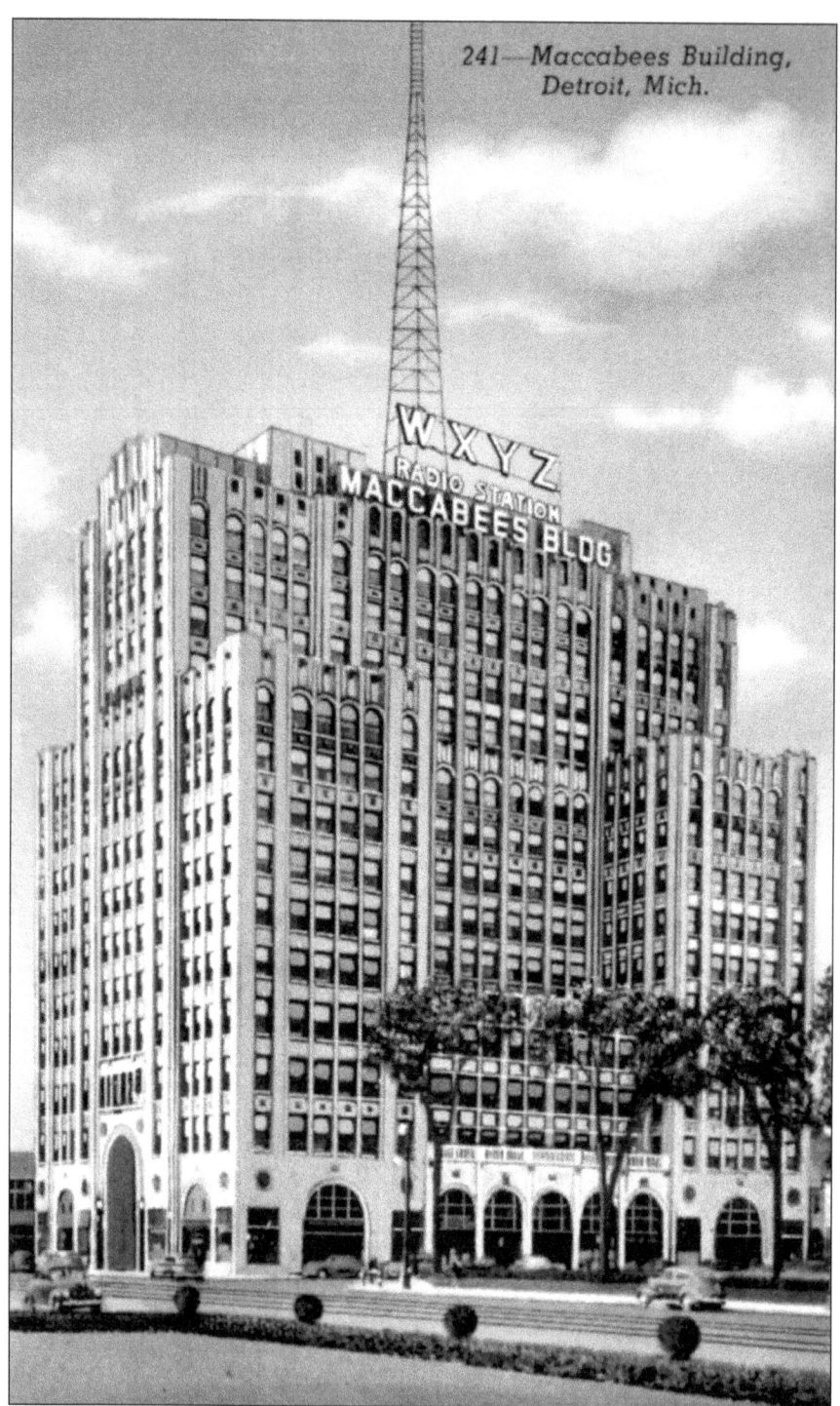

The Maccabees Building (1927) on Woodward Avenue in the Cultural Center is another Albert Kahn work which utilized vertical piers to make the building look taller. This structure's projecting arms allowed maximum light and air to the tenants in the building. This vintage postcard shows radio station WXYZ at the top of the building, although it is no longer there today.

Two

ART DECO BUILDING MATERIALS

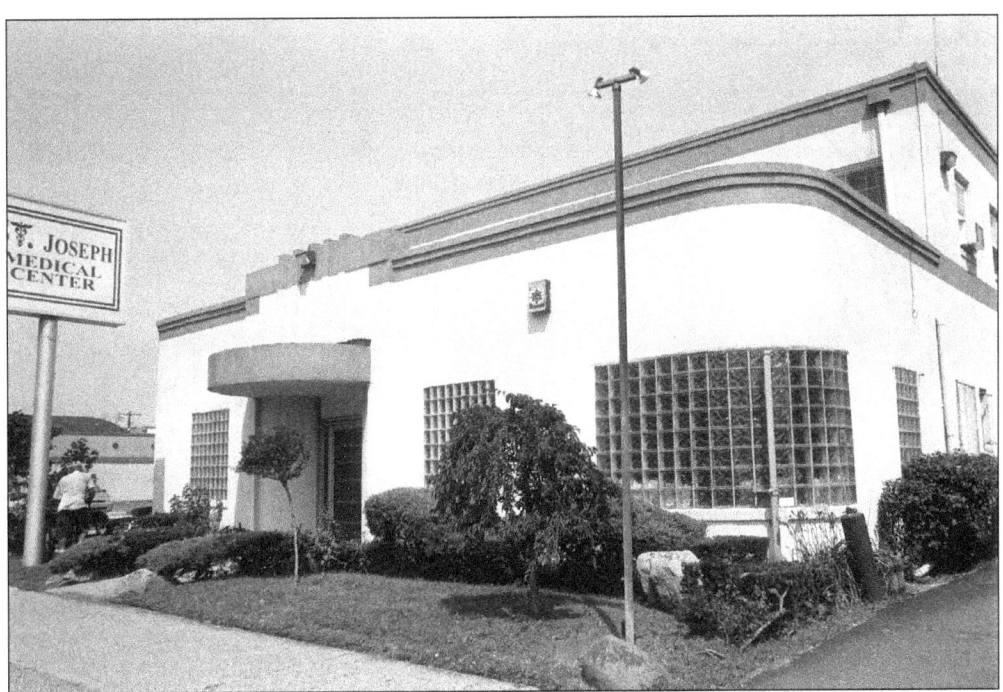

New materials were used on Art Deco buildings, and old materials were being used in a new way. Stucco is a very old material, and here it is used to cover the masonry of this very Miami Beach-style Art Deco structure on Woodward Avenue in Detroit. The combined use of glass block and alternate color of the coping at the roofline give this building its streamline art moderne style.

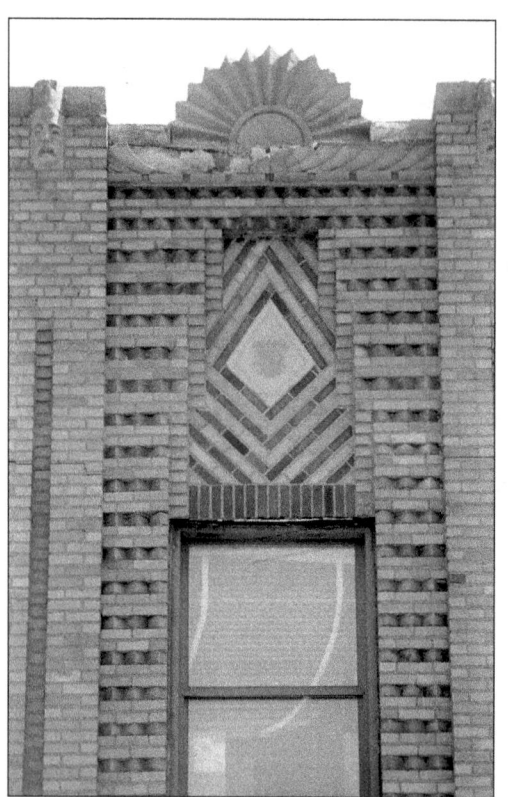

Brick has been used as a building material for thousands of years, and in this Art Deco building, brick is used in various patterns and angles to create the art moderne decorative effects.

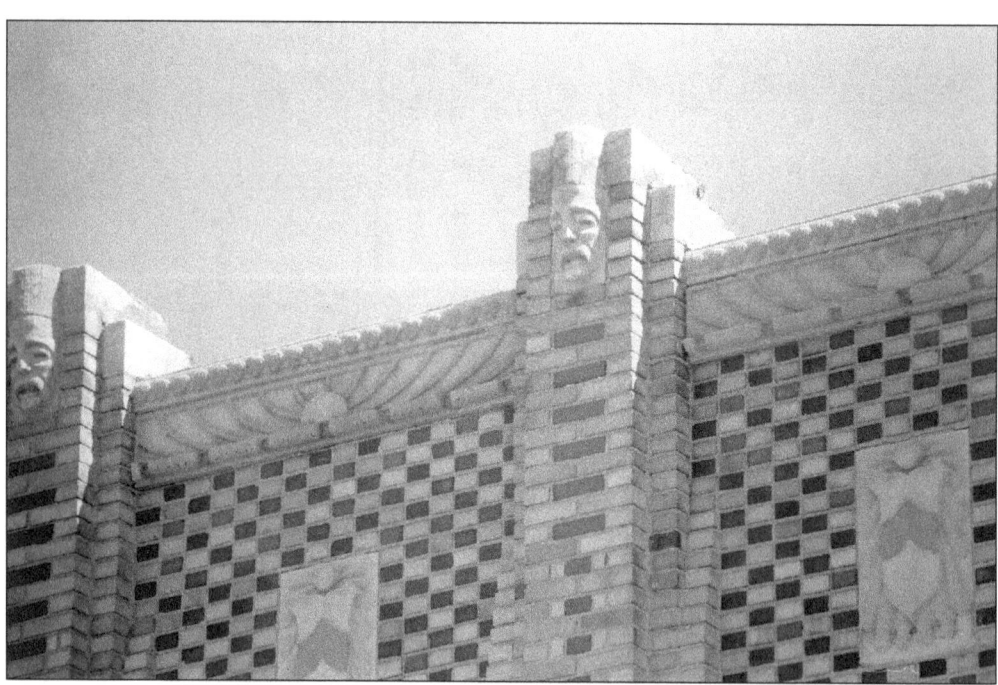

This building on East Jefferson and Chalmers in Detroit has fabulous examples of brickwork combined with cast stone to animate the details on the façade.

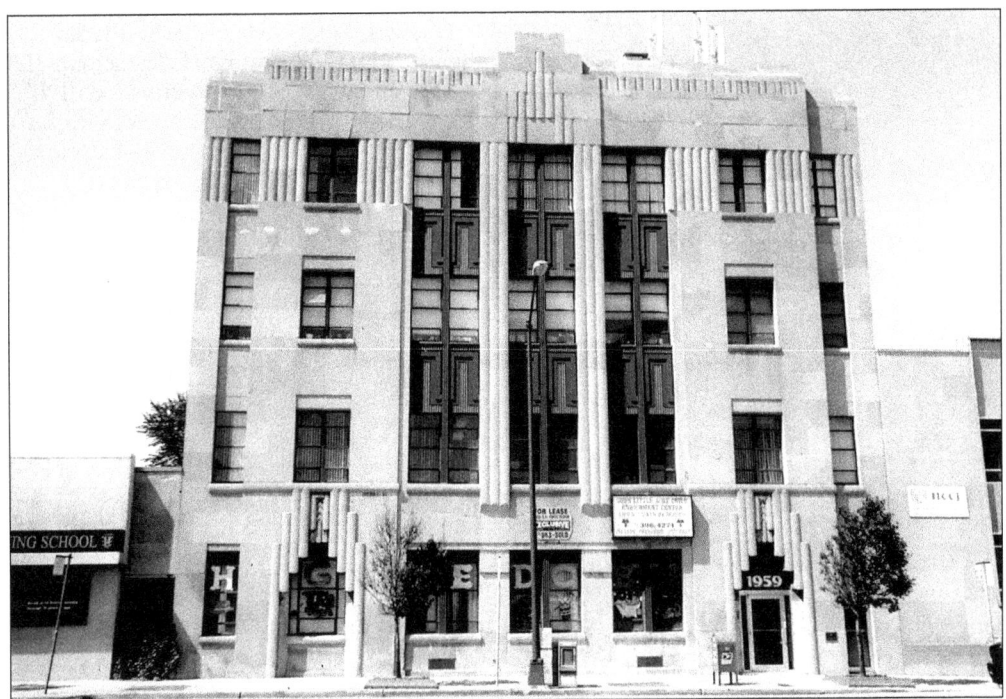

Limestone has been used as a facing material for centuries. Here on the former Willens typesetting company's plant, it creates a smooth, planar façade which is broken by fluting. This building is located on East Jefferson in Detroit, and was originally home to various printers and typesetters including the Detroit Electrotype Company and Saturday Night Press Incorporated.

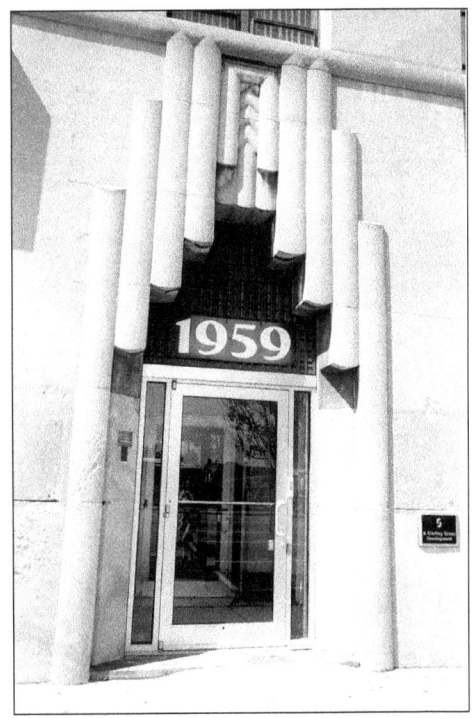

The impressive entrance to this structure has been emphasized by limestone formed in a stepped arch.

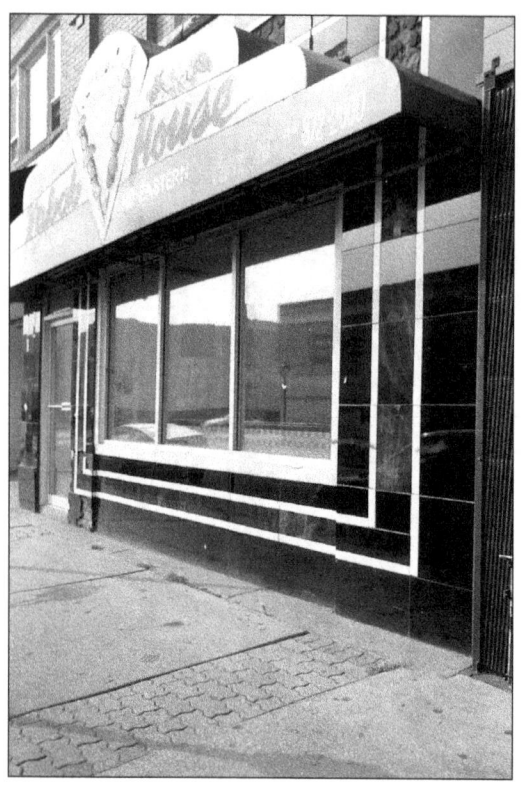

This storefront in Hamtramck is faced with "structural glass block," a facing material, which is not structural at all. It was known by the brand names "Vitrolite" and "Carrara Glass," and gave older stores a fashionable streamlined appearance.

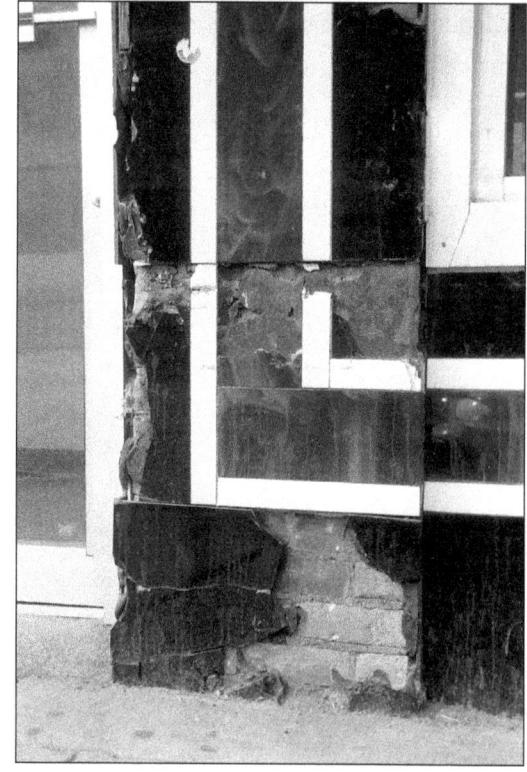

"Vitrolite" was one of the exciting new building materials being introduced in the Art Deco era. This close-up shows why Vitrolite fell out of favor—it breaks!

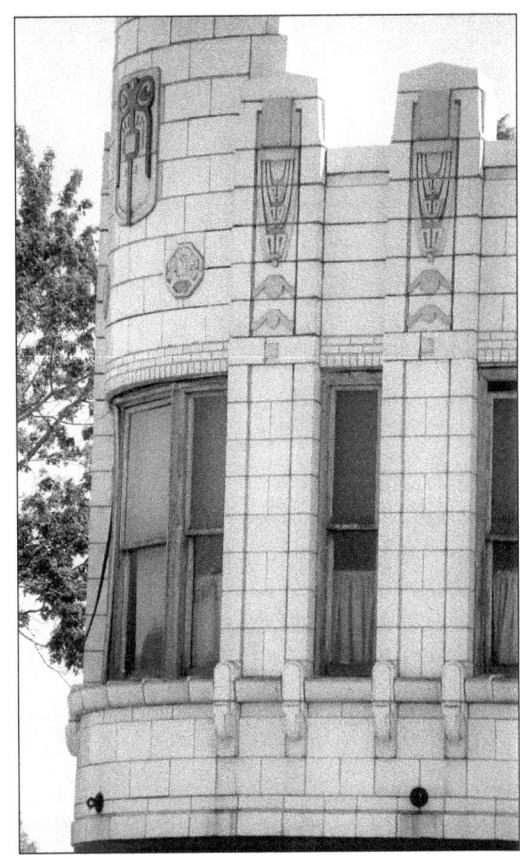

White glazed terra cotta tile was used in fabulous Art Deco patterns here. The Goeschel Building stands at the intersection of Gratiot and Mack. The building has stayed intact with very few changes to the first floor storefront, which has housed a restaurant supply business for many years.

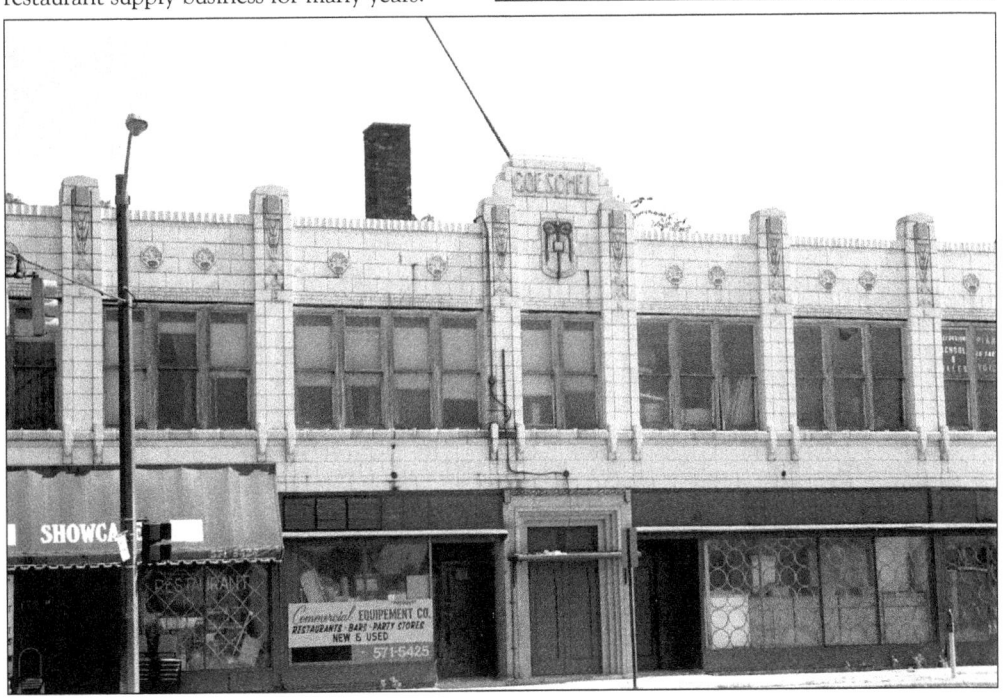

Terra cotta exterior facing on this former retail building is an example of Art Deco detailing applied in a zigzag multi-toned pattern.

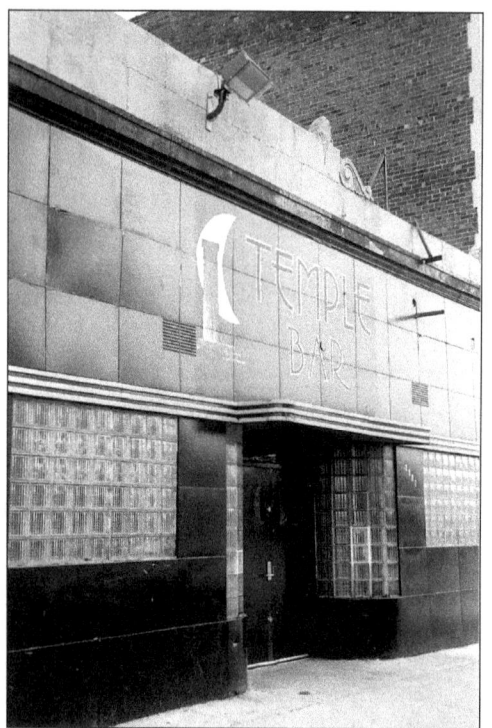

(*left*) The Temple Bar on Cass Avenue near Temple Street in Detroit uses several of the new materials of the Art Deco-era. Porcelain enamel steel panels make up the exterior facing, as well as glass block windows. Aluminum strips highlight the horizontality of the building.
(*right*) Wrought iron was formed into the curved and geometric shapes of the Art Deco style.

Three
DOING BUSINESS
INDUSTRIAL, RETAIL, POST OFFICES, CLINICS, AND COMMUNICATIONS

Grinnell Street in Detroit could be called the "Miami Beach of Art Deco Industrial Buildings." This building on Grinnell is typical of many—a streamlined exterior office fronting on Grinnell, and then a warehouse behind it. This gave the business curb appeal and an image that it was a contemporary, up-to-date industry. (Courtesy Jacques Pierre Caussin.)

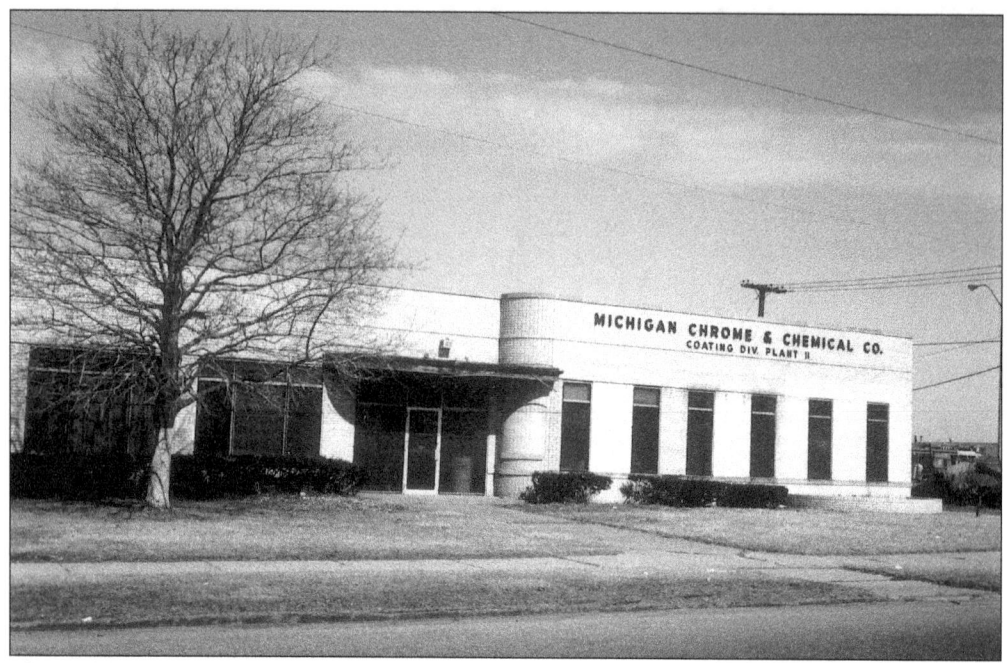

The industrial buildings on Grinnell Street were primarily built for automotive suppliers—businesses that wanted to represent themselves as stylish and contemporary. This one is at 8825 Grinnell. (Courtesy Jacques Pierre Caussin.)

The entrance to this industrial building retains its original door—a feature rarely seen today. (Courtesy Jacques Pierre Caussin.)

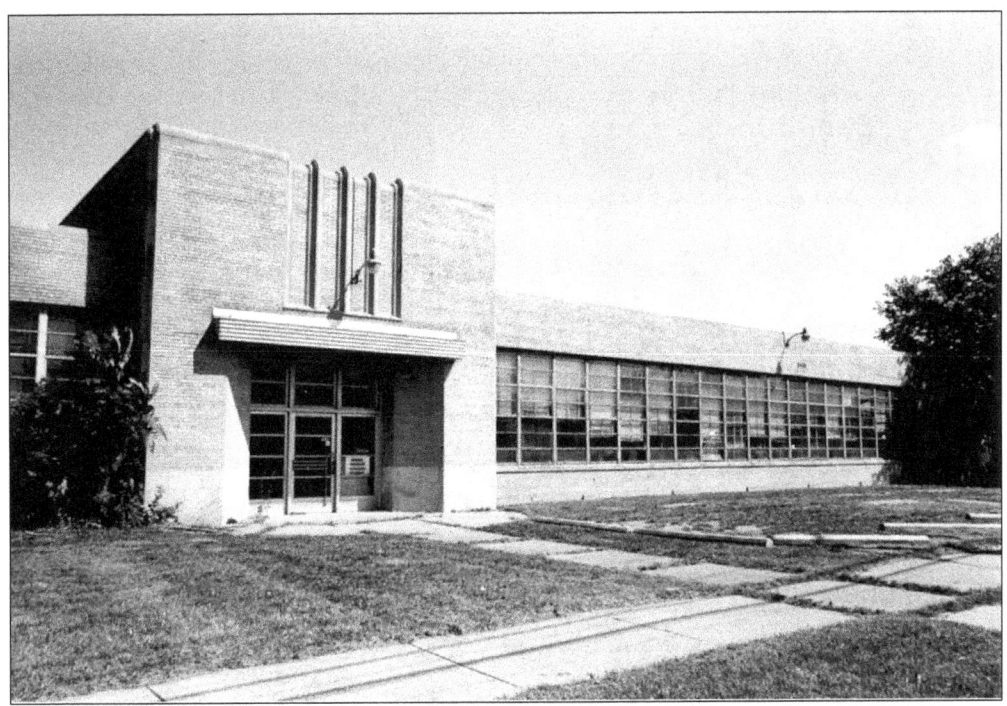

Only a few of the Grinnell Street buildings are represented here, but there are many others. In this example, the front entrance and factory were designed as one coherent building.

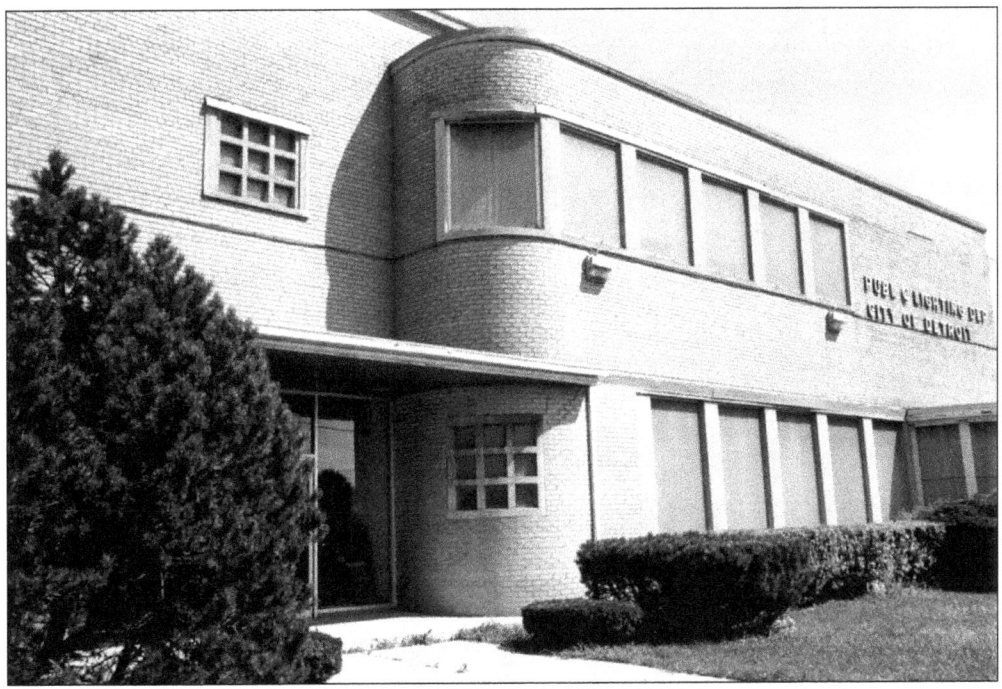

The city of Detroit's Public Lighting Department is on Grinnell Street, and is designed with a streamlined, curving façade.

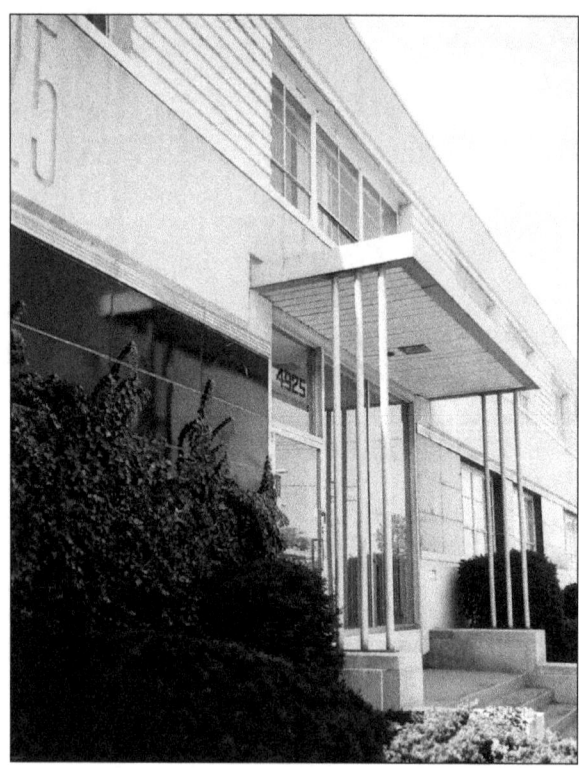

The Cadieux Stage has an interesting history. It was built in 1937 by Detroit developer Herbert V. Book, one of the Book brothers who built the Book-Cadillac Hotel and Book Building in Detroit, to house his industrial motion picture business. Various industrial film companies owned the building over the years: Wilding Picture Productions, Bell & Howell, and Maritz Communications. Today the building still serves the same purpose and is a state-of-the-art sound stage.

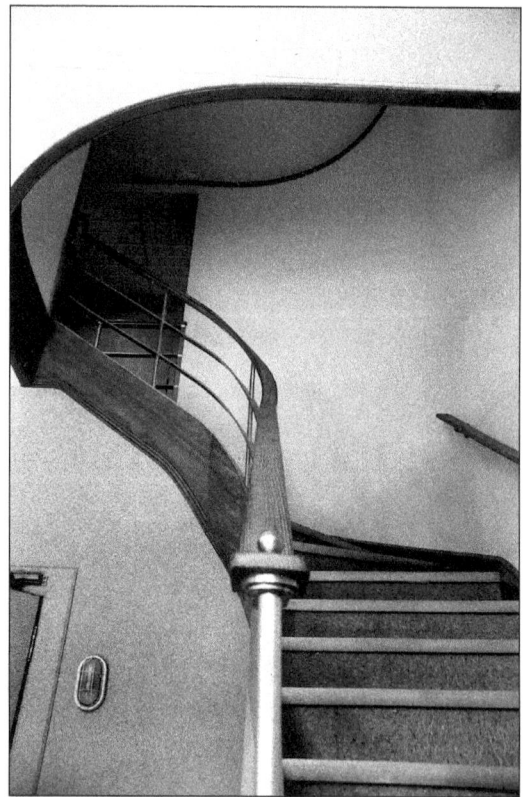

The current owner has completely restored the interior and even added Art Deco details. This curving staircase is original to the building.

The Helm Building on Hamilton in Highland Park is a factory designed in the late Art Deco style—several geometric elements and a fluted tower dominate the main entrance.

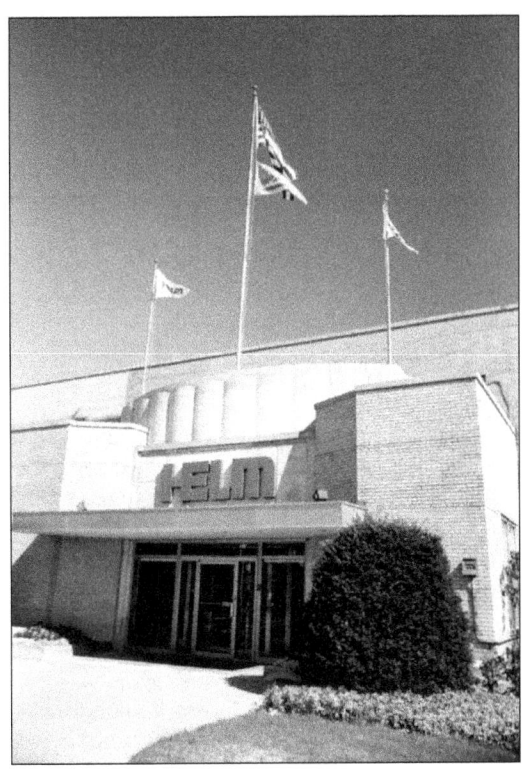

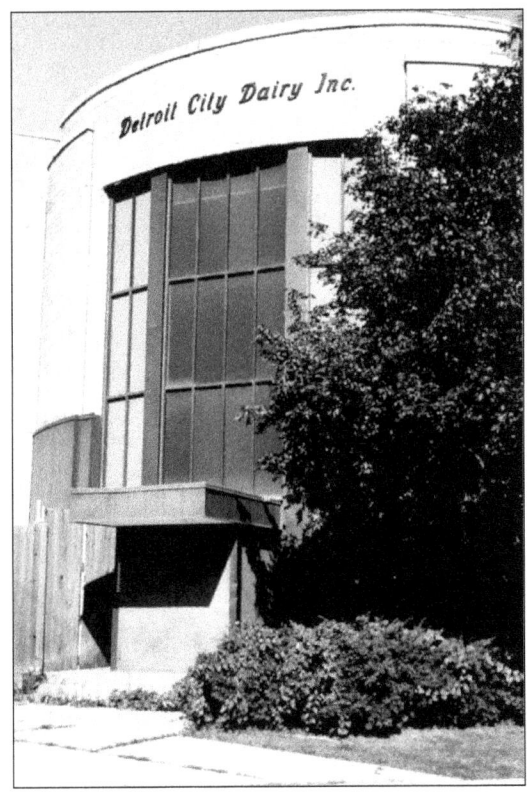

The Detroit City Dairy's former location in Highland Park also has a main entrance marked by a rounded two-story tower and cantilevered canopy.

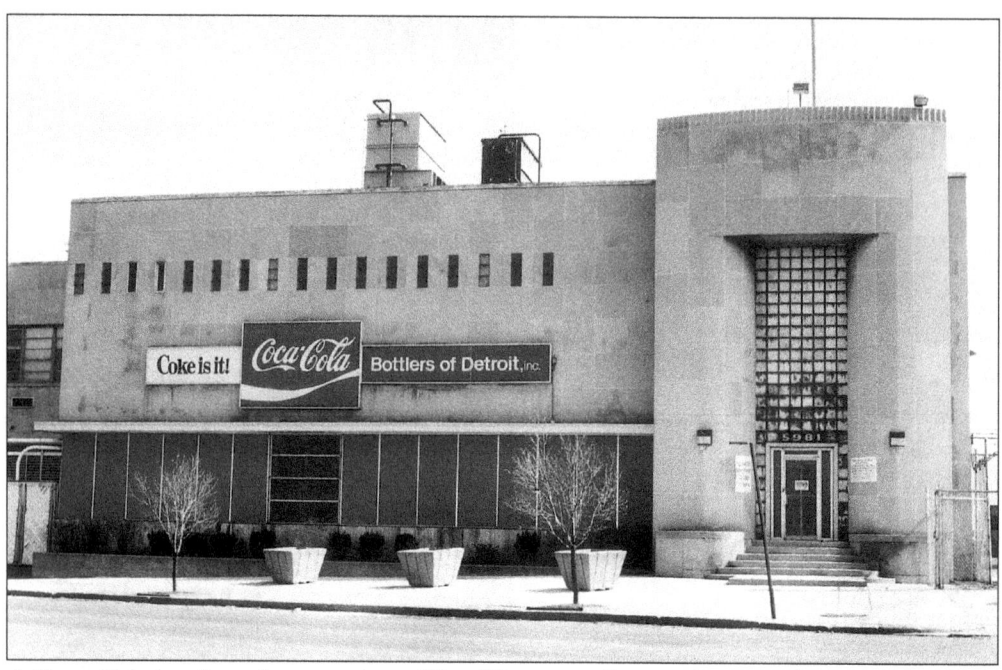

A Coca-Cola bottling plant stands on West Warren in Detroit. It is another example of Art Deco styling applied to an industrial building façade, while the utilitarian factory is behind the main entrance. (Courtesy Audra Bartley.)

The Mellus Building in Lincoln Park was built in 1941 for the Mellus Newspaper Company. The Mellus Newspaper Company ran a successful downriver newspaper for over 30 years. Now vacant, this building's restoration would be an enhancement to Fort Street's business district. (Courtesy Leslie Lynch-Wilson.)

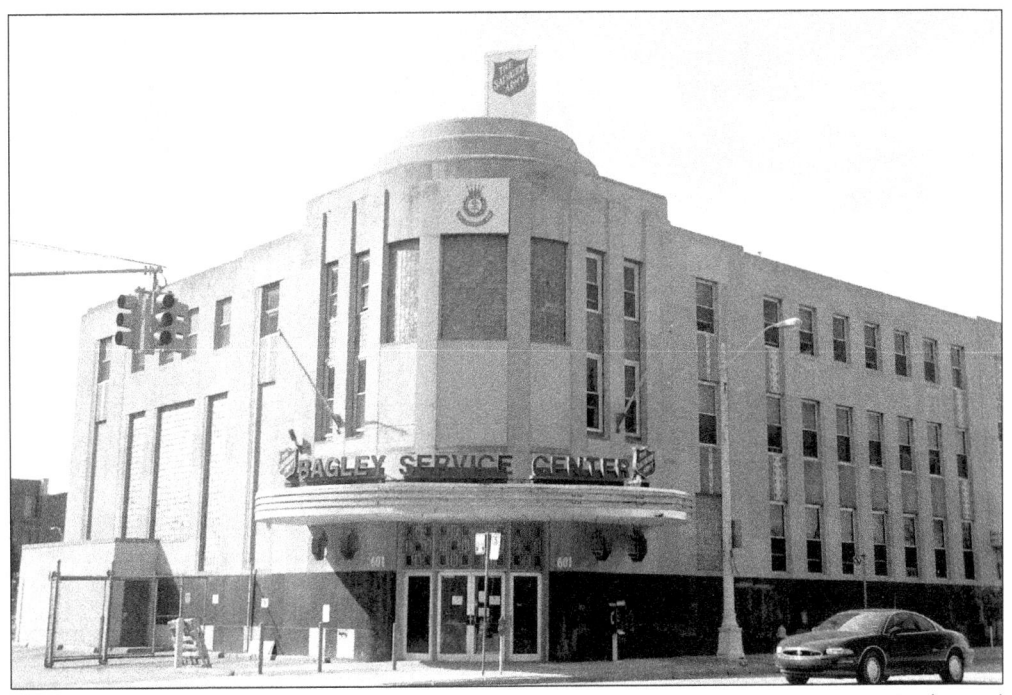

The former headquarters for the Salvation Army was built in downtown Detroit on Bagley and Second Street. The four-story building's prominent curved corner tower defines the intersection.

The entrance to this former factory for Giovanni's on Erwin Street in Detroit incorporated the company's symbol into the main entrance. Though the windows have been filled and altered, the building's geometry and symmetrical entrance remain intact. (Courtesy Jacques Pierre Caussin.)

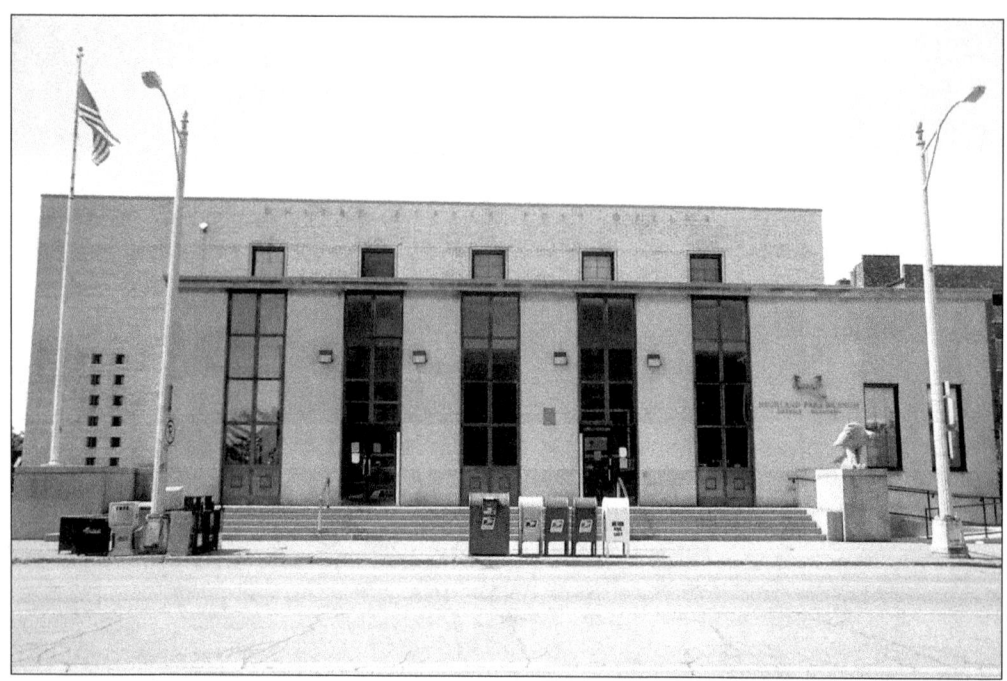

The Highland Park Post Office on Woodward Avenue was built in 1939 from the Office of the Supervising Architect of the Department of Treasury, Louis A. Simon. This is the International Style of architecture—representations of columns are simply the brick piers between the windows.

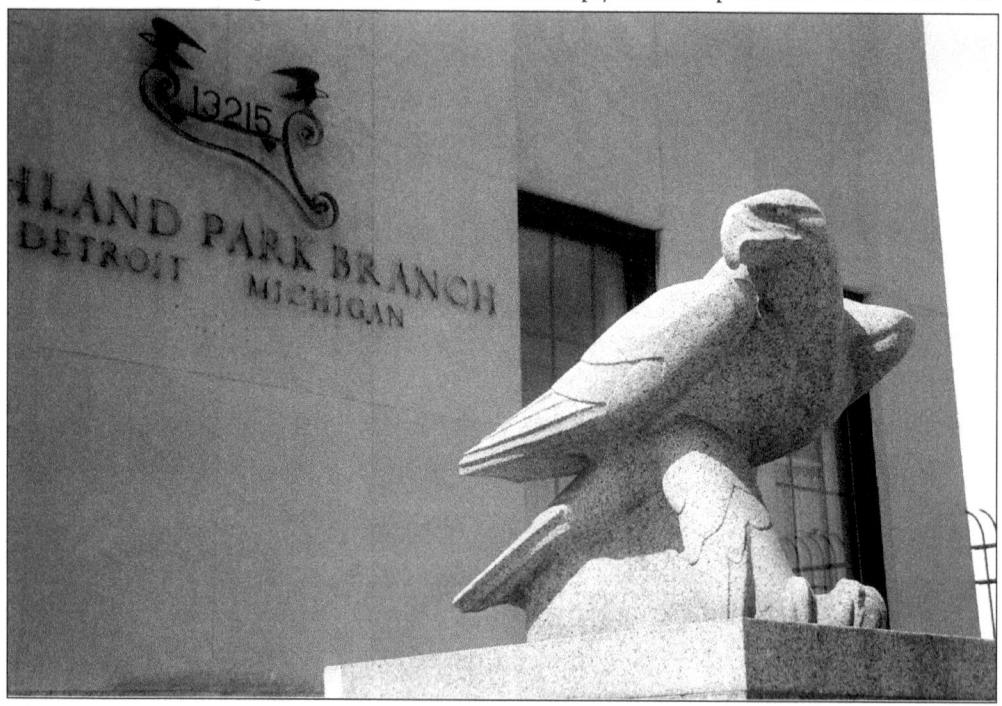

This eagle stands in front of the Highland Park Post Office. It was sculpted by Erwin Springweiler in 1940 and was funded by the United States Treasury Department's Section of Fine Arts program.

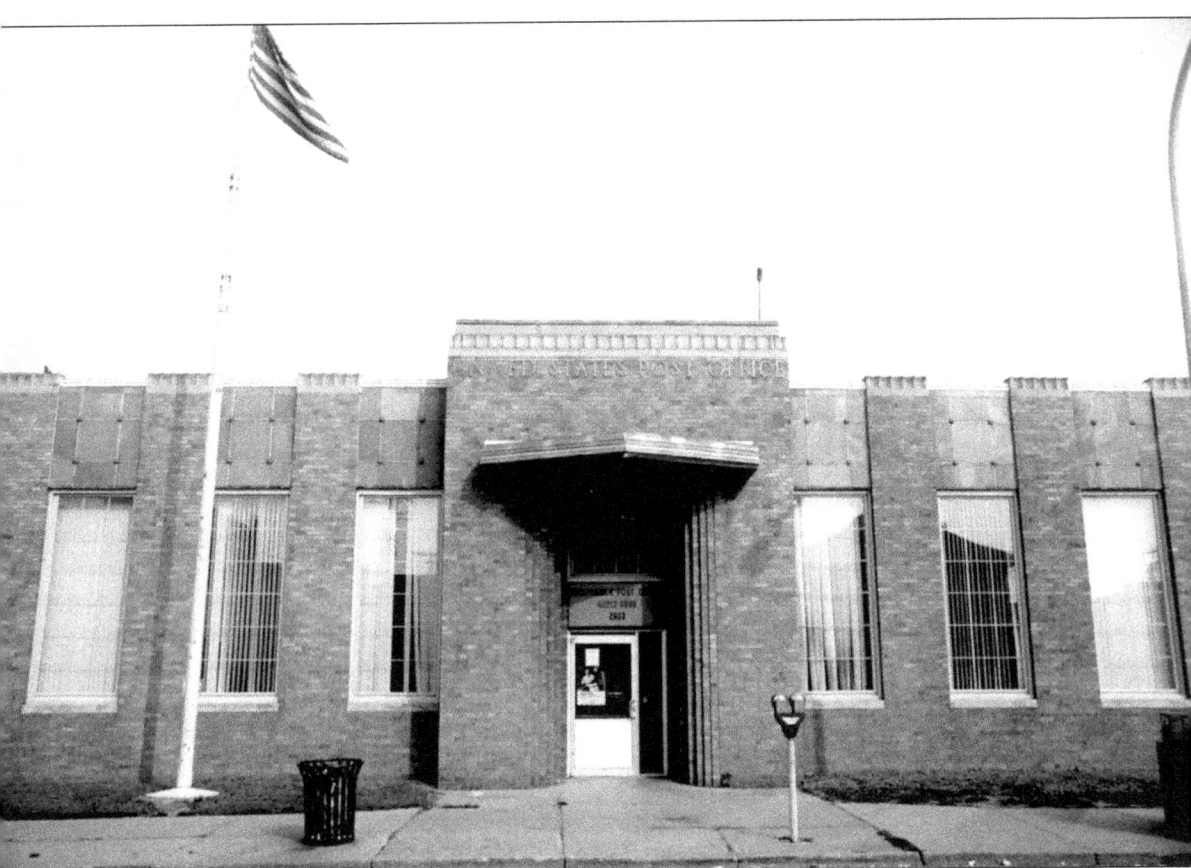

The Hamtramck Post Office was built in 1936, during the depths of the Great Depression, through the Federal Works Progress Administration at a cost of $79,500. The design was done by the Office of the Supervising Architect of the Department of Treasury, Louis A. Simon. The building also boasts three impressive WPA painted panels inside, as well as numerous Art Deco details. While money was in short supply during the Depression, that did not stop the architect from creating a classic Art Deco design including such flourishes as a massive brass lantern over the front entrance.

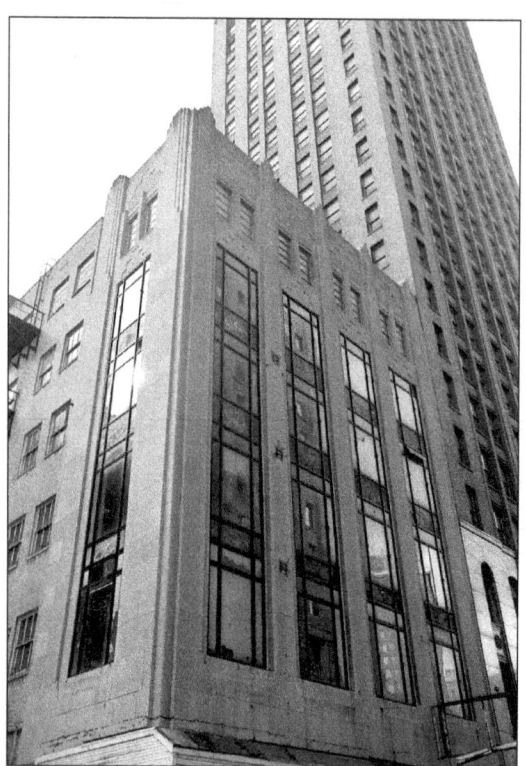

The terra cotta exterior of this retail building on State Street in downtown Detroit has delicate Art Deco detailing at the roofline. This structure was once home to the Colonial Department Store.

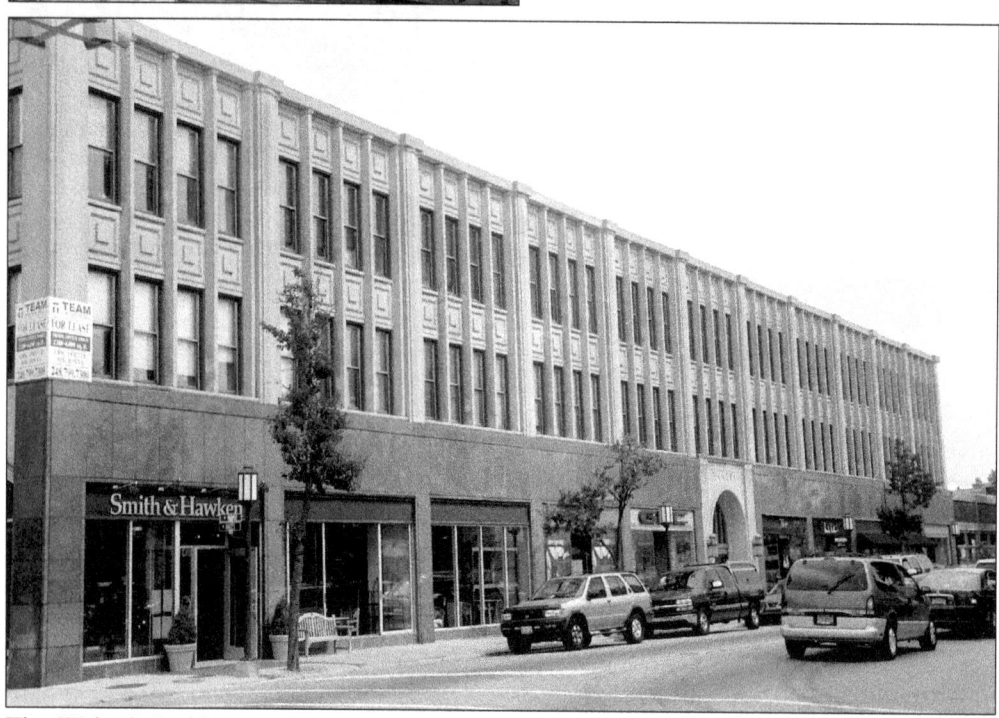

The Wabeek Building in downtown Birmingham, just north of Detroit, was supposed to be several stories taller. But local opposition to a "skyscraper" in the small city forced the project to be scaled back. Much of the originally planned Art Deco detailing was reduced.

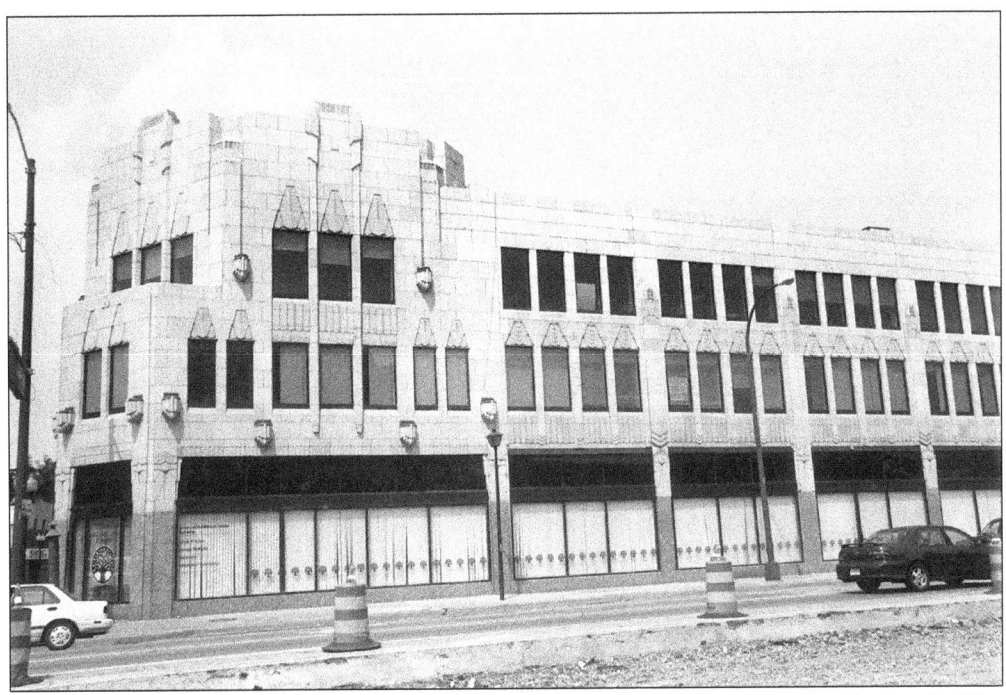

The J.M. Schaefer Building in Dearborn is at Michigan Avenue and Schaefer Road. This handsome retail and office building was built in 1930 by architect Louis Kamper. Originally there were 17 stores on the first floor and 45 office suites above on the second floor. It became run-down by the 1980s, but a new owner completely restored it in 1997.

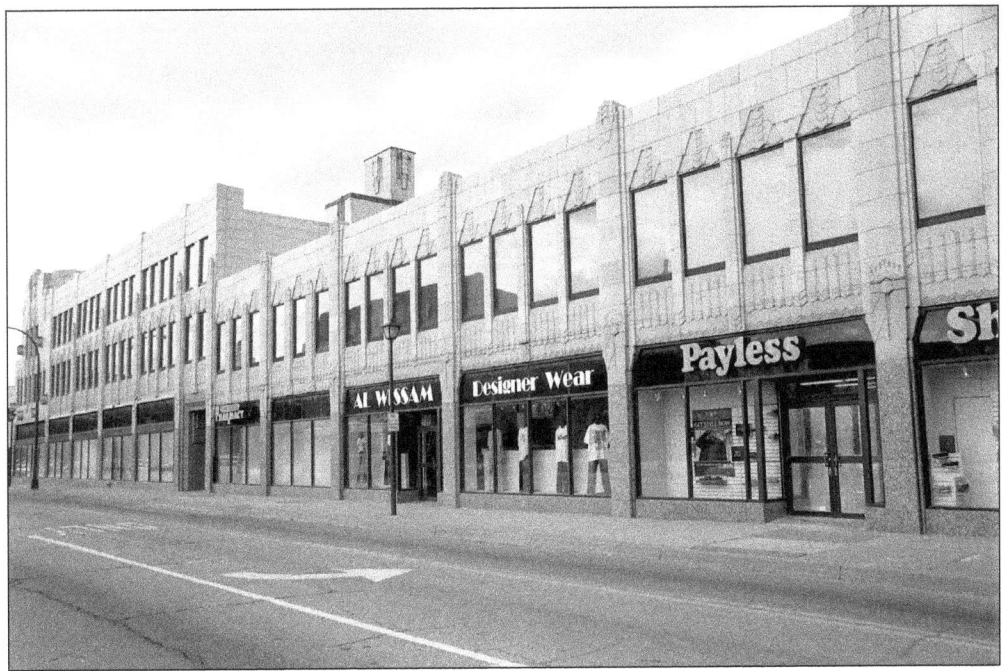

The Schaefer Building fills the entire block in length and is once again home to a variety of retail stores.

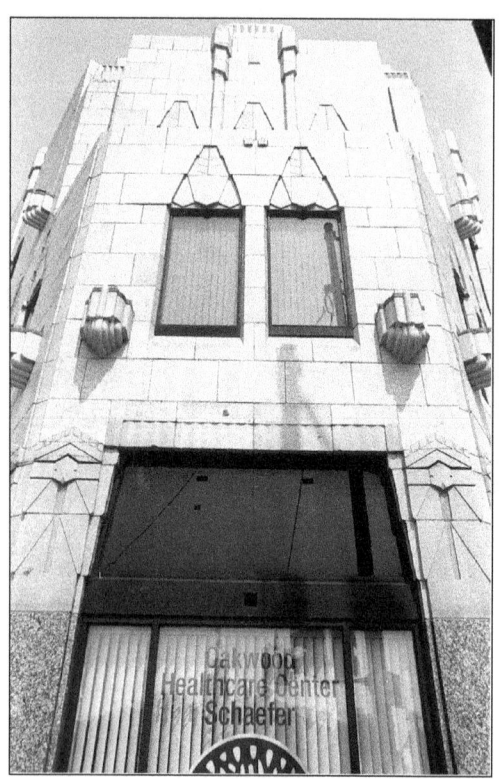

The multi-toned terra cotta exterior and "lion's paws" light sconces are once again lit at night.

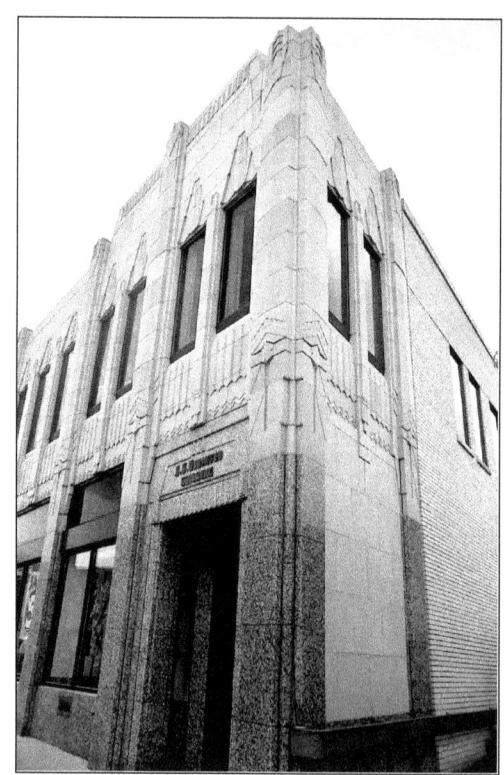

The Art Deco style used on the Schaefer Building is the "zigzag" style which referred to the angular patterns.

The Simmons & Clark jewelry store has been located downtown on Broadway since 1925 when it was founded by Fred Simmons and Harry Clark. The store is in a 1923 white terra cotta building, and in 1934, Simmons & Clark installed a new modern storefront using black Vitrolite and chrome.

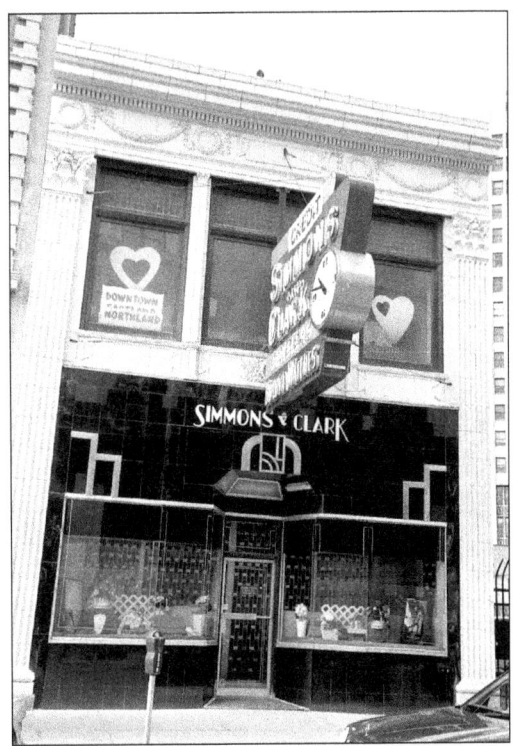

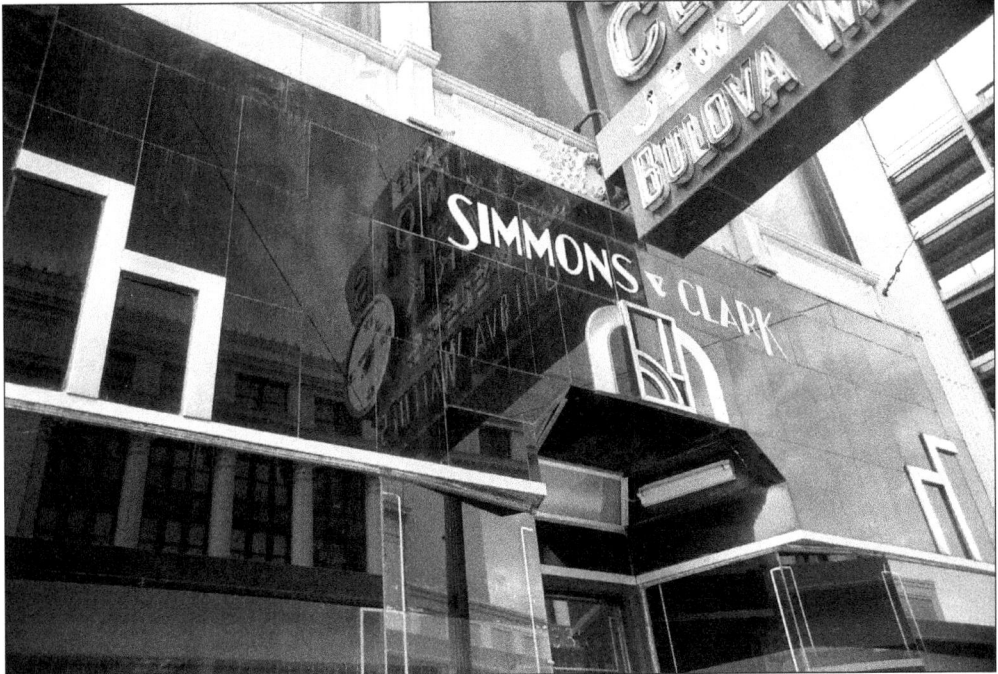

The Simmons & Clark name was mounted in custom-made Vitrolite, and a fabulous Art Deco design element in chrome was placed just below their name. A projecting neon sign and clock were added in 1956. Recently restored, this storefront is one of Detroit's best examples of retail Art Deco design.

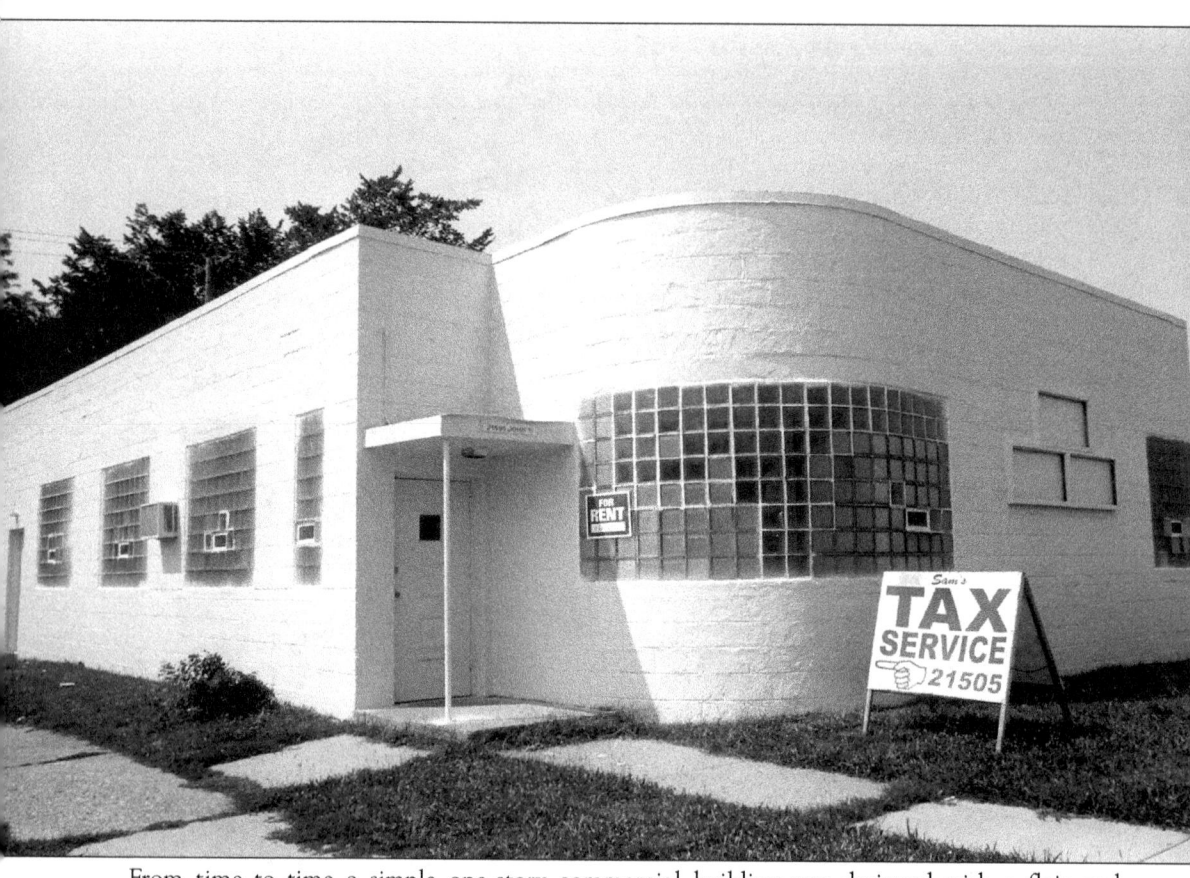
From time to time a simple one-story commercial building was designed with a flair and streamlined sense of motion. This building in Hazel Park may not be flashy but it has style.

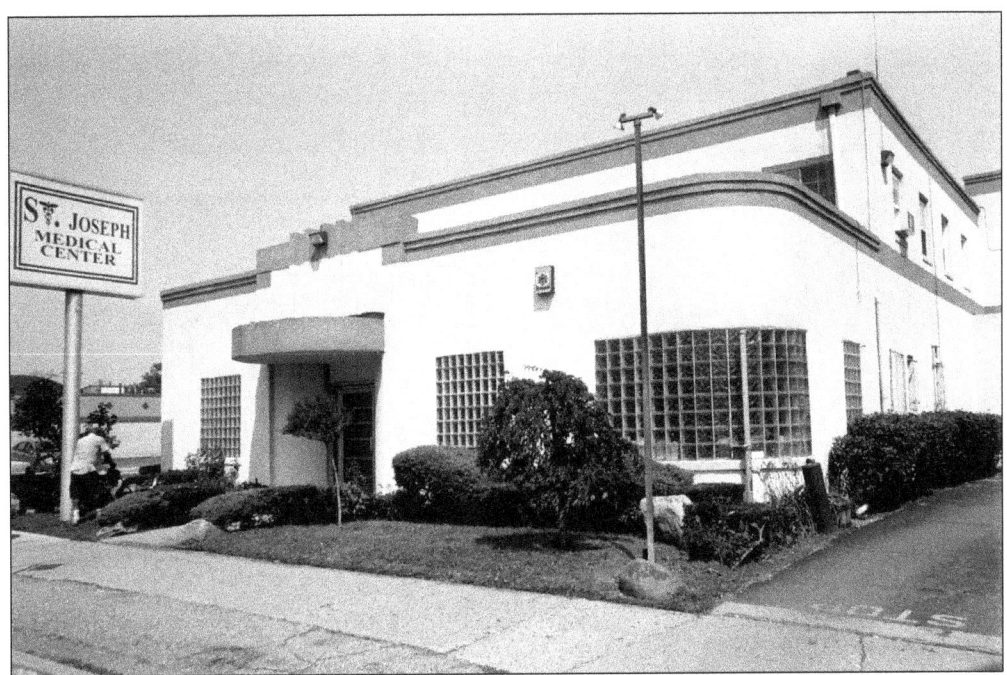

Clinics have frequently utilized the clean white lines of the streamlined Art Deco style to represent the contemporary, sanitary health care provided inside. The St. Joseph Medical Center is on Woodward in Detroit.

This streamlined clinic is on Van Dyke in Detroit. The brick on this building has been painted white, and the curved glass block windows are original.

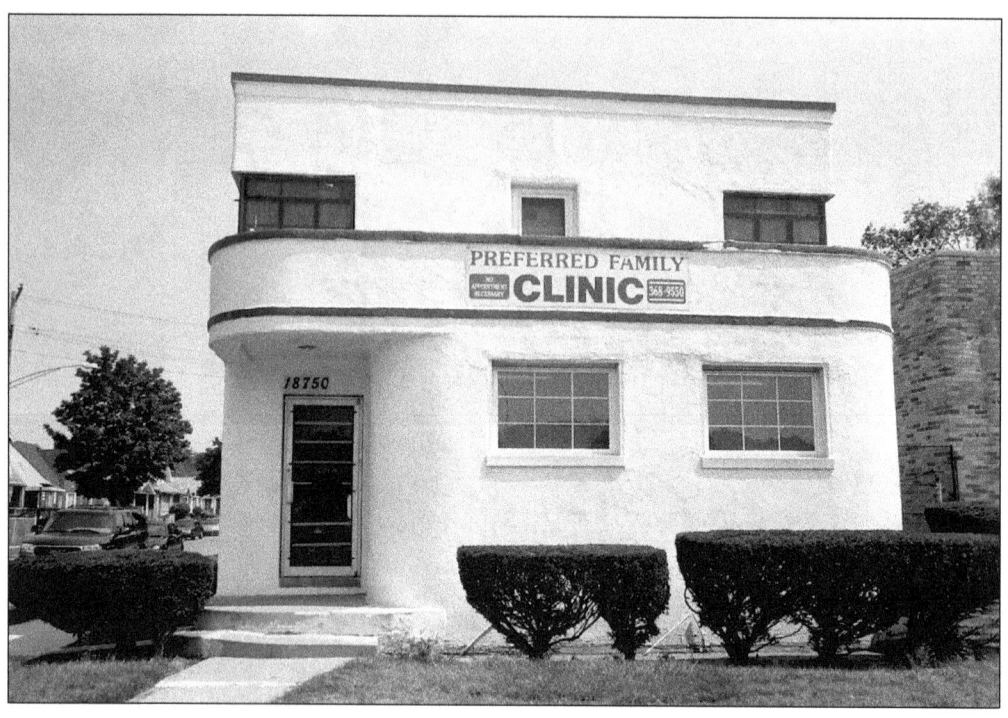

The Preferred Family Clinic also uses the streamlined style and the white stucco exterior. It is similar to the Miami Beach buildings from the deco era. This clinic is on Woodward near Seven Mile Road in Detroit.

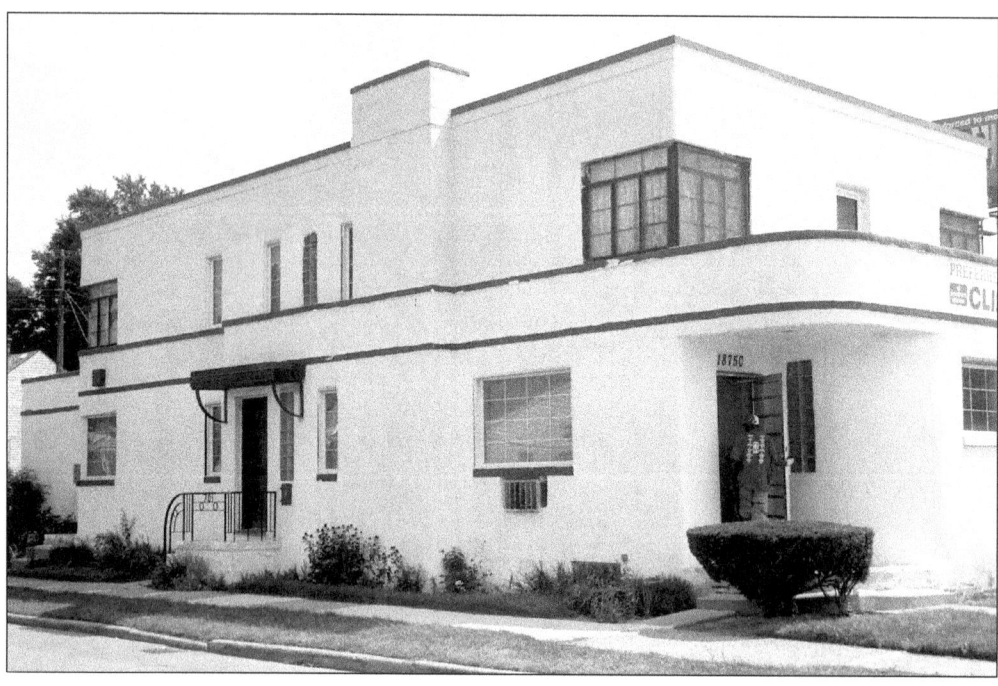

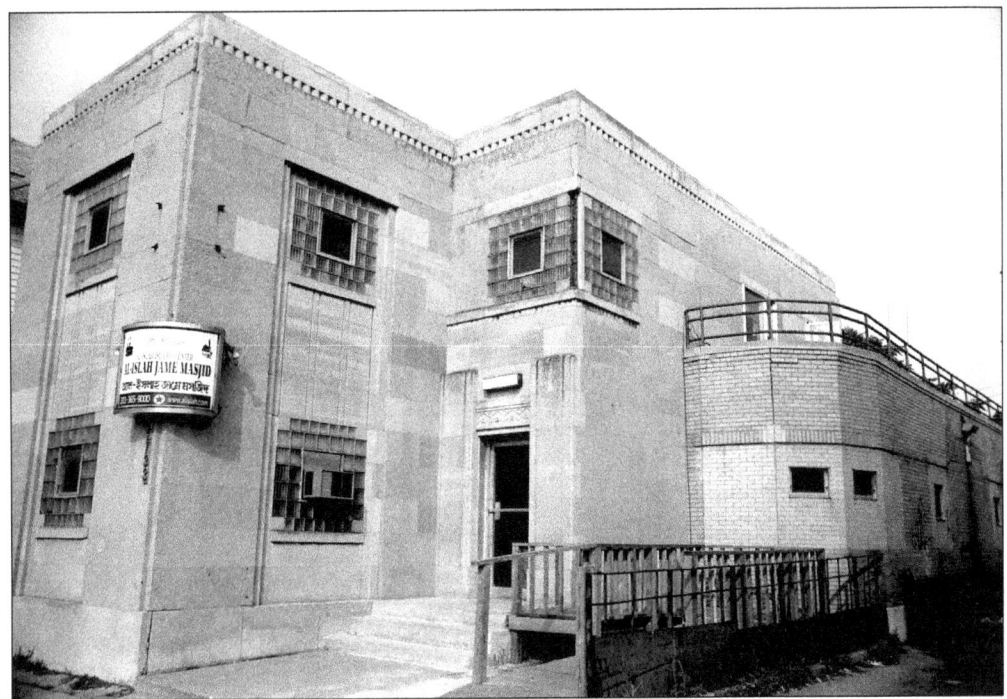
The Jabczenski Chiropractic Clinic in Hamtramck was probably built in 1928. The yellow sandstone used in construction is identical to that of a bank built at that time just a block away. Today it serves as a Moslem mosque, but it retains its original Art Deco styling.

The narrow interior hall of the Jabczenski Chiropractic Clinic gives no indication of its Art Deco exterior.

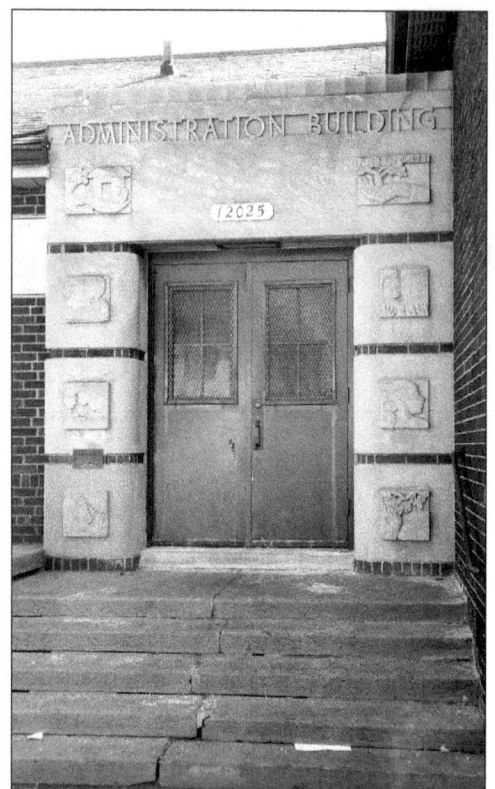 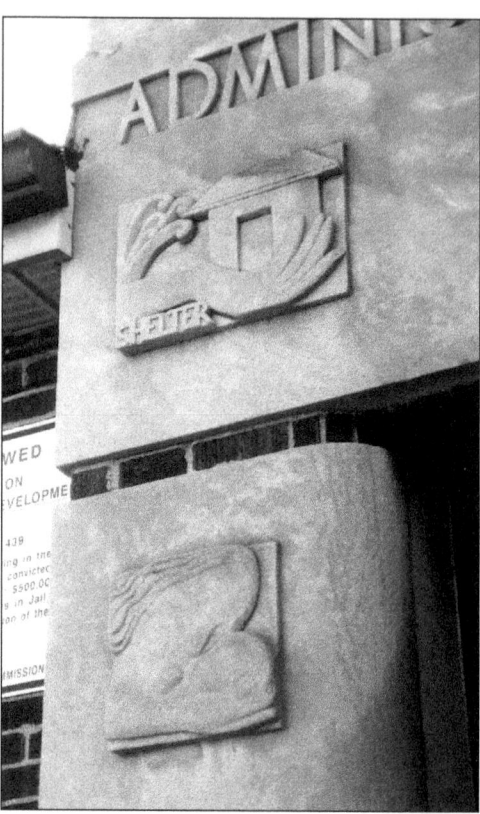

This Administration Building in Detroit has wonderful WPA-era plaques on each side of the entrance. The plaques express the themes of either shelter or health. (Courtesy Jacques Pierre Caussin.)

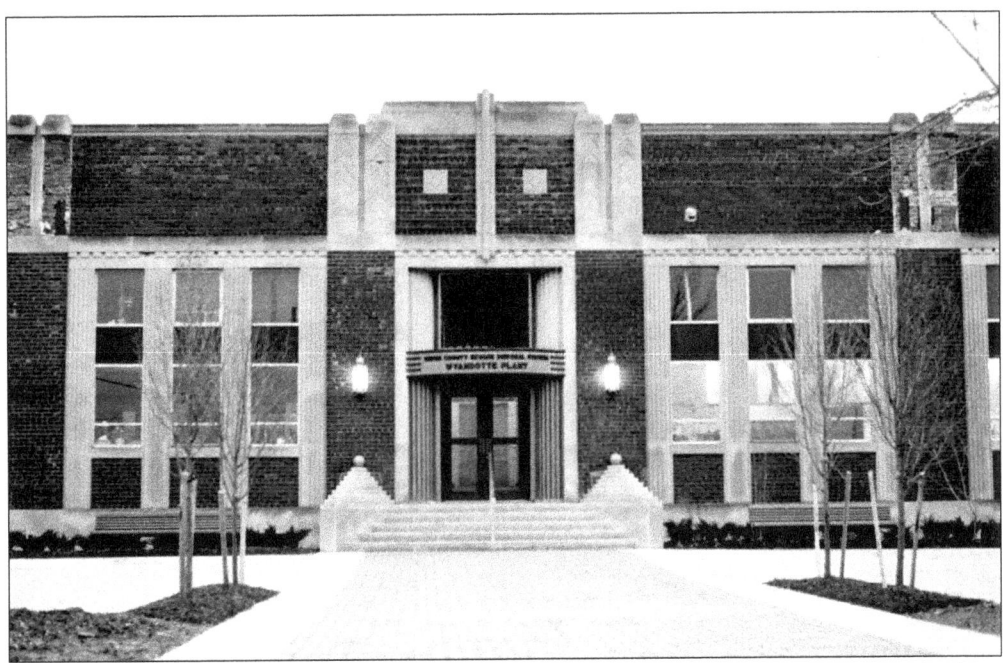

The Wayne County Sewage Disposal System Wyandotte Plant on Central Avenue, built in 1938, has a combination of Art Deco detailing and traditional detailing. Although the windows have been altered, the building's cast stone trim is intact. The two stepped pyramids capped with a ball on each side of the entrance stairs are delightful. (Courtesy Dan Drotar.)

Many municipal buildings from the 1930s incorporated the Art Deco style—at least at their doorway. The Grosse Pointe Park Storm Water Pumping Station on Kercheval has a streamlined curved entrance. (Courtesy Jacques Pierre Caussin.)

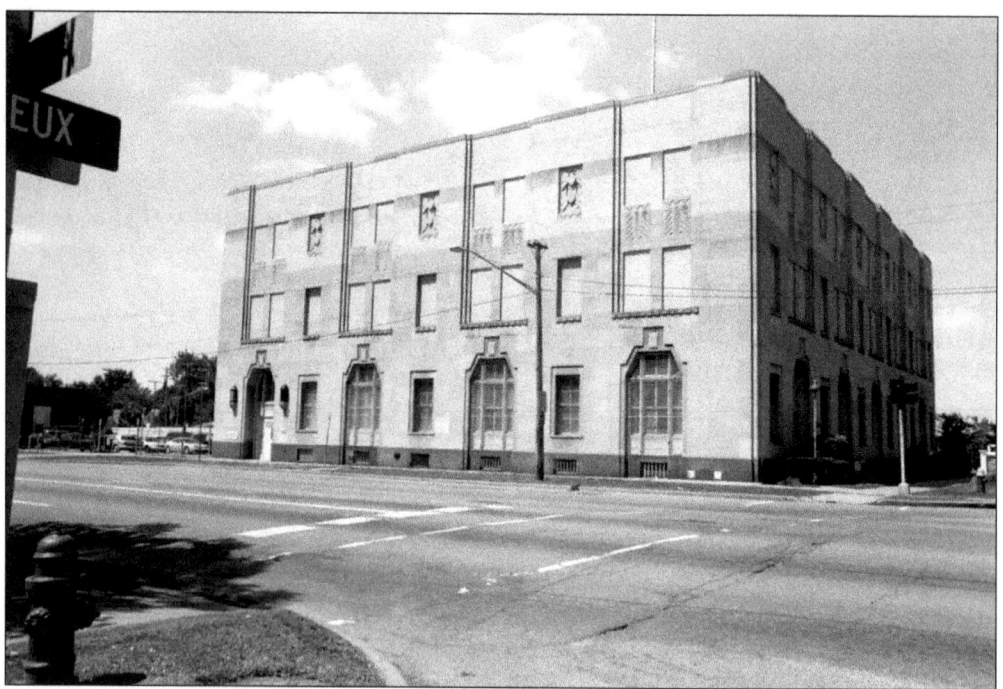

The communications industry often used the Art Deco style of architecture to represent their cutting edge status. This structure is still used as a phone switching station. It was originally called the "Niagara Dial Central Office" and is located at Cadieux and Mack in Detroit. Built in 1928, it has since had many windows filled in with brick, but the structure's cast stone chevrons and zigzag terra cotta are intact.

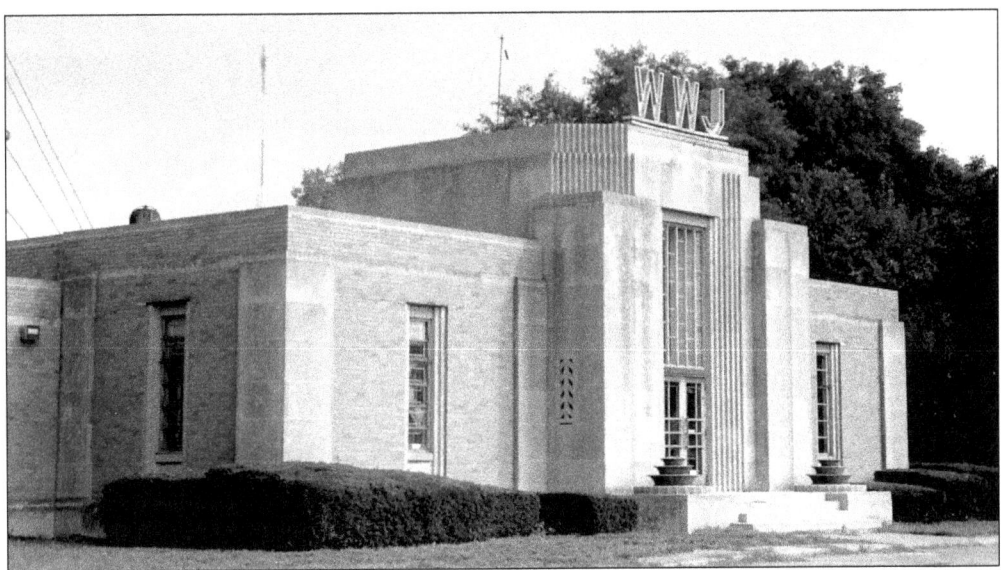

Radio was the new media of the 1930s, and it used the contemporary "modern" design to represent its technological advances. The WWJ transmitter station on Eight Mile Road has remained an intact example of Art Deco design. The two exterior luminaries on each side of the entrance beam light on the building façade at night.

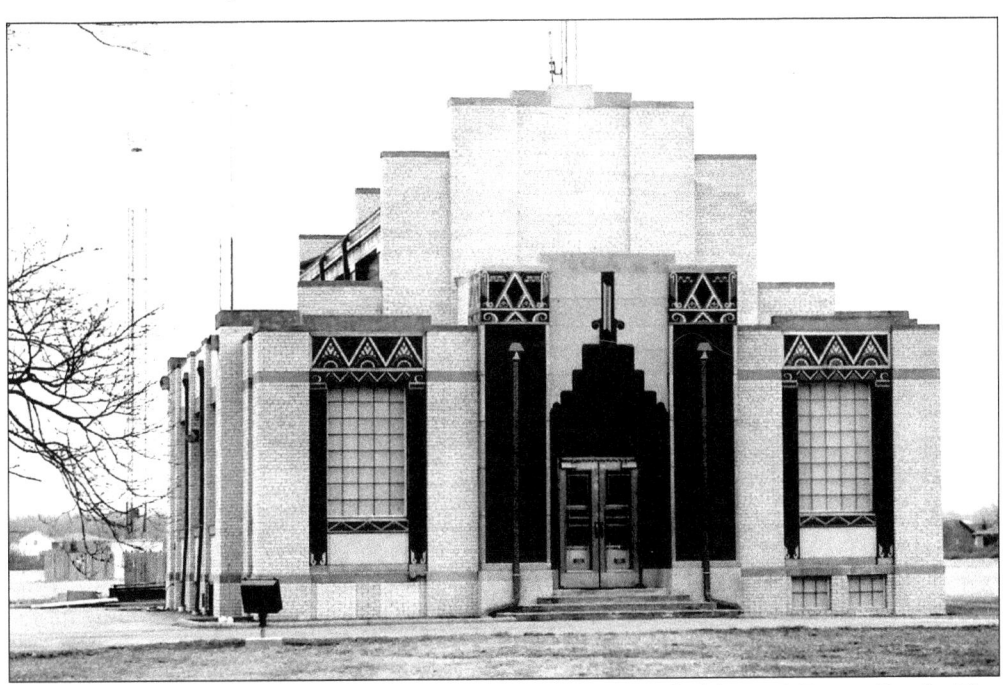

The WJR transmitter in Riverview is on the southwest corner of Sibley and Grange Roads. This transmitter building was designed by Cyril Edward Schley in 1934. Schley was the architect of many of the theaters in Detroit, and his theatrical style is evident in this structure. The design exhibits all the hallmarks of the zigzag Art Deco style. Its jagged silhouette is stepped back to a central tower. The ornate, colorful ceramic tile on this completely unique building makes it one of our rare jewels. (Courtesy Dan Drotar.)

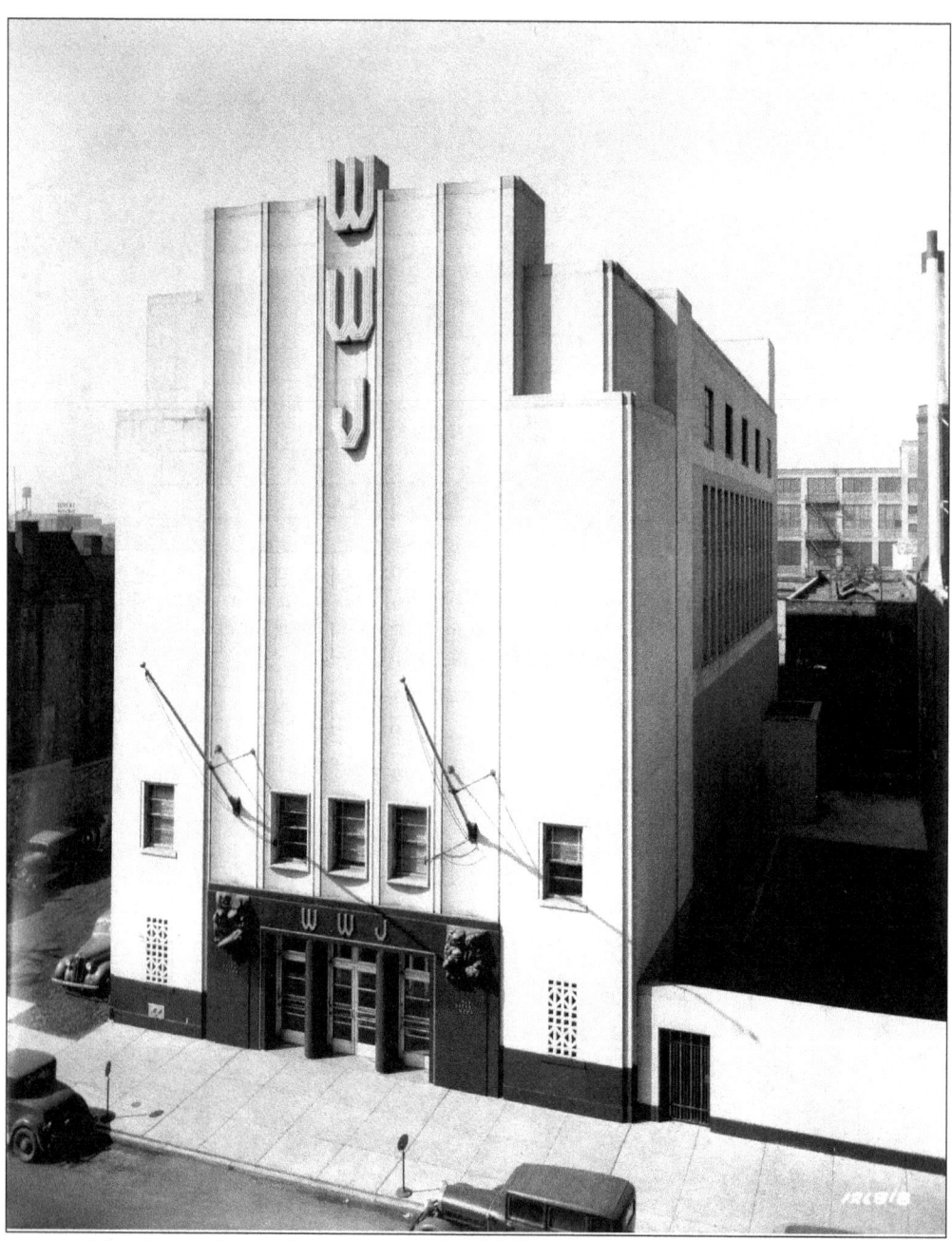

Designed by Albert Kahn's firm in 1936, the WWJ Broadcast Station cost $1 million, and was promoted as a radio broadcasting station without an equal in the world. It later became Michigan's first television station. Popular shows such as "George Pierrot's World Adventure Series" were broadcast live from the 340-seat auditorium. Located on West Lafayette in downtown Detroit, the building has also been home to the Chamber of Commerce. It has been renovated since this historic photo was taken, but the symmetrical 70-foot façade of buff-colored Indiana limestone remains. (Courtesy Manning Collection.)

Four

BY THE SIDE OF THE ROAD
ROADSIDE ARCHITECTURE

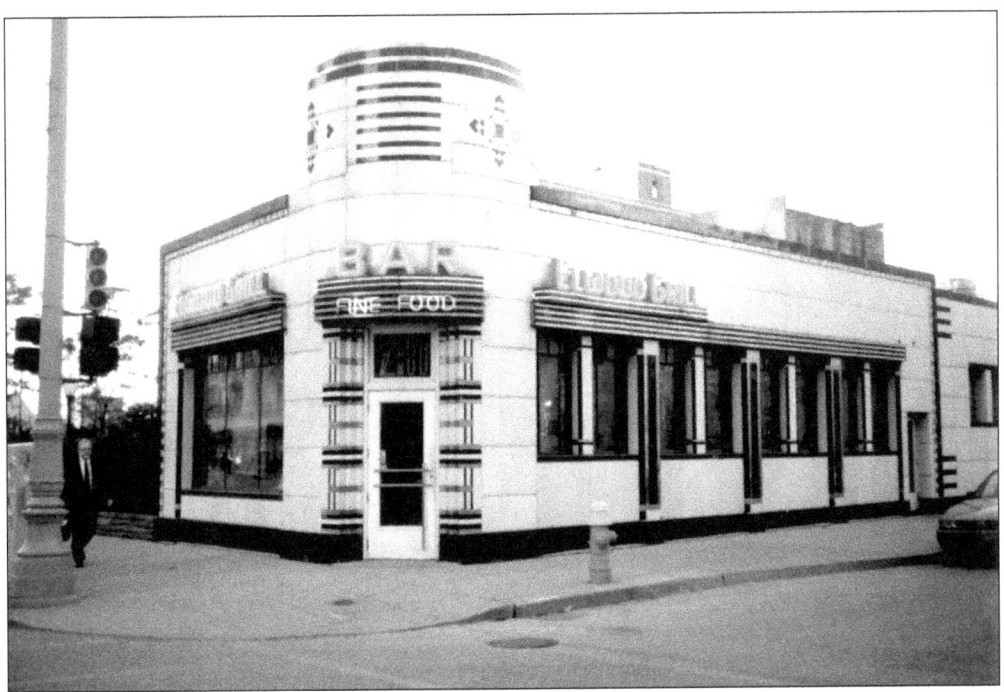

The Elwood Bar and Grill is one of Detroit's most recognized Art Moderne roadside treasures. This photo shows the Elwood in its original location—at the corner of Elizabeth Street and Woodward Avenue—which is where it derives its name by combining the "El" and "Wood" of each street. Built in 1936 by Charles Noble, the Elwood functioned as Woodward's roadside diner for decades. Purchased by Chuck Forbes and restored in 1989, it became a hip retro bar and restaurant.

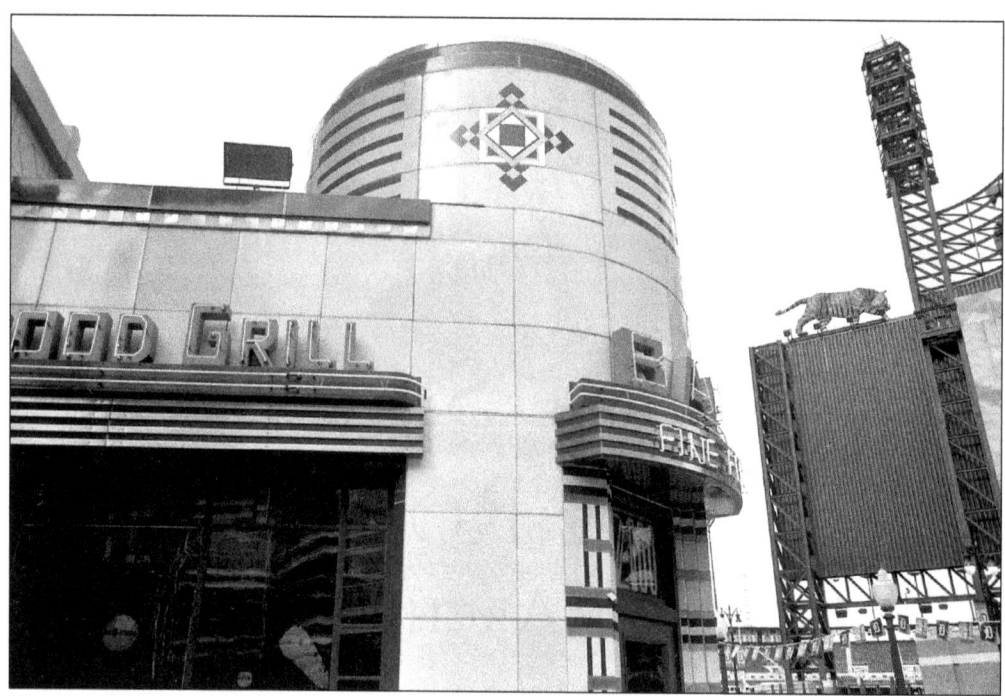

In 1997, the Elwood was threatened with demolition when it was determined to be in the way of a parking lot for the new baseball stadium, Comerica Park. Mr. Forbes had the Elwood moved, and then restored it again at its new location, at Adams and Brush Streets. It is now located just beneath the Detroit Tigers' scoreboard.

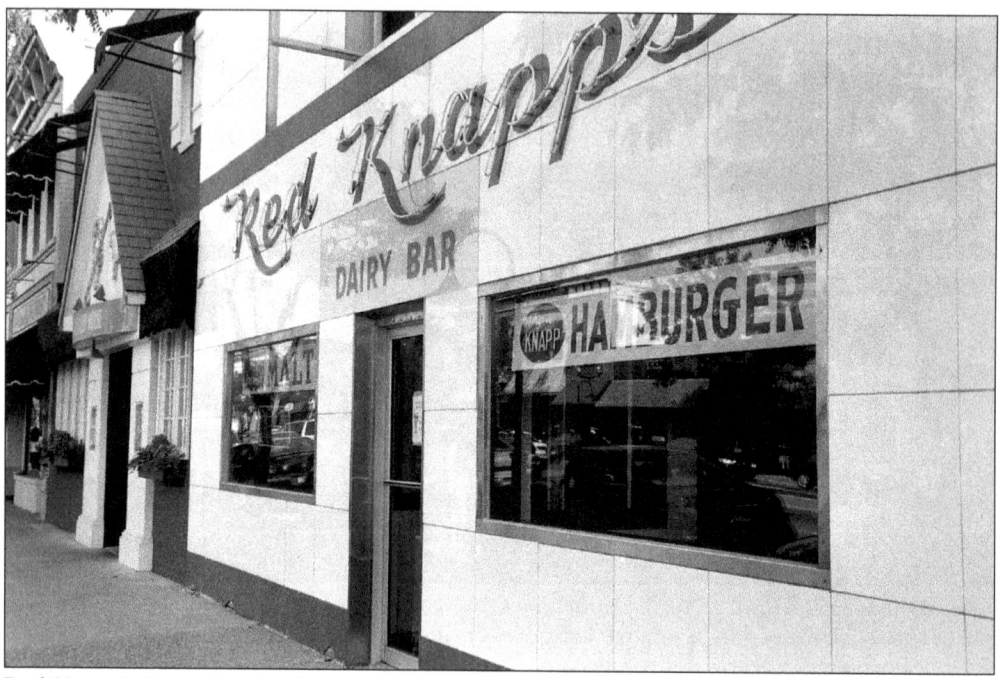

Red Knapp's Dairy Bar has been serving customers on Main Street in Rochester since 1950. Sheathed in white Carrara Glass, the contrasting red neon sign makes the façade stand out.

Roadside architecture fans and those craving "sliders" still come to this former White Tower hamburger stand at Michigan and Calhoun in Dearborn. The intact interior and exterior make this building a standout. Look closely at the little cartoon figure—he is formed from a "w" and a "t."

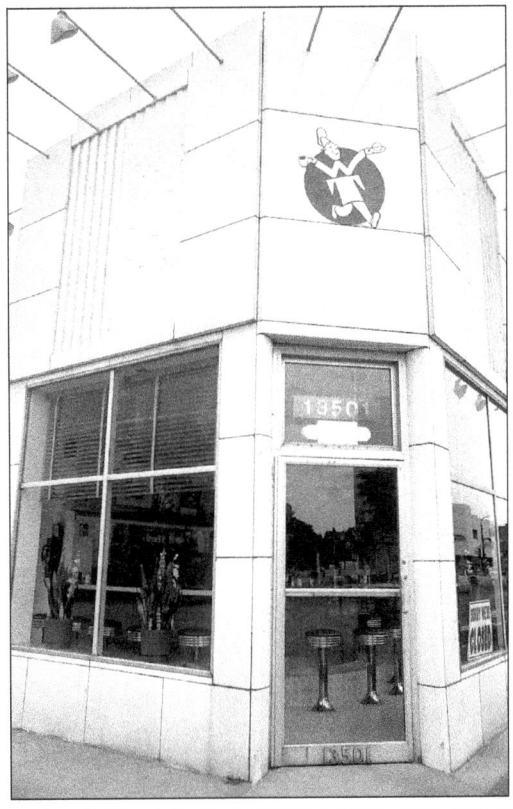

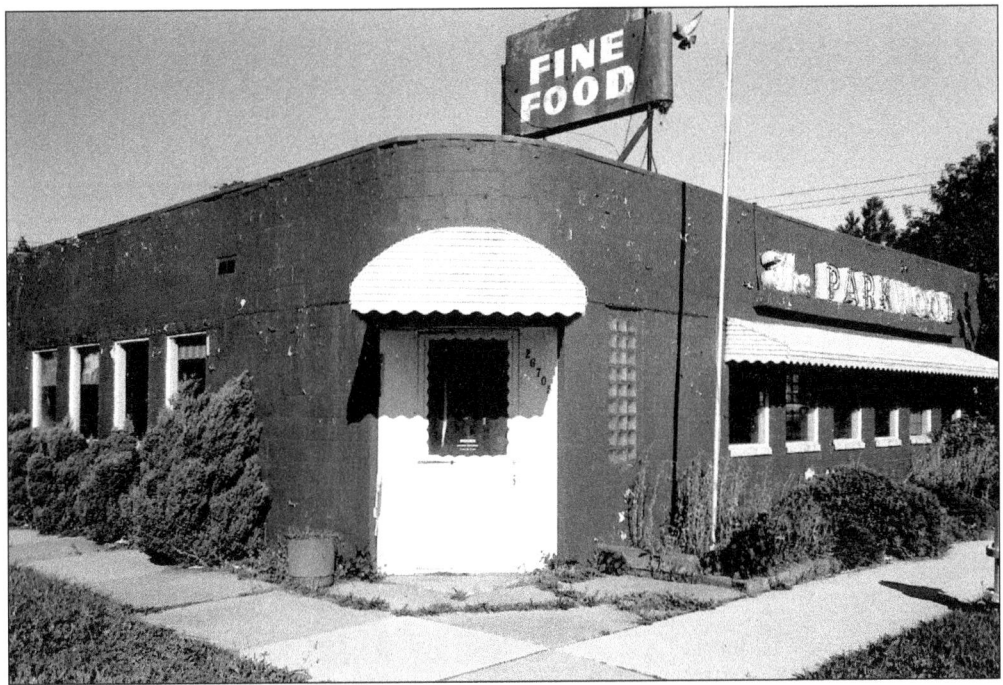

The Parkwood Diner on Coolidge in Oak Park has been vacant for years. It is slated for a total renovation, but for now it retains its vintage diner styling.

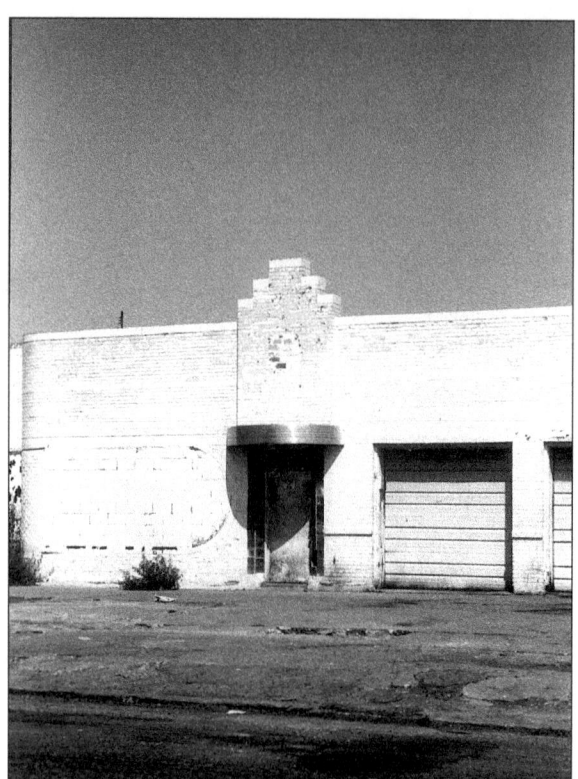

This building on the north side of Seven Mile Road in Detroit was probably some sort of automobile service business. The oval-shaped window has been bricked in, but is visible to the left. The stepped tower over the entrance is another Art Deco remnant.

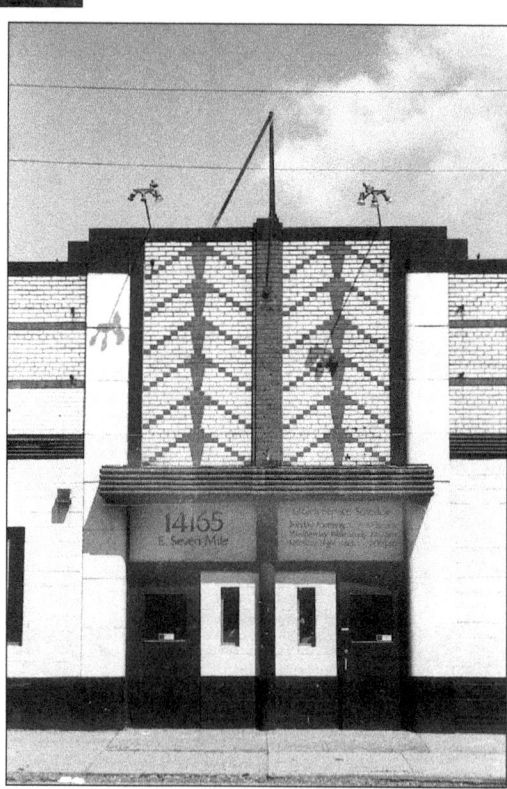

The Art Deco fishbone-patterned brick over the entrance to this building now marks the entrance to a church.

This gas station on Cadieux in Grosse Pointe is beautifully maintained, and its porcelain enameled steel exterior is in perfect condition.

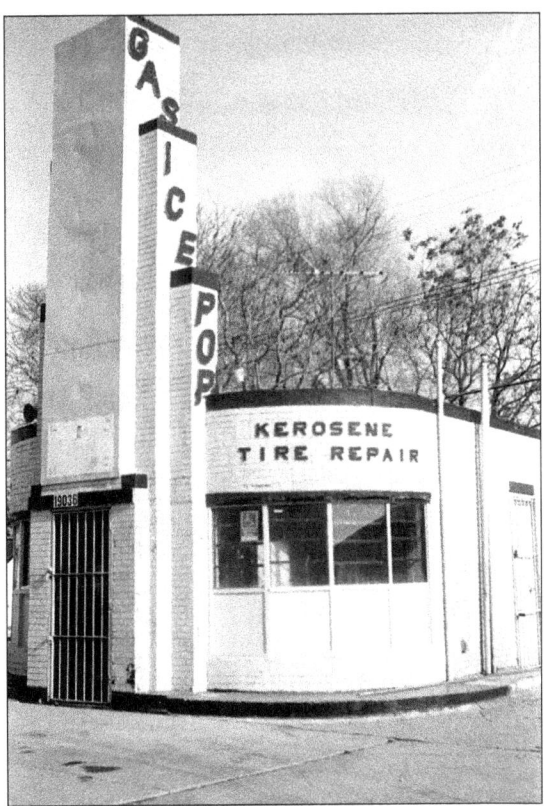

The Dix Gas Station in Melvindale is no longer in existence. It used an exaggerated stepped entrance to display advertising. (Courtesy Dan Drotar.)

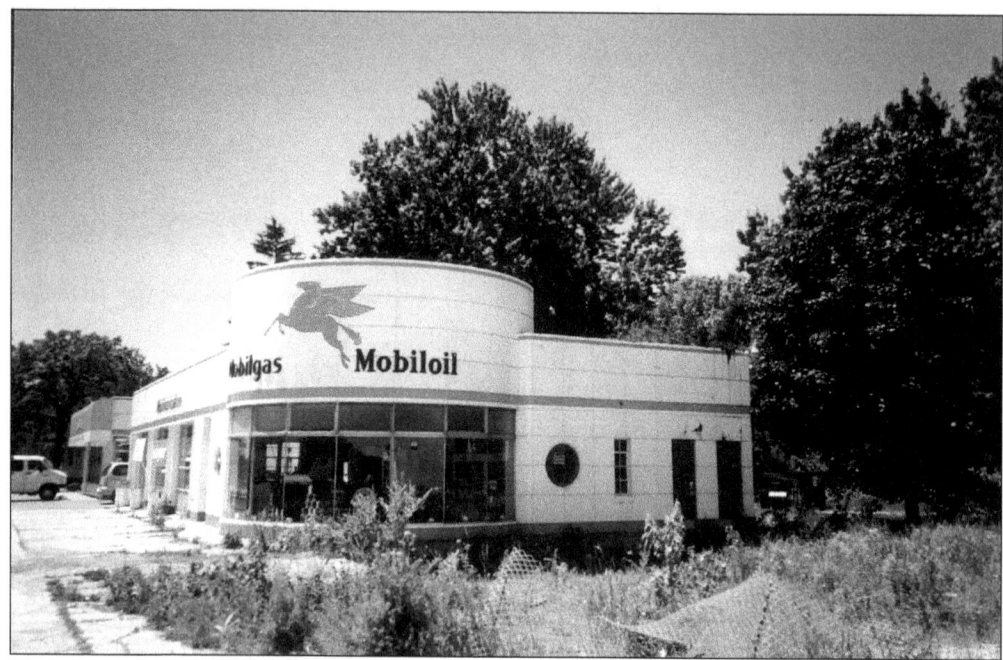

The March Mobile Gas Station is now demolished and lost forever. Built in 1947, it survived until it was torn down in 2000. The building was a rare example of the "Drum Style" gas station designed by New York architect Frederick Frost for the Mobil Gas Company. This vintage roadside architectural gem was located on Gratiot just north of 15 Mile Road, and was replaced by a modern retailer.

This image reveals the detail of the porcelain enamel steel exterior and entrance to the gas station.

Five

APARTMENTS AND HOMES

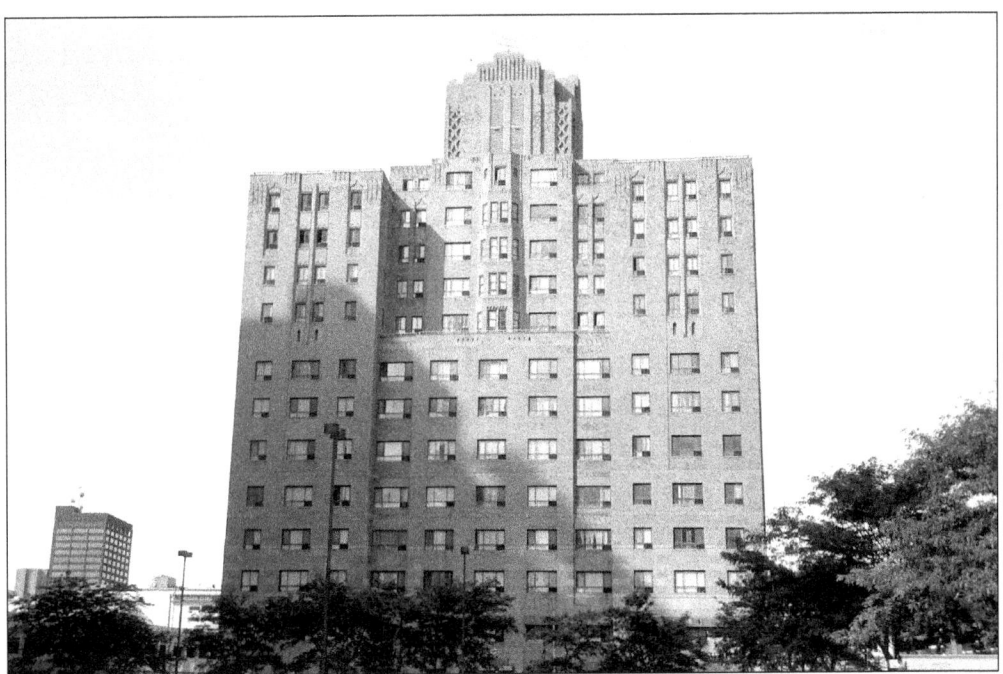

The Town Apartments were originally constructed as the Pontchartrain Club in 1928. The Depression put an end to the club, and the building sat with the upper stories unfinished until the 1960s when they were converted into apartments. Located on First Street at Bagley in downtown Detroit, the Town Apartments are still well occupied. Designed by architect Wirt Rowland while he worked for Smith, Hinchman & Grylls, Art Deco detailing survives on the tower.

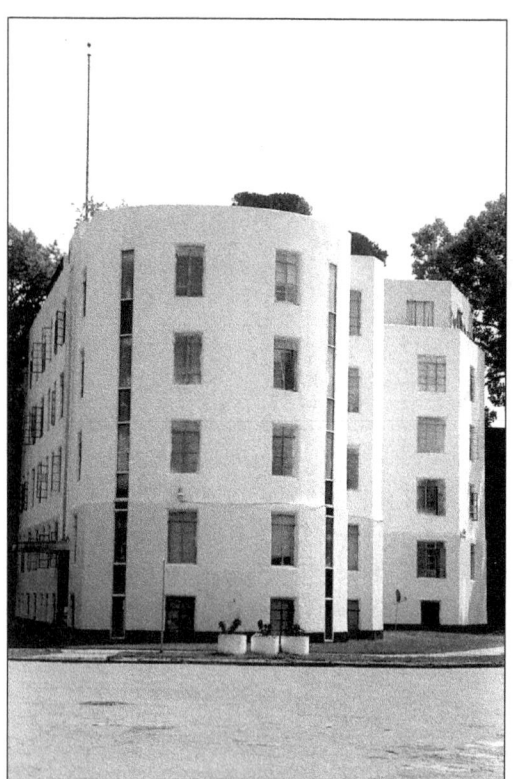

The Palmer Park historic district in Detroit has a number of Art Deco apartment buildings. The building at 999 Whitmore was designed by architect Talmadge Hughes in 1937. This was one of the first cast concrete residential buildings in Detroit. The apartments are two-story townhouses. The rooftop once boasted a Japanese-style garden with a fountain.

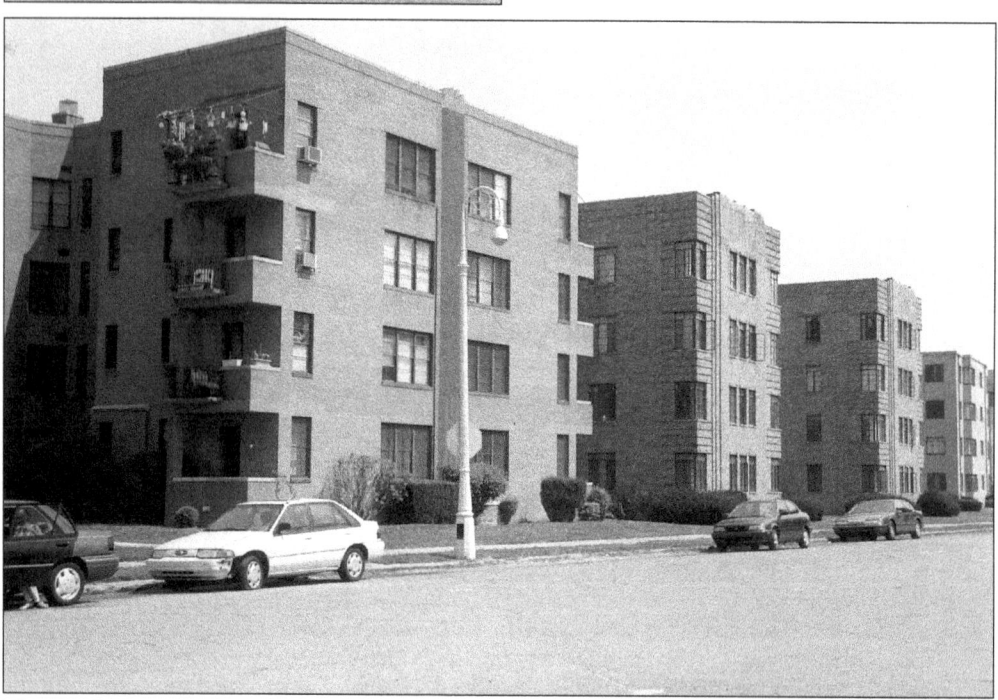

This is Detroit's Deco apartment row in Palmer Park. These apartment buildings were designed by architect Robert West in the late 1930s. They combine to make a fabulous streetscape of late Deco architecture.

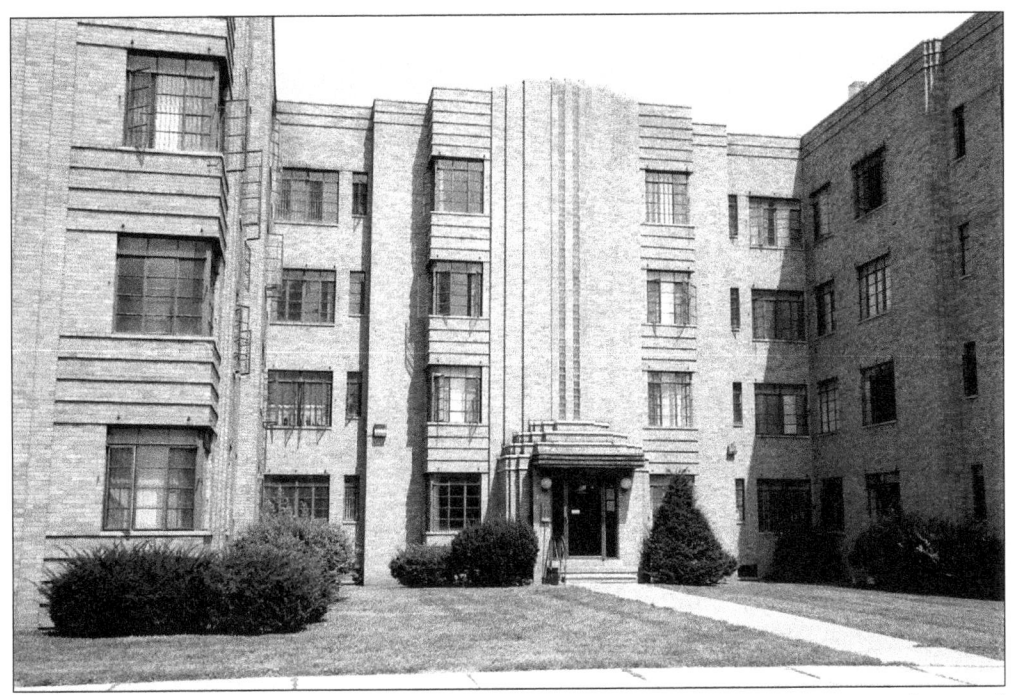

This apartment building at 950 Whitmore retains its original corner casement windows and horizontal banded brickwork. Note the two vertical strips of glass block above the entrance. These linear elements emphasize the building's horizontality.

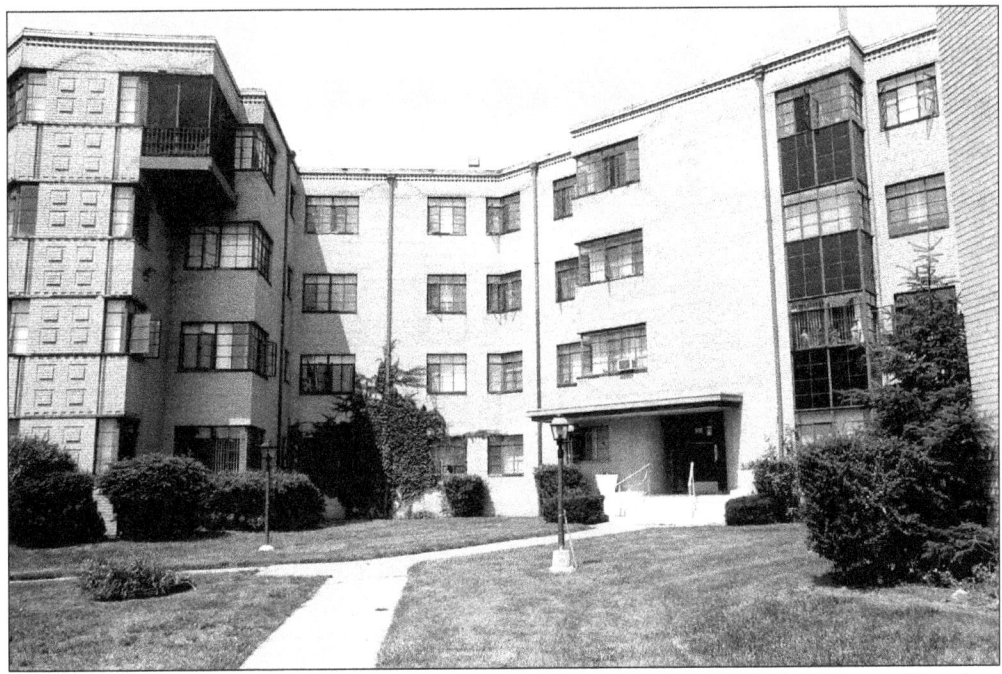

This apartment building on Whitmore in Palmer Park is attributed to Isador M. Lewis, a Canadian architect. The screened balcony in the upper left corner of the photo is said to have been the original owner's apartment. The architect set the building in unusual angular configurations.

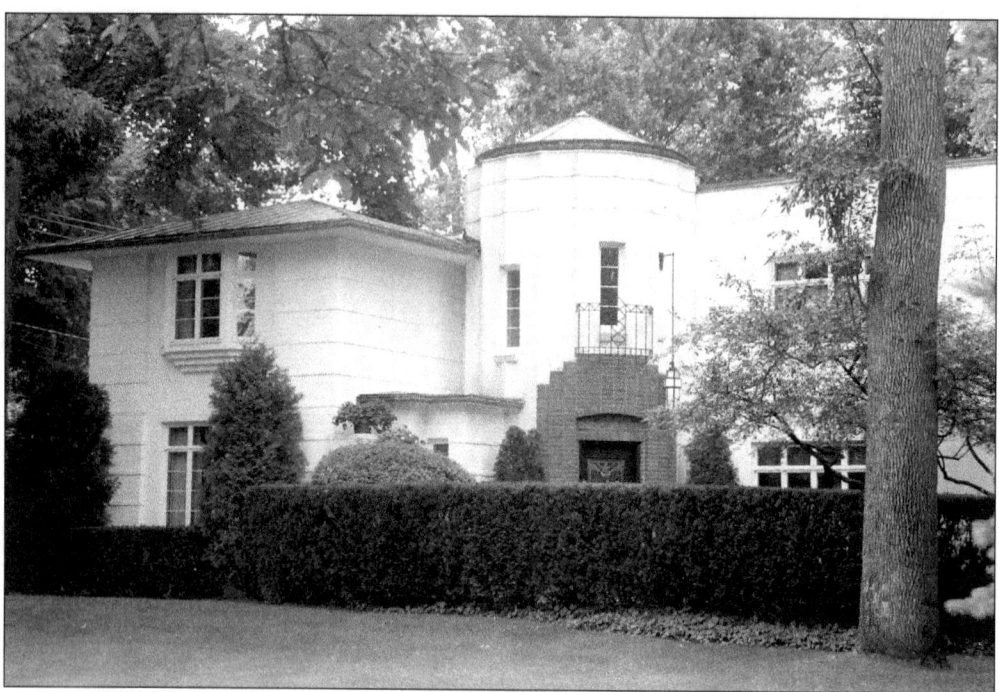

This magnificent Art Deco home in Birmingham was built in 1935. The two-story home features a fluted round turret at the entrance. The exterior is white stucco with white brick trim, and red brick at the front door entrance. The copper roof is also intact.

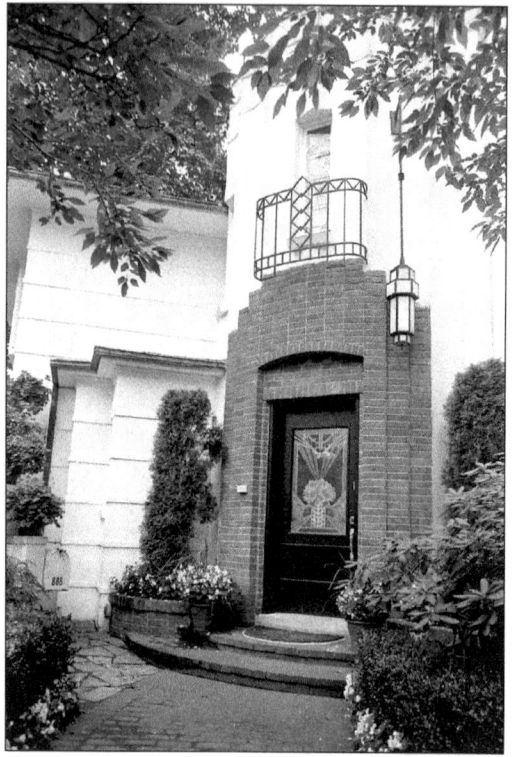

The front door features a fabulous imported French acid-etched glass panel. Note the light fixture and balconette railing. The home is lovingly maintained and furnished by a couple who collects and restores Art Deco furniture.

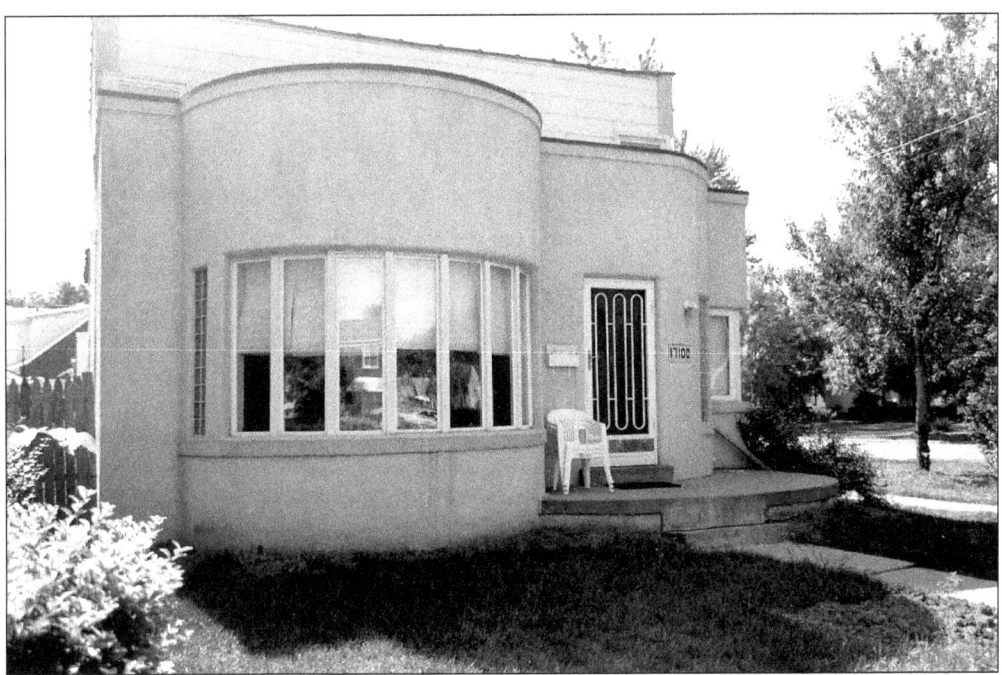

This streamlined stucco home is located on Cadieux in Detroit. The curved living room bay window is streamlined sleekness. This was a "House of Tomorrow" show house, and the interior features fabulous tile work in almost every room.

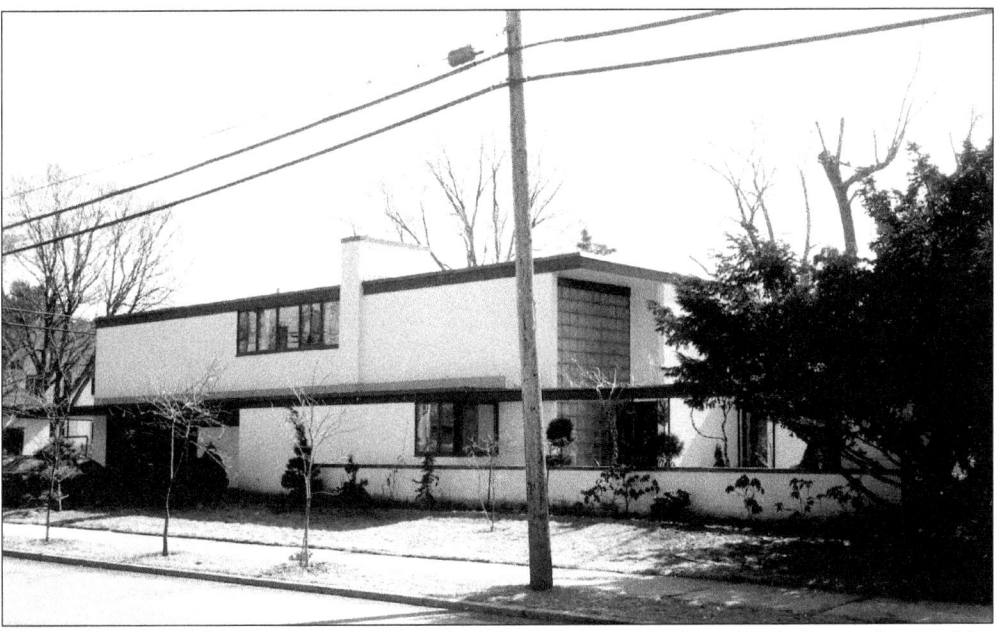

The Millard Pryor house in Grosse Pointe Park was constructed in 1938. It was designed by Michigan architect Alden B. Dow. The home could be classified as belonging to the "International Style," which was made popular by German architect Walter Gropius. This two-story home is constructed of cinder block painted white. A long horizontal pergola which runs the length of the lot ties the building to the site. (Courtesy Jacques Pierre Caussin.)

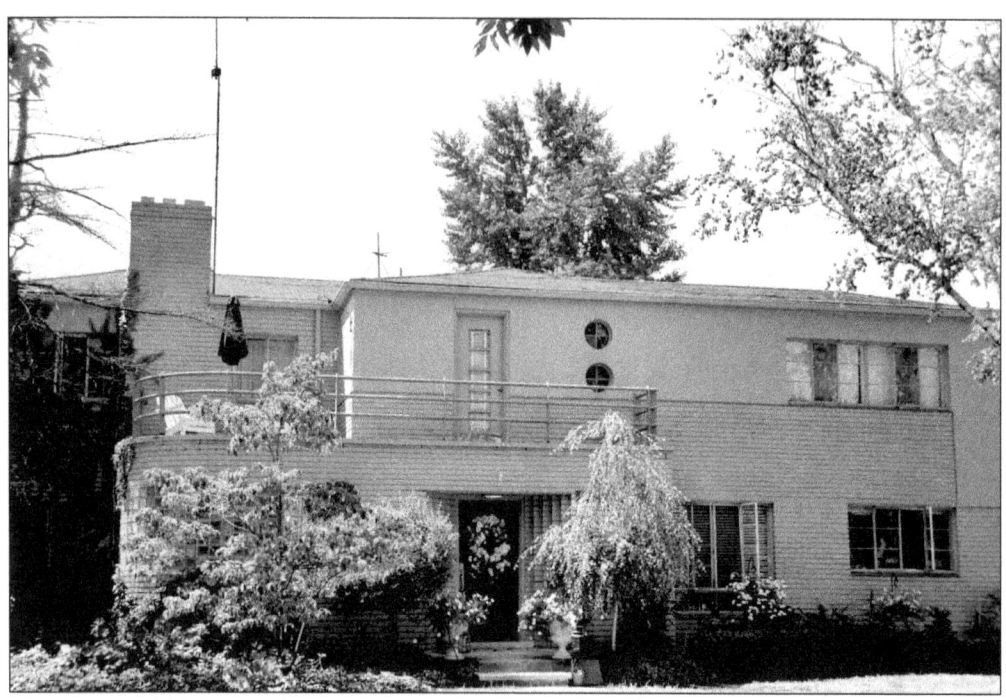

This home could be referred to as "Nautical Deco" in style. Because of the popularity of cruise ships, this home's designer has incorporated a ship's balcony railing and porthole windows.

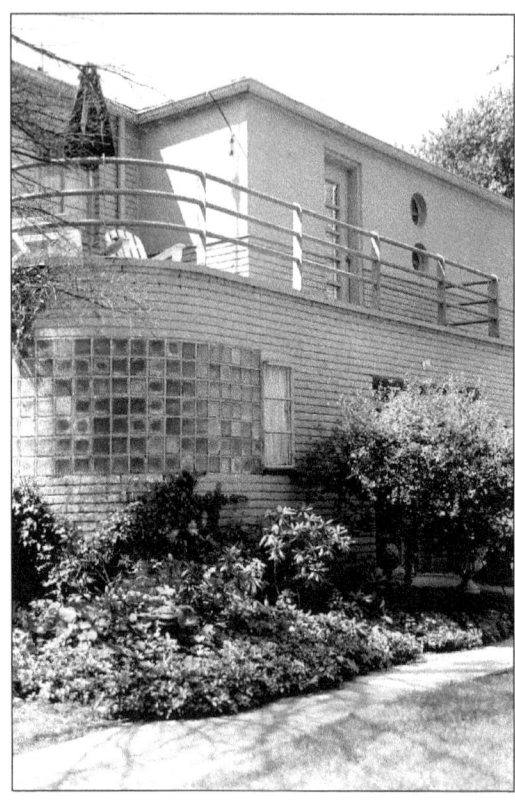

Glass block windows add to the authenticity of this Nautical Deco home.

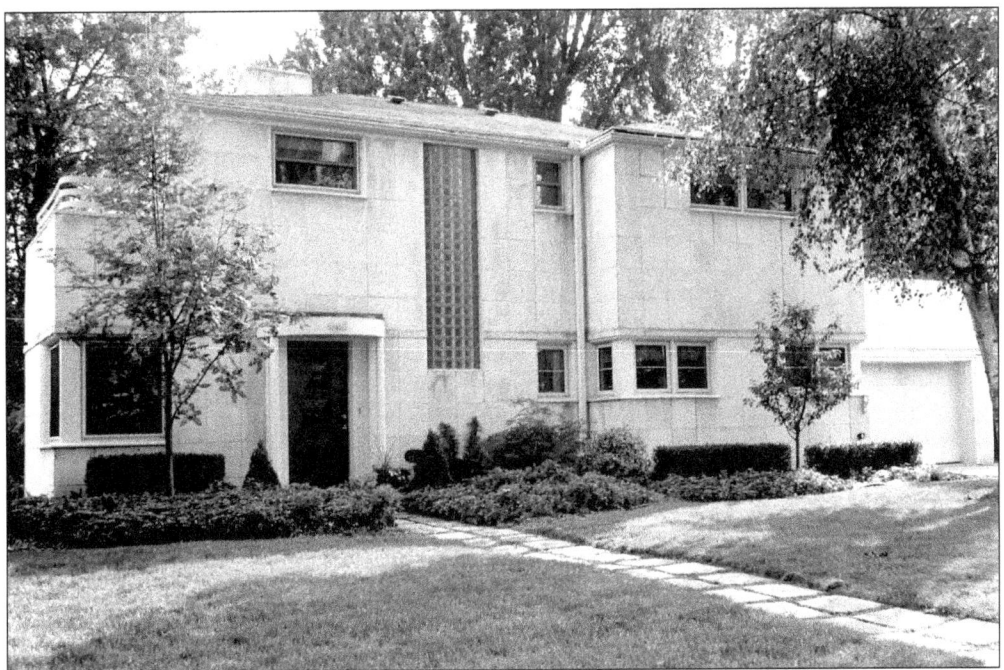

This Grosse Pointe Art Deco home has been lovingly restored. Originally built by young architect Lyle Zisler for his own family in 1937, it was featured in a *Detroit News* article, which called it "the most modern house in Detroit." The home is faced with light-colored sandstone and truly stands out in a neighborhood of conservative Grosse Pointe homes.

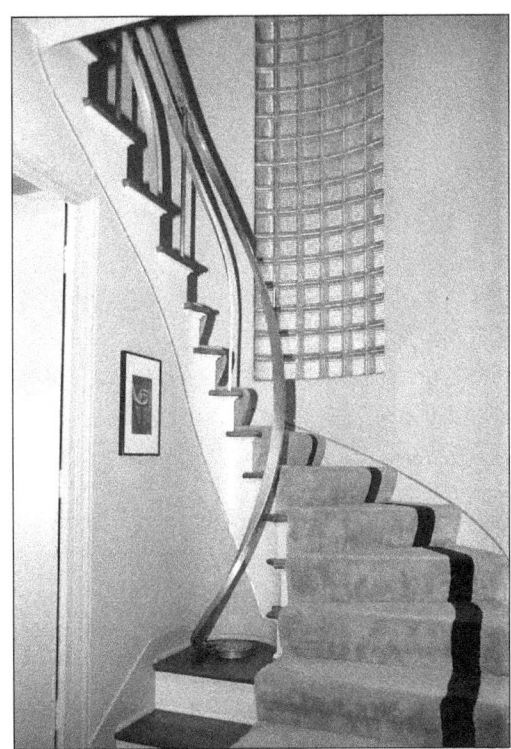

The curved aluminum railing on the staircase was formed completely through bending; there are no welds. The sweeping glass block walls over the staircase add another Deco streamline touch.

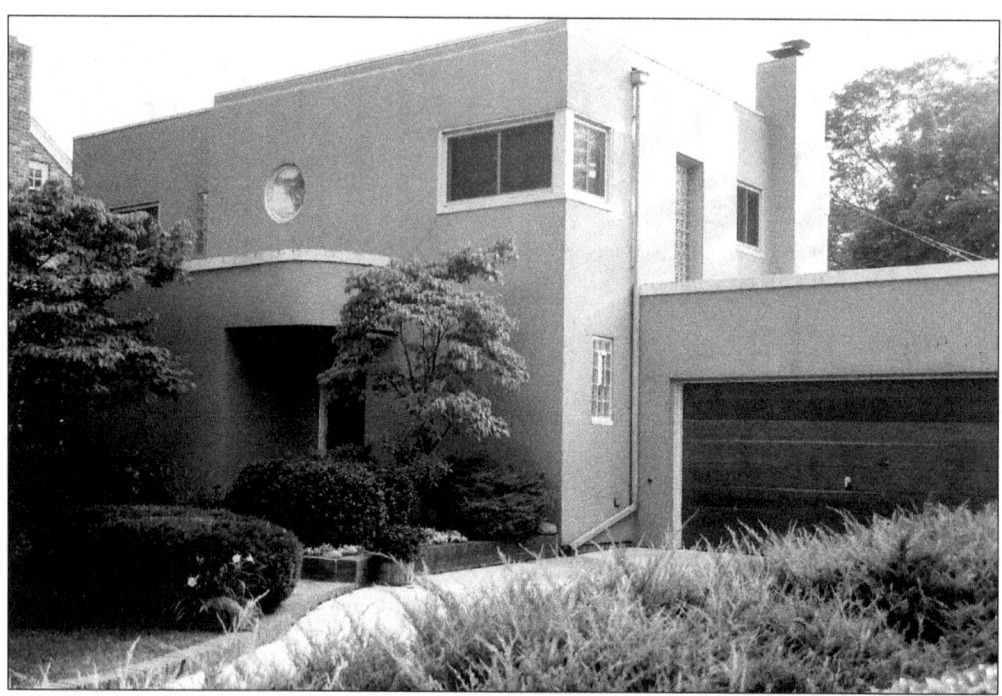

This home was probably very similar to the Nautical Deco home in Grosse Pointe, but it has had the windows replaced, and the upper porch railing removed. Surely it was once white stucco.

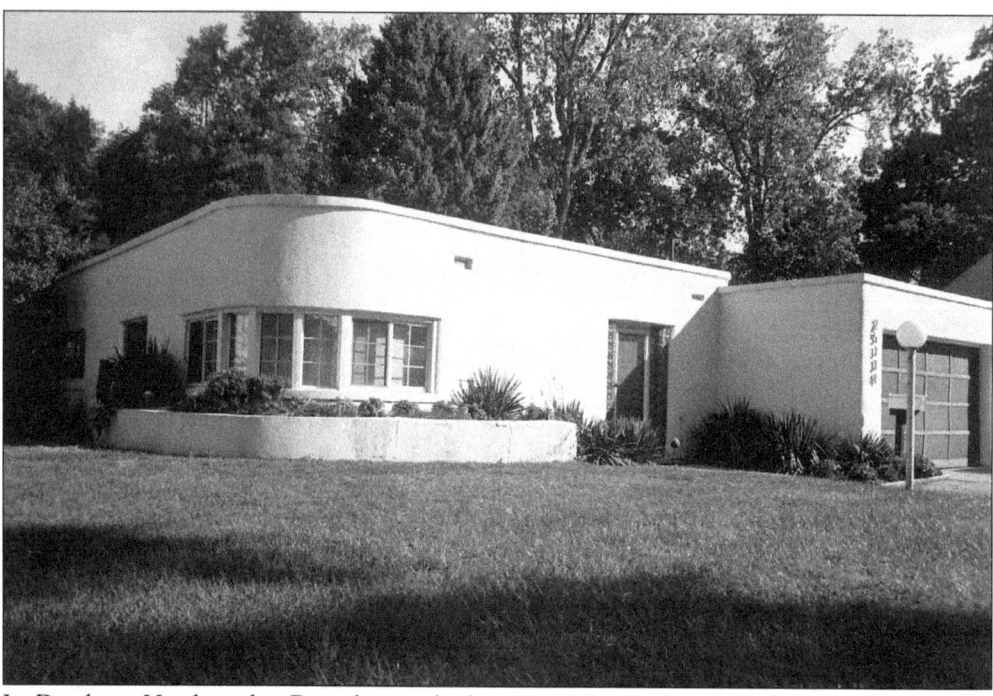

In Dearborn Heights, this Deco beauty built in 1943 is another curved, streamlined stucco home—but with an attached garage. This house is a ranch, and has appropriate tropical landscaping which includes yucca plants.

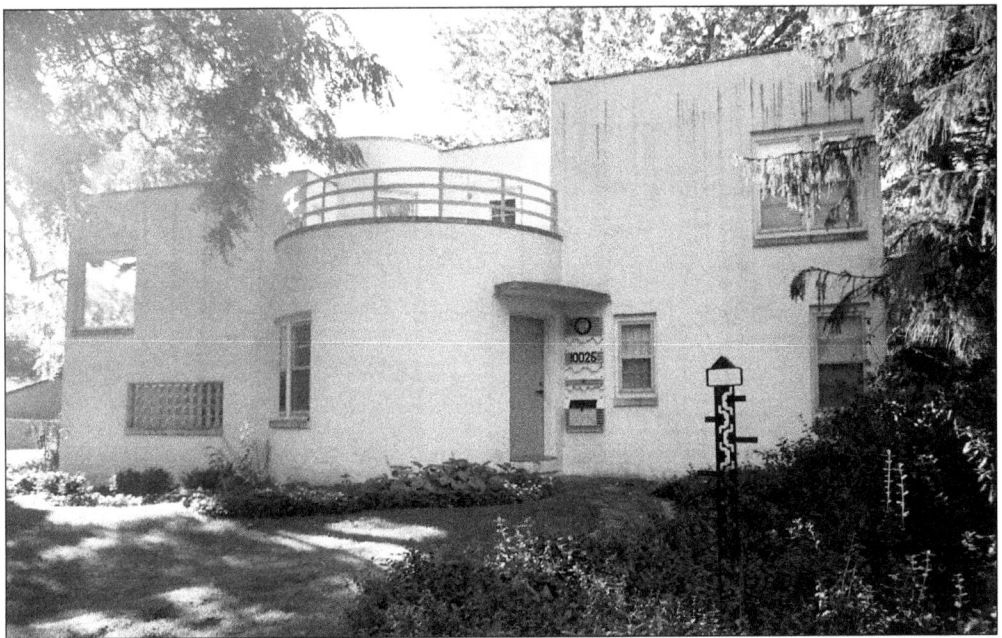

Huntington Woods has several Art Deco homes, this one being the most spectacular. It was built in 1937 by H.H. Weimeister. The rounded first floor entrance hall and office create a porch above on the second story. The porch railing emphasizes the curve of the rounded bay in the center. It doesn't look like it, but it is actually a quad-level home.

This Huntington Woods home has a series of cubes and rectangle forms combined to create a very modernistic residence. The emphasis here is on horizontality and form. This home was built in 1937 by H.H. Weimeister and is made of concrete block. There are a few other Deco homes in Huntington Woods, although they are in various stages of repair. The architecture is quite unique for such a small community.

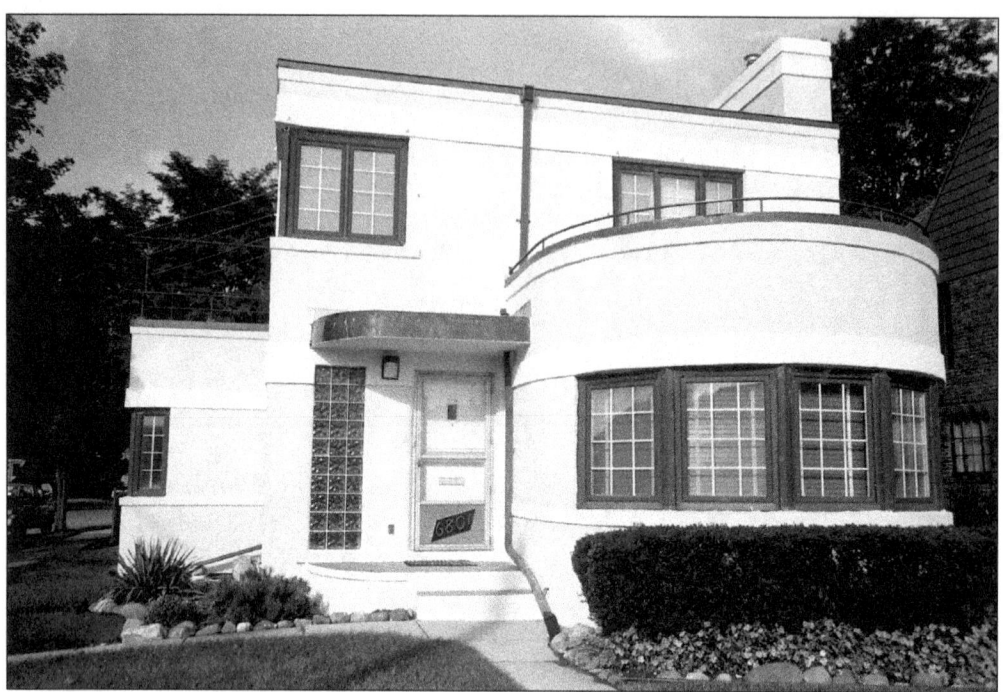

Dearborn boasts one of the most fabulous Deco homes to be found in the metropolitan area. Built in 1939 by architect Arthur L. Weeks Jr., it is cinder block construction with a stucco exterior. This house is truly "Tropical Deco" in the Midwest. Note the railing over the round window bay which emphasizes the roundness of the bay.

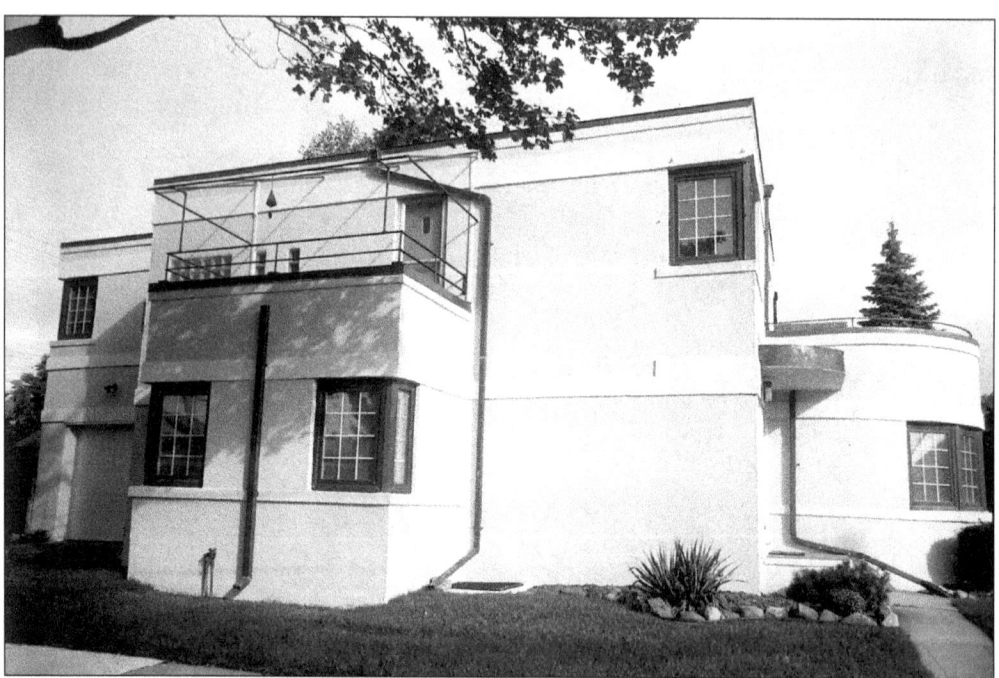

The back of this home has a second story "sleeping porch"—a common feature in the days before residential air conditioning.

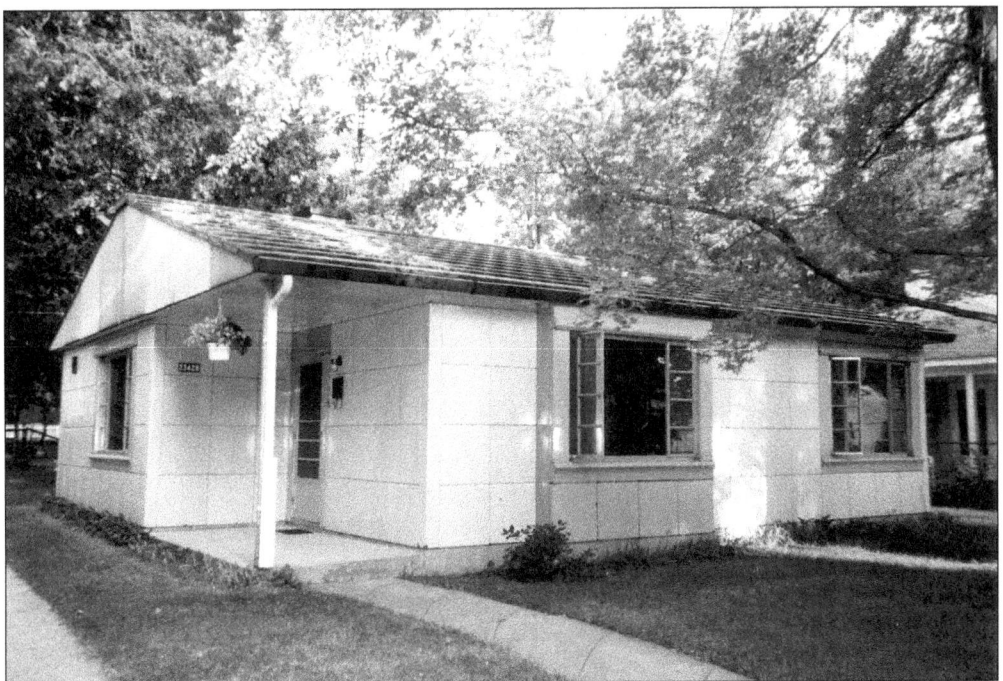

This house is not Art Deco in style, but it is modern in concept. This is a completely intact example of a Lustron House—a prefabricated home made completely of steel. The house was constructed on a cement slab, and the porcelain enamel steel wall panels and roof were shipped to the site. The Lustron House concept was the brainchild of engineer Carl G. Strandlund, and he was answering the problem of the post-World War II housing shortage. There are five Lustron Homes in a row in Oak Park, and this one is still owned by the original buyers.

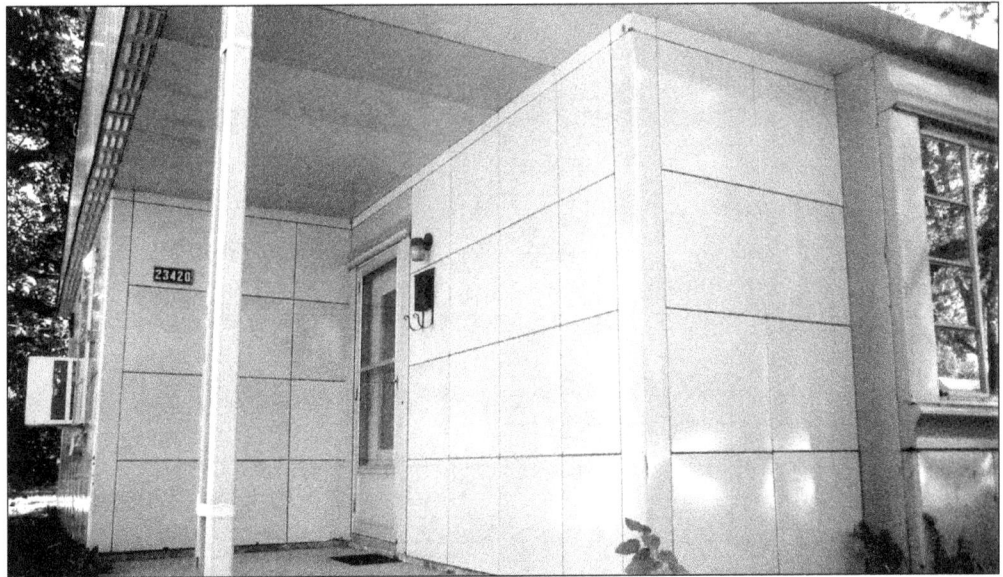

This close-up shows the porcelain enamel steel panels on the home's walls. The selling point of the Lustron House was that it never needed paint—just hose it down once in a while. This home still has its original steel casement windows, door, and roof.

The home's interior walls are also all steel panels. This owner uses lots of magnets.

This copy of the original sales brochure for a Lustron House is vintage 1949. There were 2,492 Lustron Houses built in the United States until several government scandals closed the company in 1951. Detroit can be considered fortunate to have examples of the Post War era's attempt at "modern living."

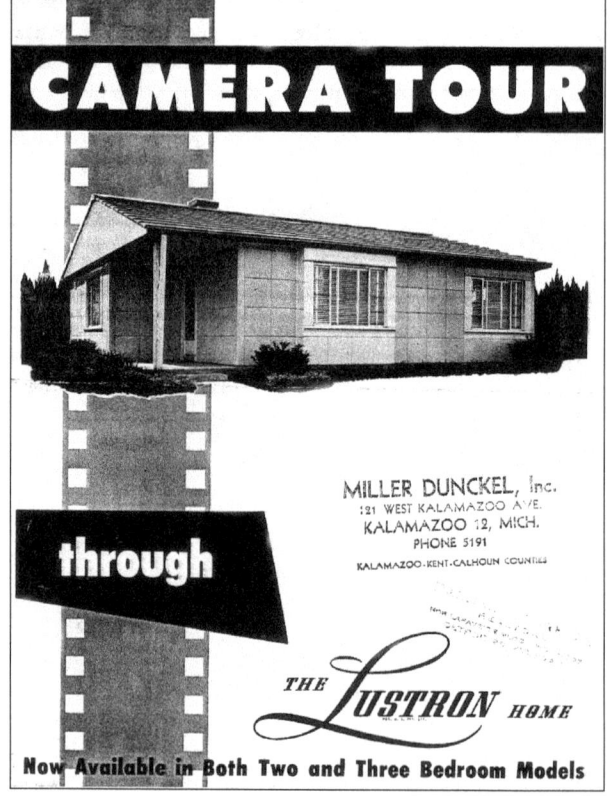

Six

DETAILS ABOVE THE DOOR

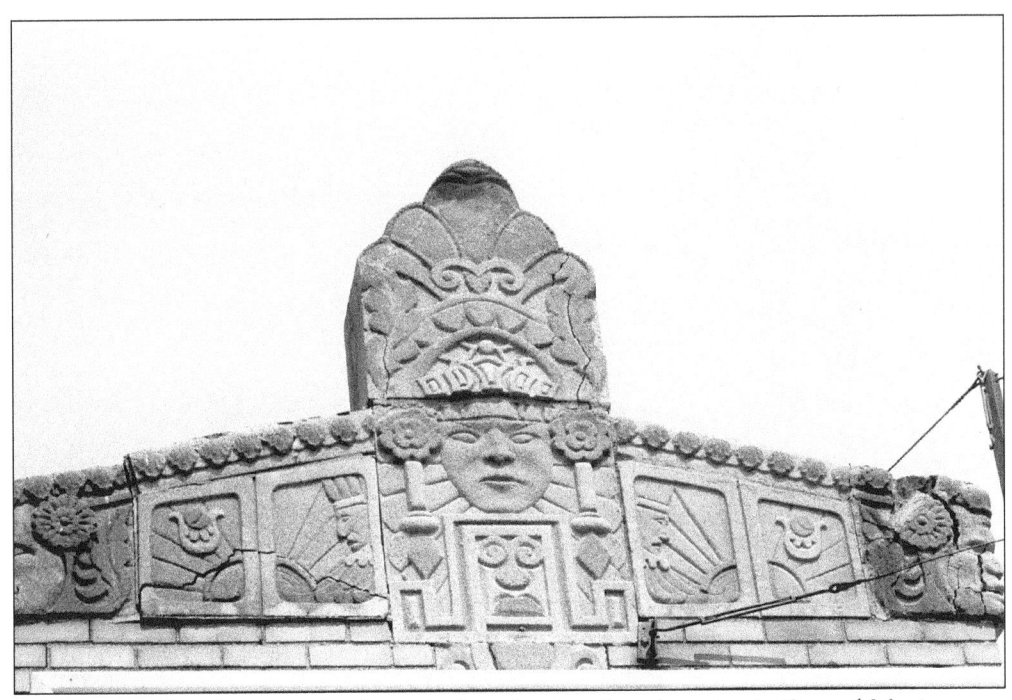

Mayan Revival is the name for the style that developed as the ruins in Central Mexico were being excavated and widely published. It is a colorful chapter in the Art Deco style category.

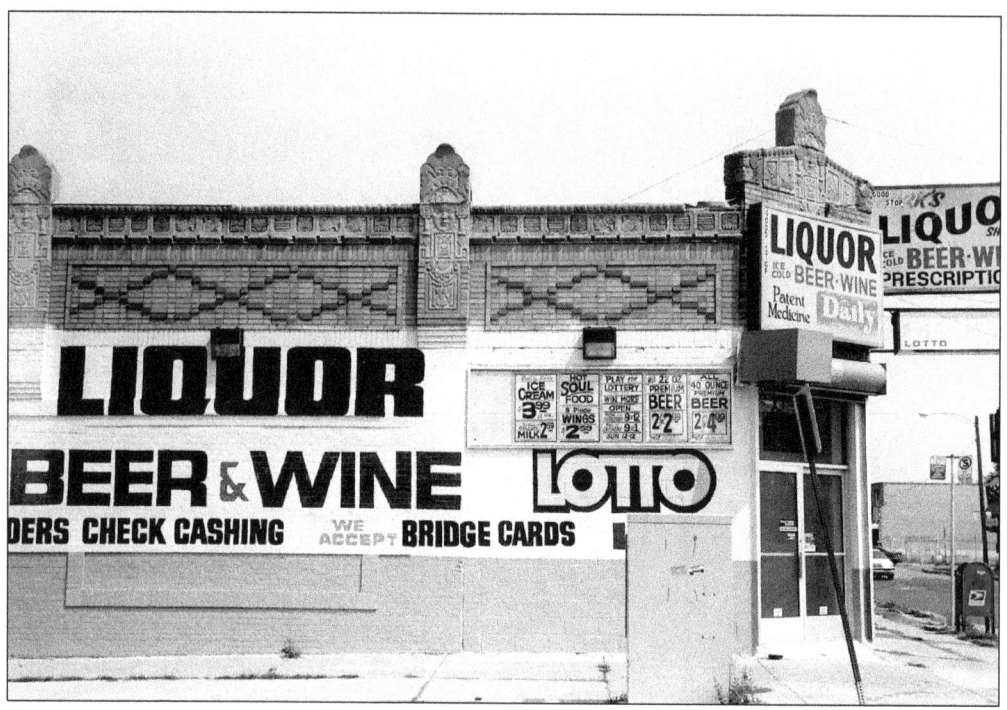

Sometimes an egregious liquor store paint job can overwhelm architectural detail located just above.

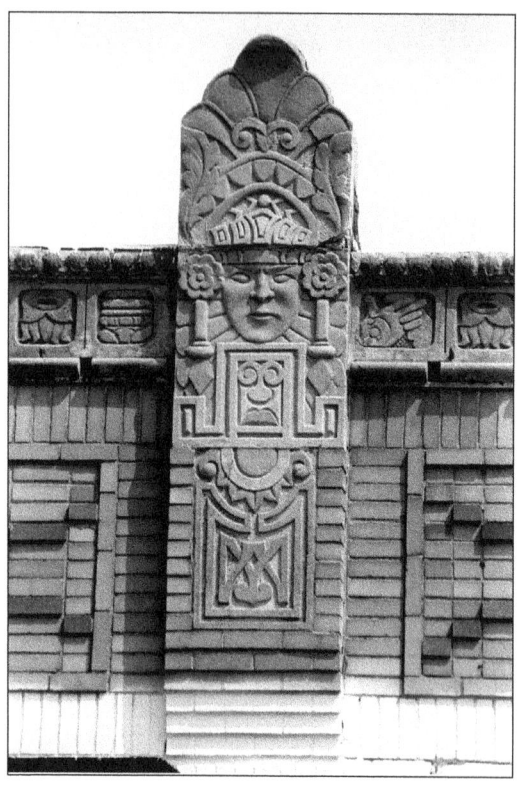

Original Mayan Revival decorative terra cotta details still rise above the store's signage. This building is in Detroit on McNichols and San Juan Street.

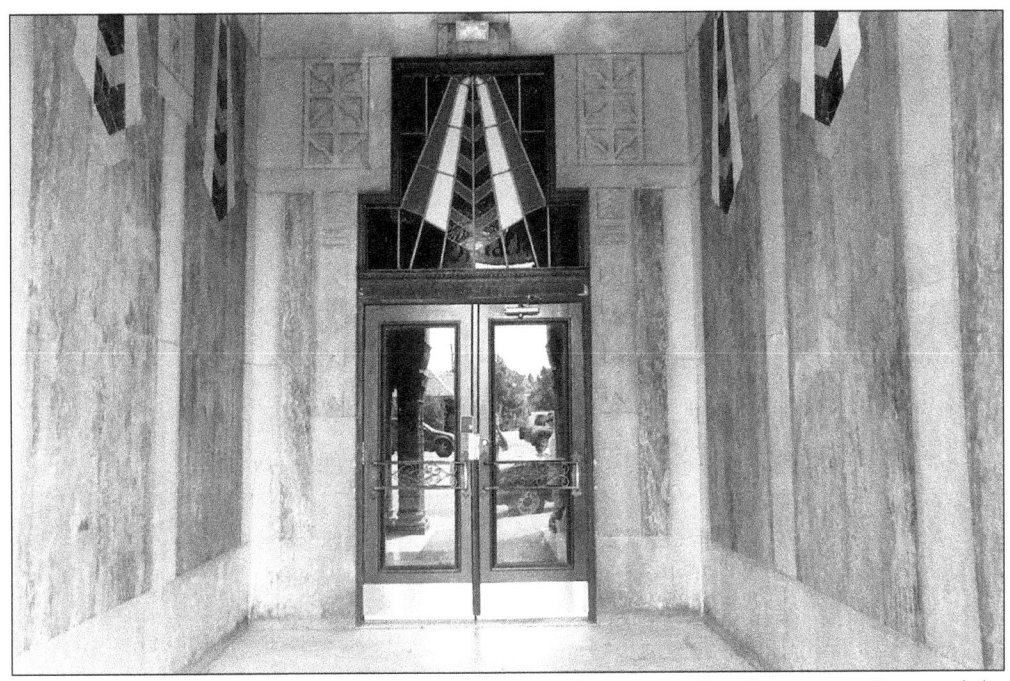

The Highland Towers in Highland Park is located on Woodward Avenue. Designed by architects Weidemier and Gay in 1932, this eclectic Moorish apartment building has a stunning Art Deco entrance vestibule.

Beautiful marble panels line the vestibule and various colored marble was used to create the French Art Deco design pattern. The pattern was repeated in stained glass above the doors.

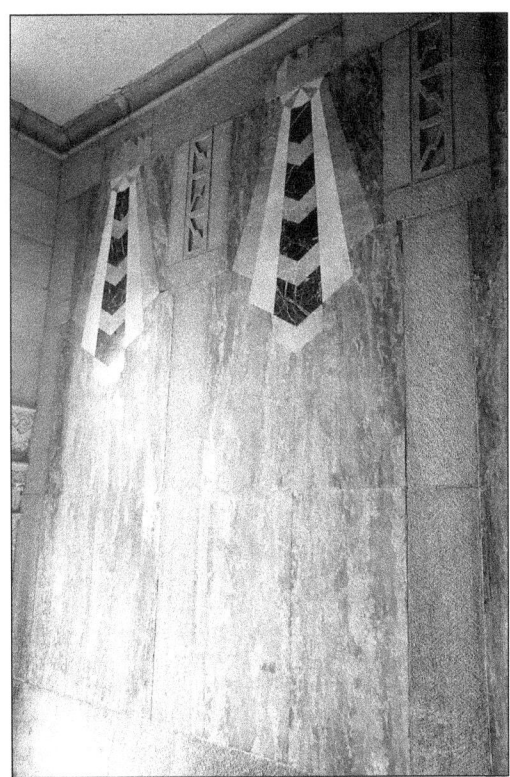

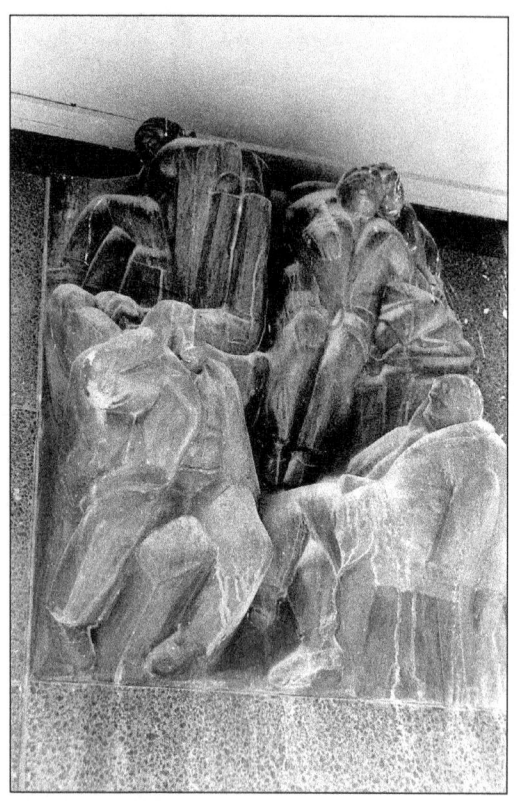

This is a relief sculpture on the side of the entrance to the 600 West Lafayette Building. It was originally the WWJ Broadcast Station. The two plaques were by Carl Milles, a Swedish sculptor who taught at the Cranbrook Academy of Art. Albert Kahn called him "the greatest sculptor of the day." In this plaque, Milles depicts a group of listeners, some interested, some bored with the efforts of the musicians.

This relief sculpture, also carved in black granite, whimsically represents musicians playing. Carl Milles was one of the most significant sculptors of the 20th century, and it is unfortunate that these plaques are neglected and subject to damage from pigeons.

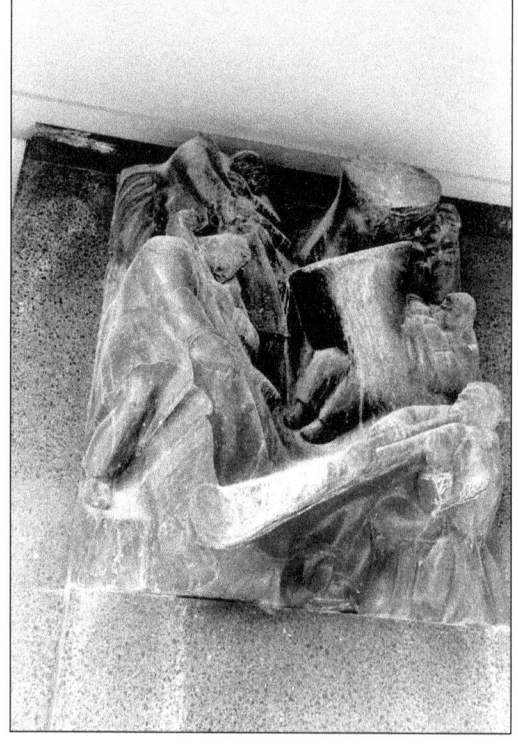

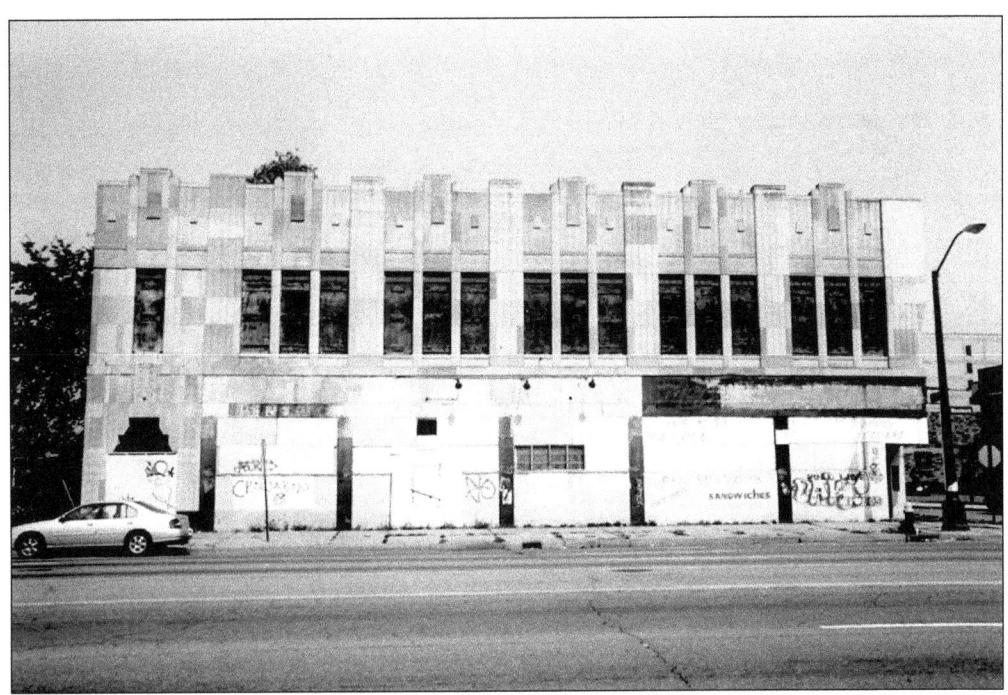

Woodward Avenue was widened in the 1930s, and several structures had their old façades shaved off to receive new Art Deco façades. This vacant historic building in Brush Park features a sandstone and terra cotta exterior.

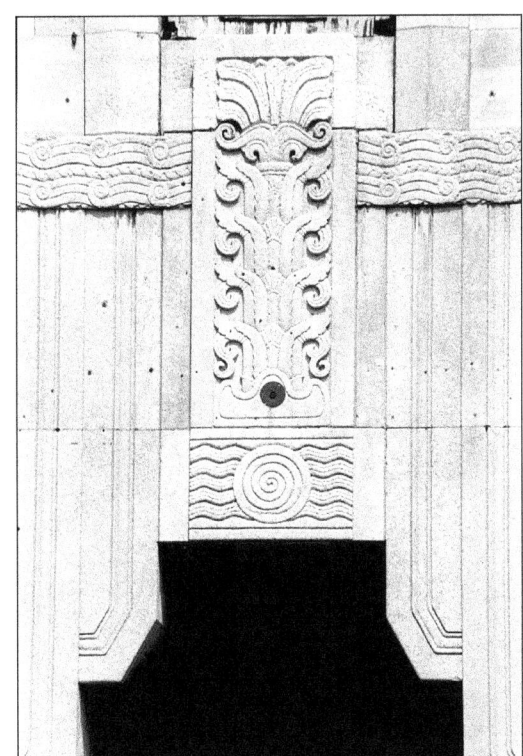

The detail above the entrance is called the "Frozen Fountain" and it is common in Deco buildings in California and Florida. This is Detroit's only example of the Frozen Fountain on a building exterior, and it is in danger of being demolished.

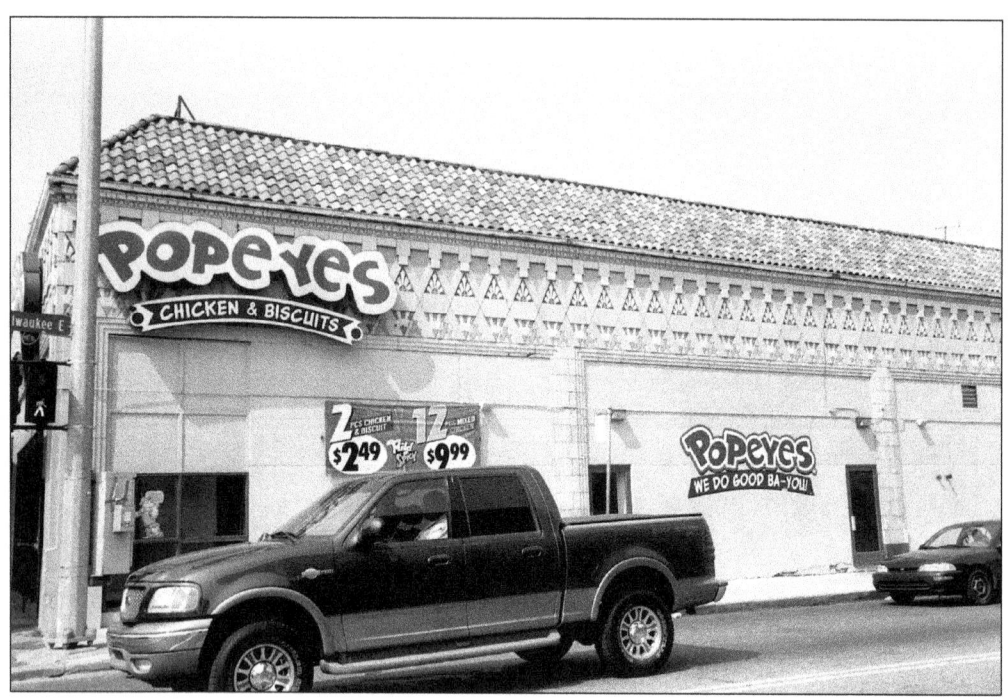

Try to ignore the signage for Popeye's. There is a reason to look closer. This building is at Woodward and Milwaukee in the New Center district of Detroit.

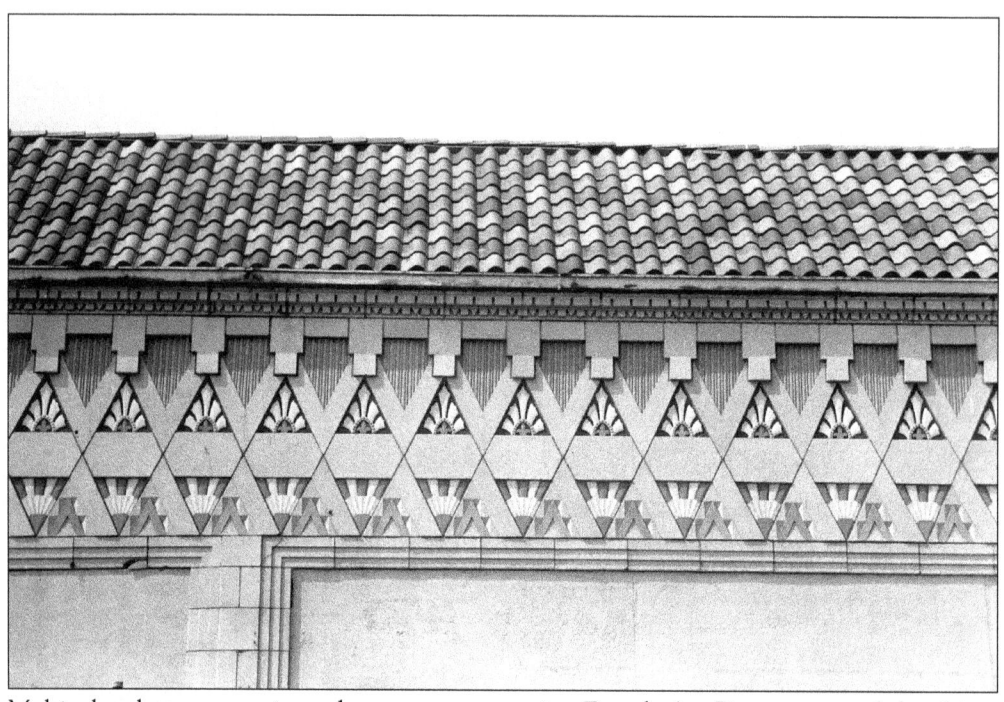

Multicolored terra cotta is used to create a stunning French Art Deco patterned detail just below the roofline as a frieze on this retail building.

Seven
THEATERS AND A BALLROOM

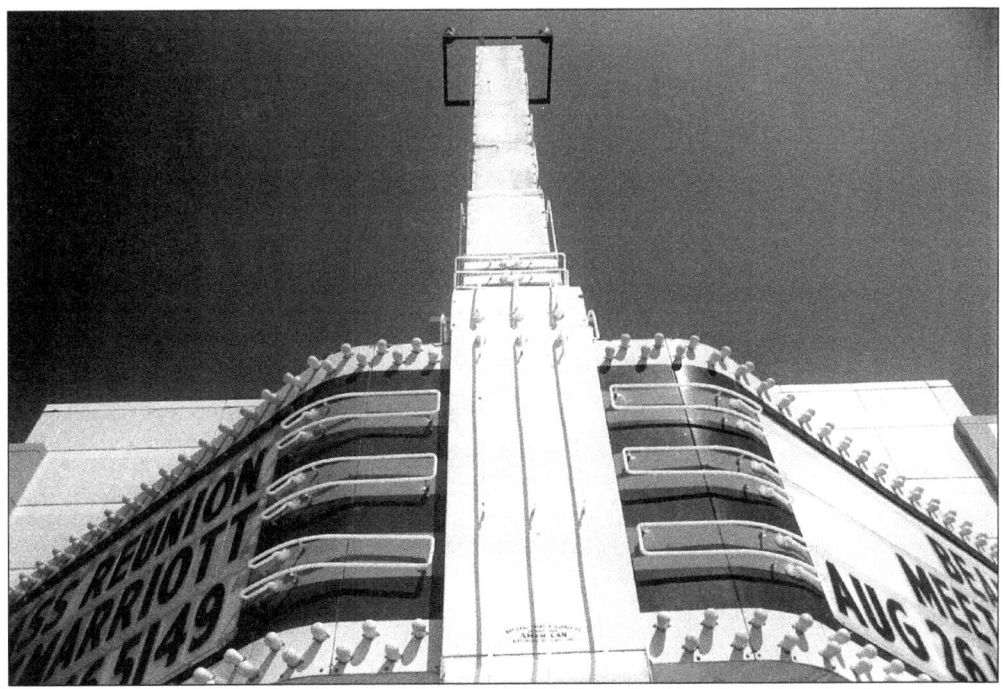

Movie palaces and neighborhood theaters alike were designed with dramatic Art Deco and Art Moderne styling. This is a close-up of the Berkley Theater's symmetrical marquee.

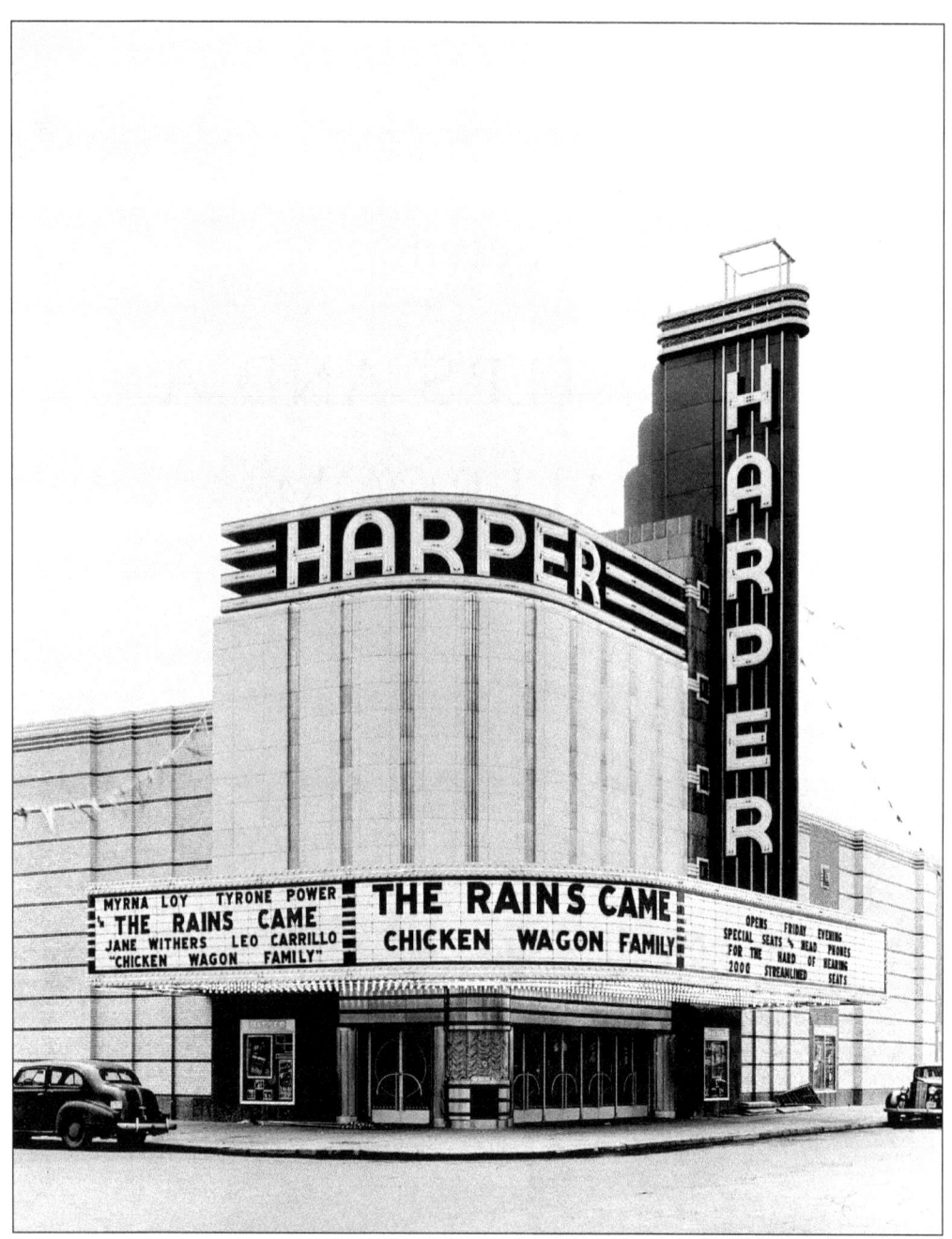

The Harper Theater survives today as a nightclub called Harpos. Designed in 1939 by architect Charles N. Agree, it originally had 2,000 seats, making it a very large neighborhood movie house on the east side of Detroit. The streamlined curve at the corner over the box office and lobby give the building a sense of motion. (Courtesy Detroit Historical Museum.)

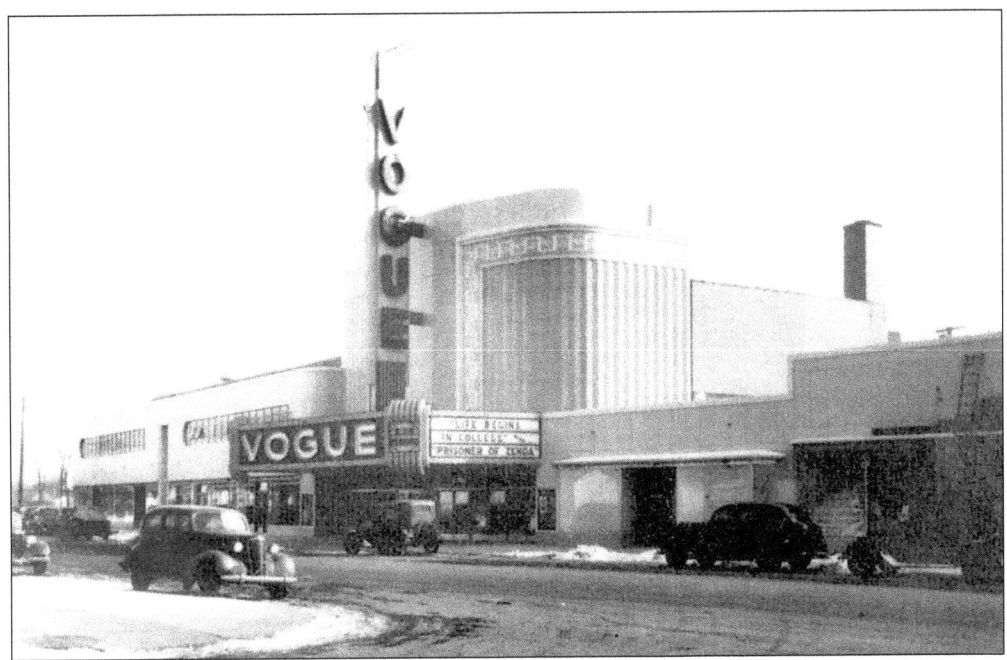

The Vogue Theater in Detroit was on Harper near Cadieux, not far from the Harper Theater. Although it looks very similar to the Harper, it was designed by a different architectural firm, Periera & Periera. (Courtesy Burton Historical Collection.)

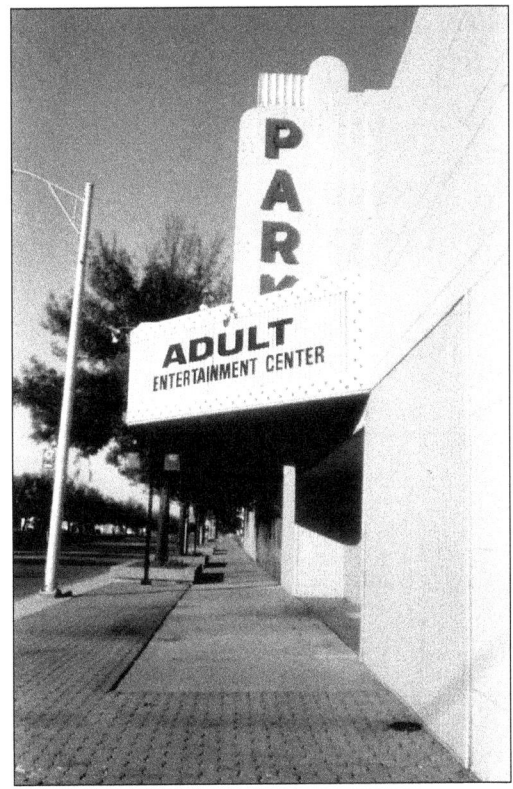

The Park Theater on Fort Street in Lincoln Park was designed by theater architect C. Howard Crane in 1925. Although residents and several city councils have been trying to get rid of the adult theater, it could be renovated again and serve a new use for the city in the future. (Courtesy Leslie Lynch-Wilson.)

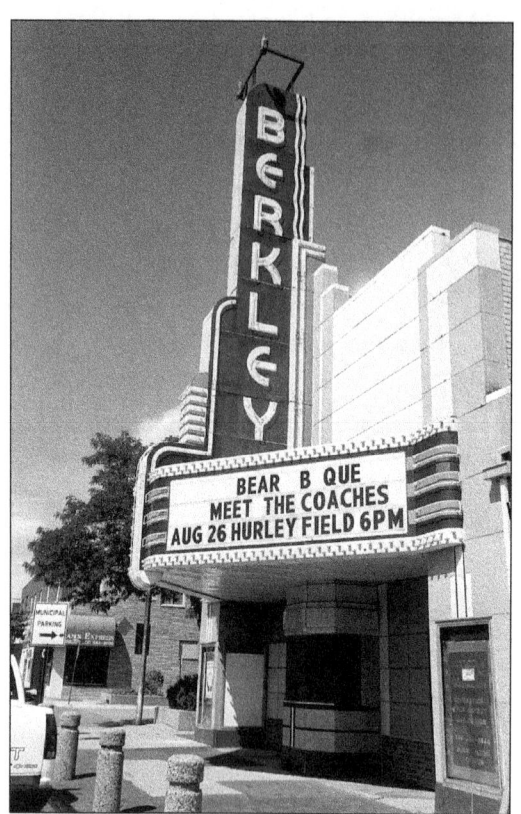

The Berkley Theater is on Twelve Mile Road in the city of Berkley. Built in 1941, it had 850 seats and lasted as a single screen theater until 1993. The owners sold the building to the Perry Drug Store chain, but the community recognized that the theater was really *the* defining architectural structure in Berkley. They fought—and the movie theater vertical marquee sign and façade remain, while the drug store entrance faces the parking lot.

The streetlight banners recognize the importance of the Berkley Theater to the city.

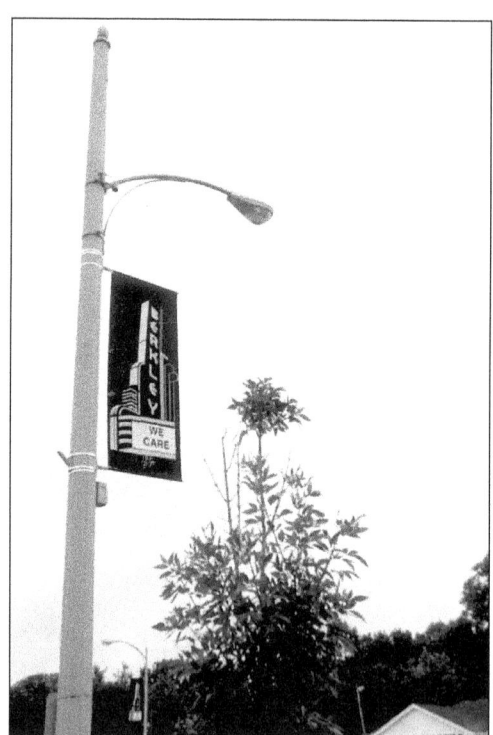

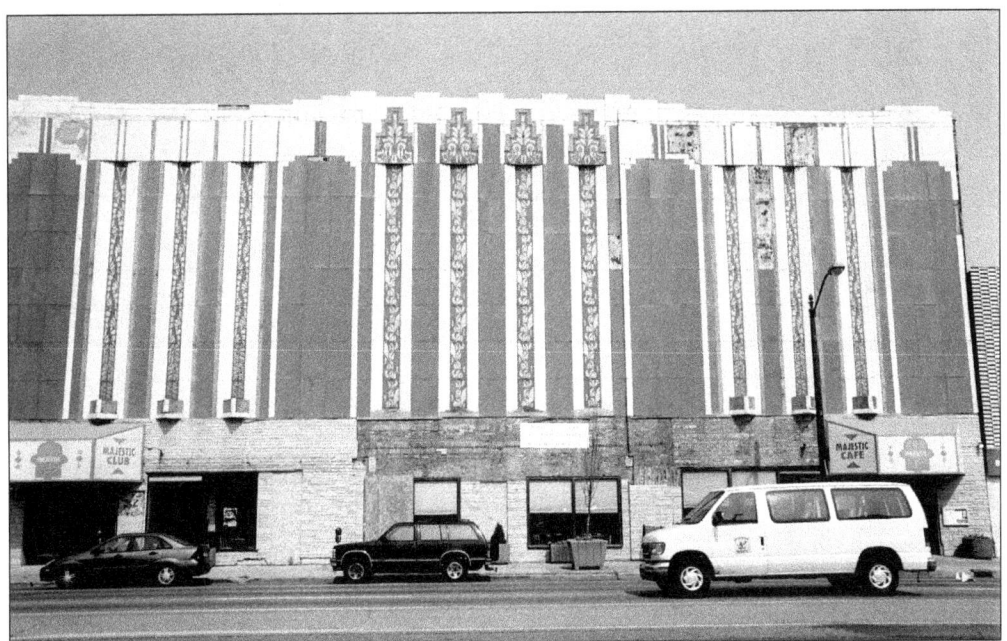

In the 1930s, Woodward Avenue was widened on the east side of the street, and the Majestic Theater was in the way. The owner had the 1915 lobby removed from the front of the building and a new façade put on.

The new 1935 façade is constructed of porcelain enameled steel from the Macotta Co., and was colored to the architect's specifications. The architects of the new façade were Bennett & Straight. The steel panels are starting to fall off, but the bright orange color and beautiful Deco design remains. The current owner is planning a historic restoration of the façade and even the addition of a marquee.

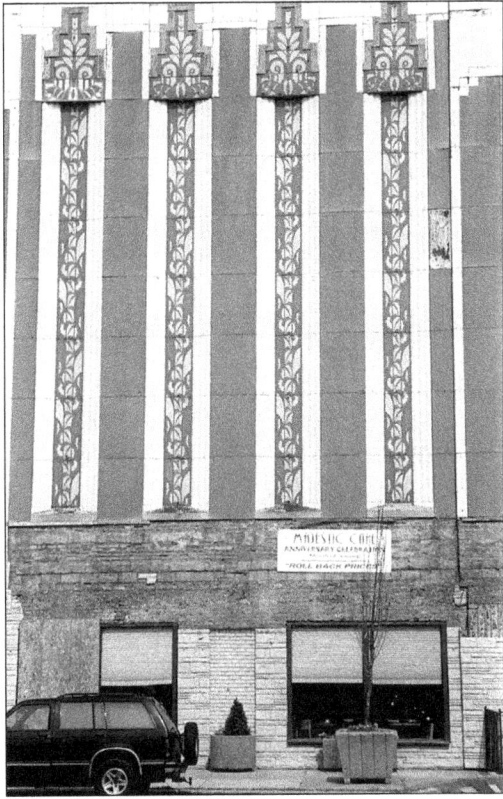

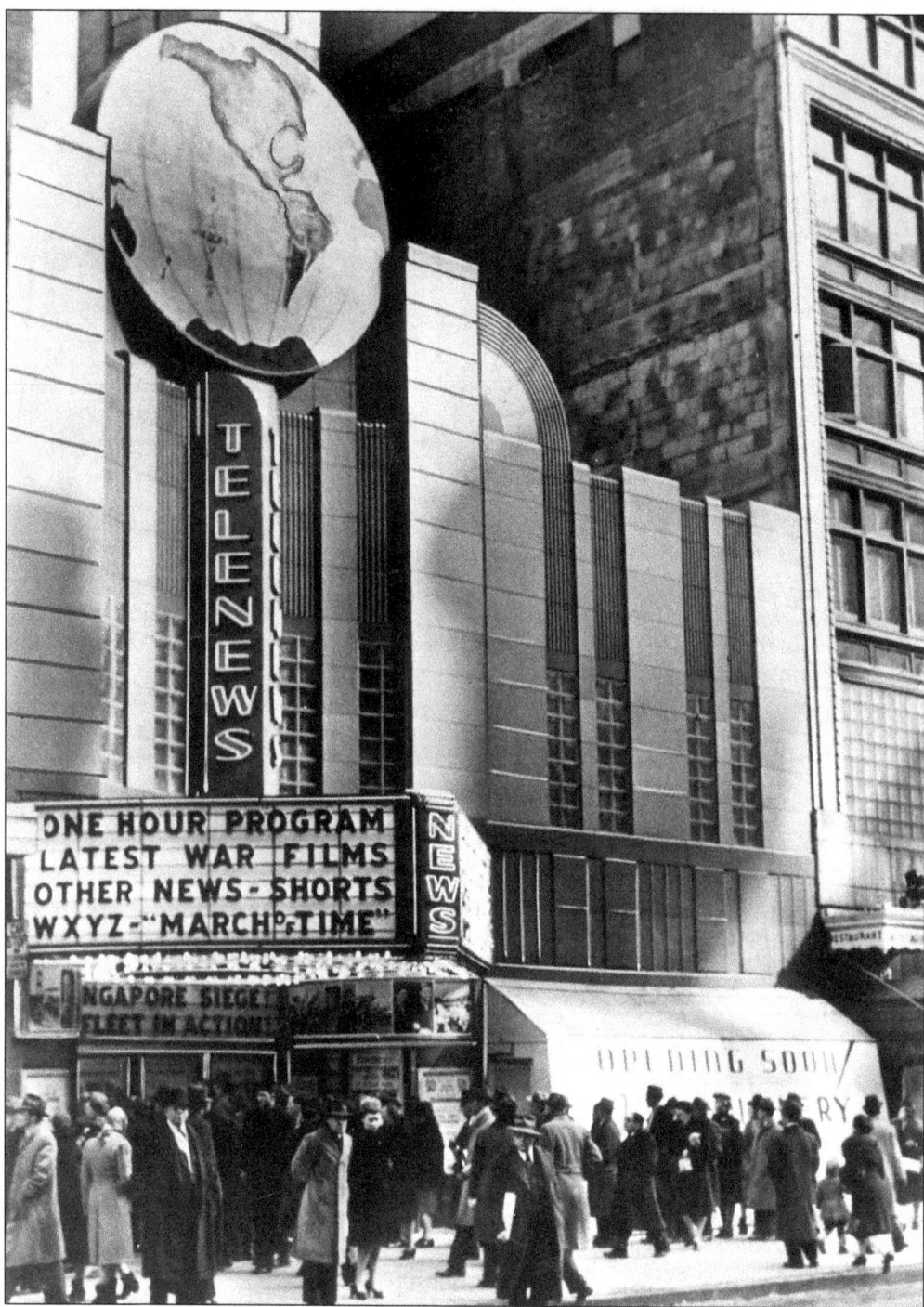

In 1942, the Telenews Theater opened on Woodward in Detroit, showing newsreels around the clock. This theater was designed by Cyril Edward Schley, and had a fabulous terra cotta façade with dark orange panels and turquoise edging that made the Art Deco façade stand out. The flat representation of the globe at the top of the building told immigrants, and anyone unable to read, that the theater showed world news. (Courtesy Manning Collection.)

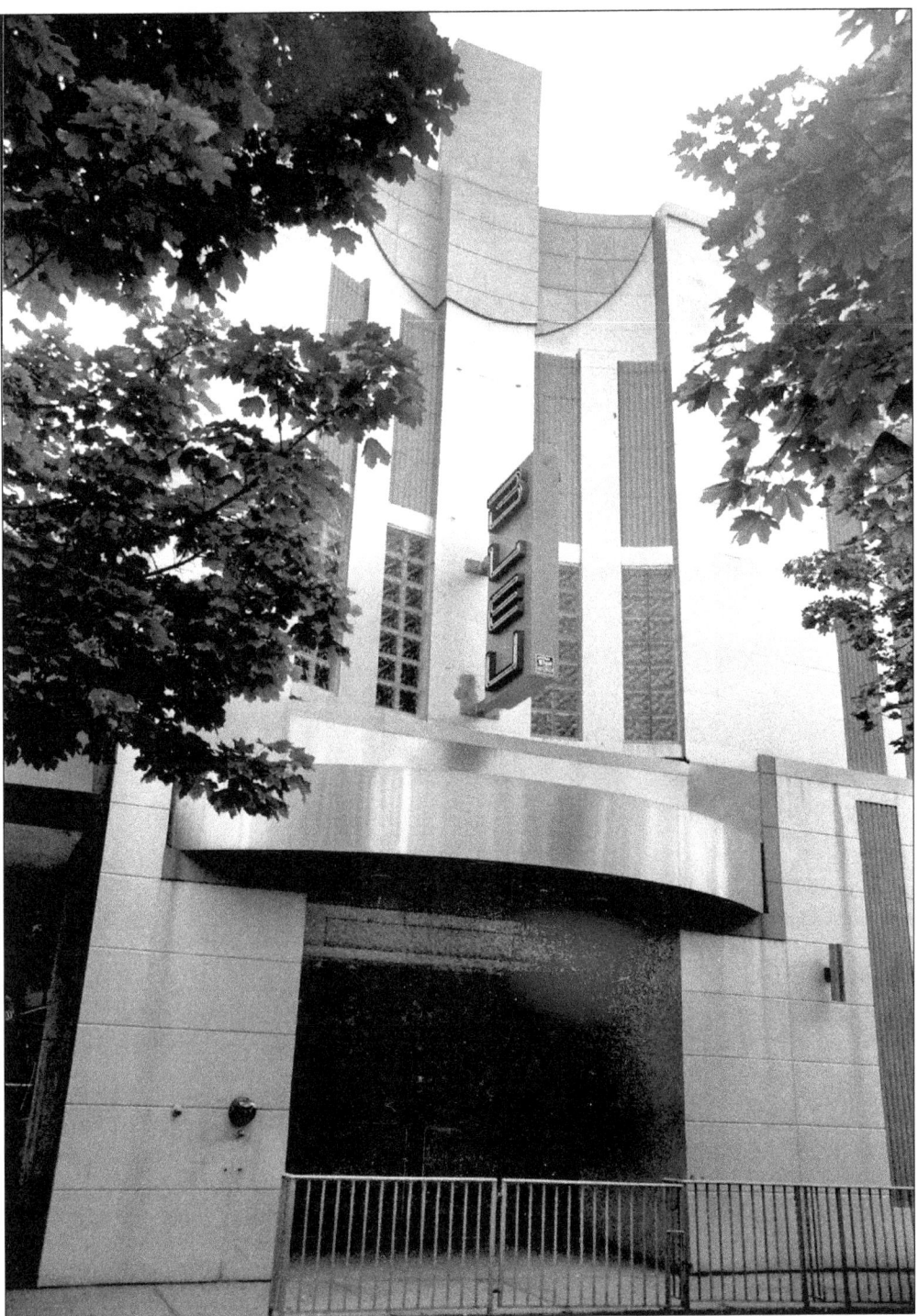

After several incarnations as a movie theater showing everything from karate movies to art films, the theater closed in the early 1990s. It reopened in 2000 as Bleu, a new techno nightclub . . . of course now painted blue. The chimney-looking tower in the center is actually the support for the globe that was originally there.

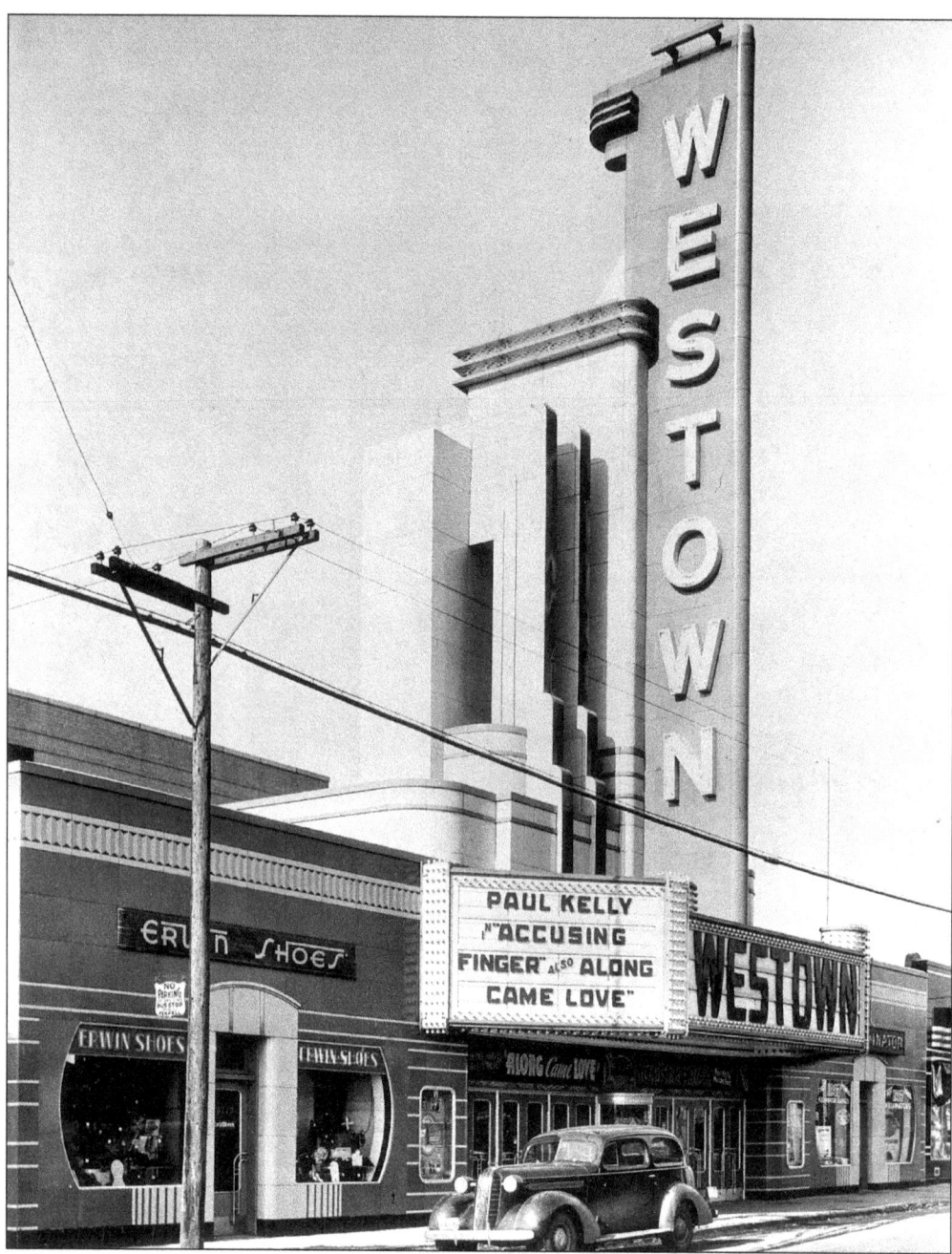

Another fabulous Art Deco theater by Charles N. Agree was the Westown, which was located on Wyoming Avenue. It had 1,700 seats, making it another large neighborhood theater when it opened in 1936. Notice the twin Deco storefronts on each side of the theater entrance. Unfortunately, this theater is no longer extant. (Courtesy Manning Collection.)

The Senate Theater was built by architect Christian Brandt in 1926. It is now owned by the Detroit Theater Organ Society, where the theater organ from the historic Fisher Theater has been installed. Organ concerts are still held at the Senate, located on Michigan Avenue and Livernois. The original vertical sign and porcelain enameled symmetrical exterior give it an exciting appeal.

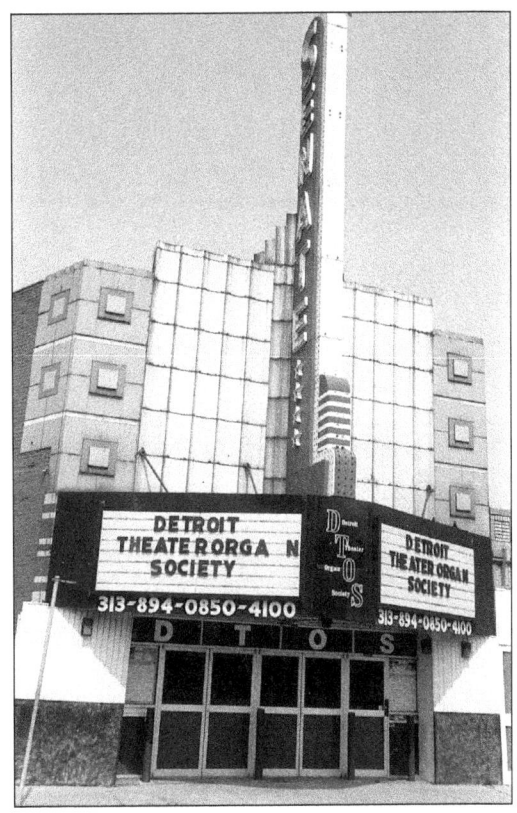

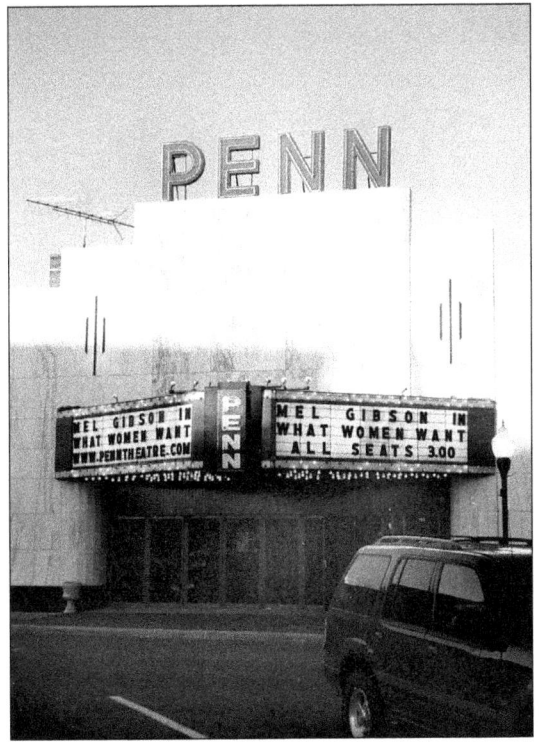

The Penn Theater in Plymouth is located on the town square at Kellogg Park. It survives as a rare example of the single screen theater—a vanishing type of architecture in this era of multiplex movie complexes. The Penn was built in 1941 and opened just three days before Pearl Harbor was bombed. It was built by Harry R. Lush and was restored in 1999.

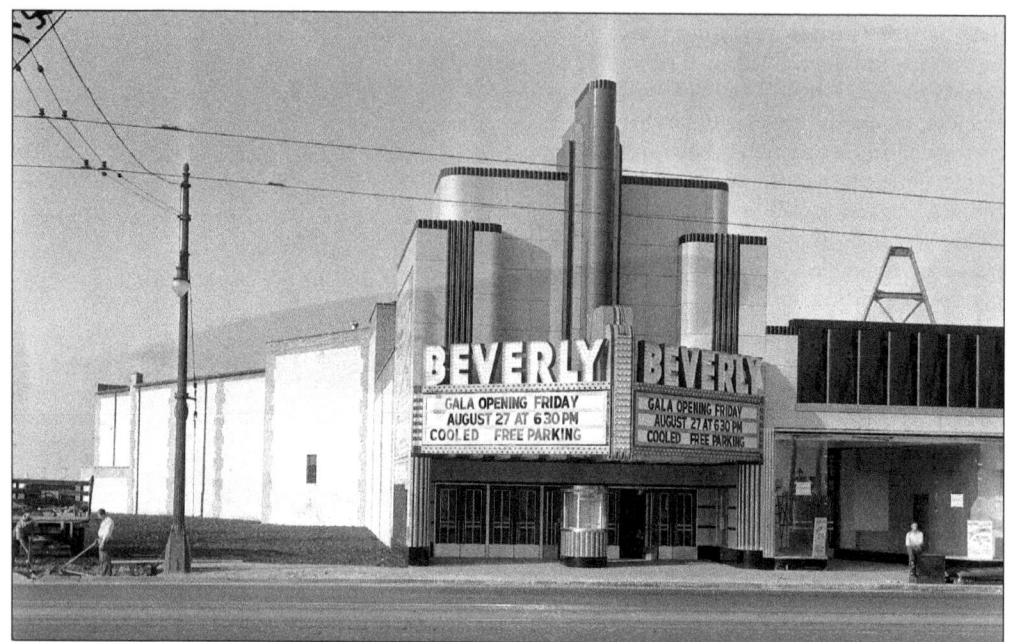

The Beverly Theater was built in 1937, also by Charles Agree, and was on Grand River at Oakman. This perfectly symmetrical façade had great lines and curves. The theater closed in 1964 and was demolished soon afterwards. (Courtesy Walter P. Reuther Library, Wayne State University.)

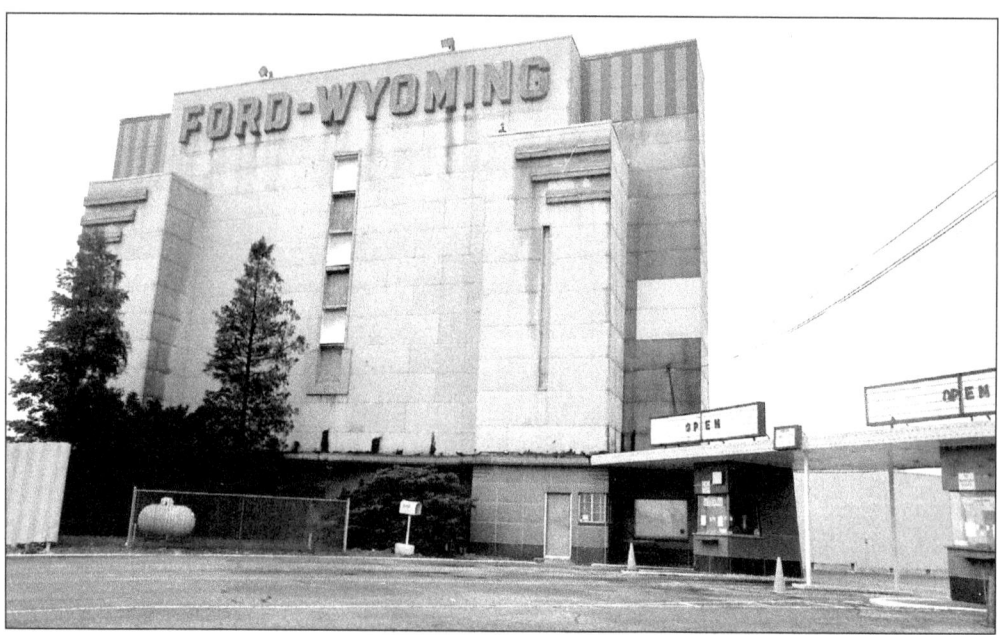

The Ford-Wyoming Drive-In is the last remaining drive-in in the metropolitan Detroit area. Located in Dearborn at the intersection it is named for, it is an Art Deco gem. The Ford-Wyoming was built in 1950 and has been running movies on the big screen ever since. A completely symmetrical façade, it is trimmed with neon and blue porcelain enamel steel panels. Drive-ins are a vanishing part of American roadside architecture—but the Ford-Wyoming is still open year round!

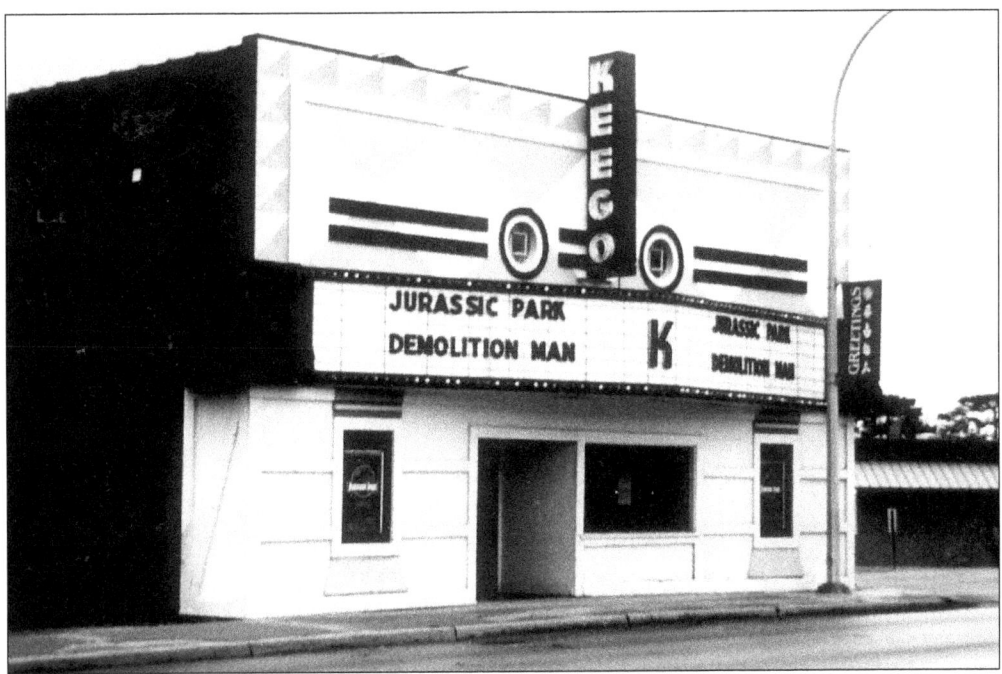

The Keego Theater in Keego Harbor was torn down in 1998 to make room for a Rite Aid drug store. This unique building was replaced by homogenous chain store architecture, as has happened so many times in this country. (Courtesy Dennis Standhardt.)

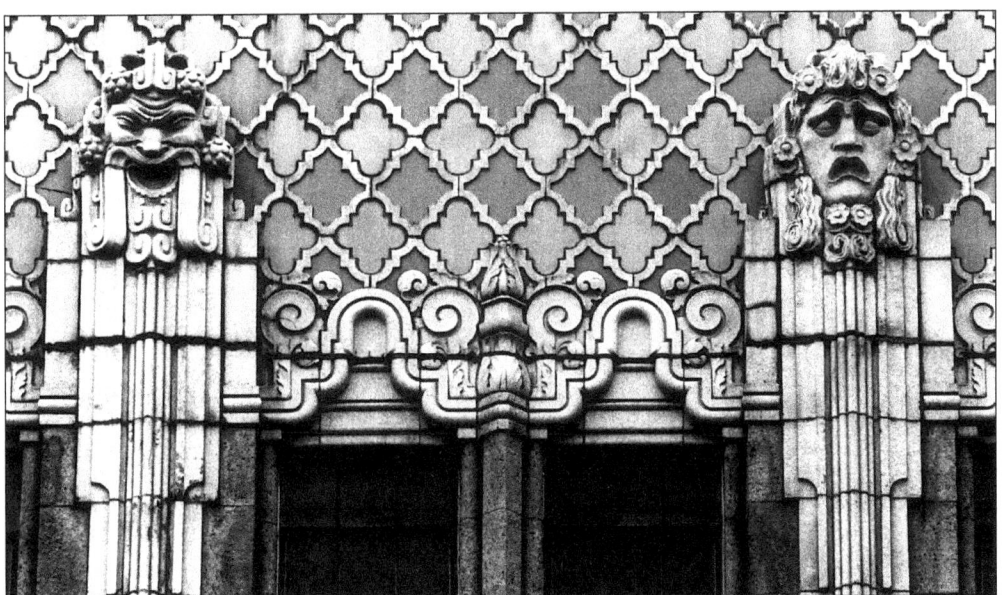

This is a detail from the façade of downtown Detroit's Music Hall. The faces of Comedy and Tragedy were sculpted in terra cotta by Detroit sculptor Corrado Parducci, who also sculpted the figures on the exterior of the Guardian Building. Music Hall opened in 1928 as the Wilson Theater, and was designed by William Kapp of the firm Smith, Hinchman and Grylls. Originally a legitimate theater for the presentation of plays and concerts, it was showing movies by the late 1930s, and in the 1950s was altered to allow "Cinerama" movies to be shown.

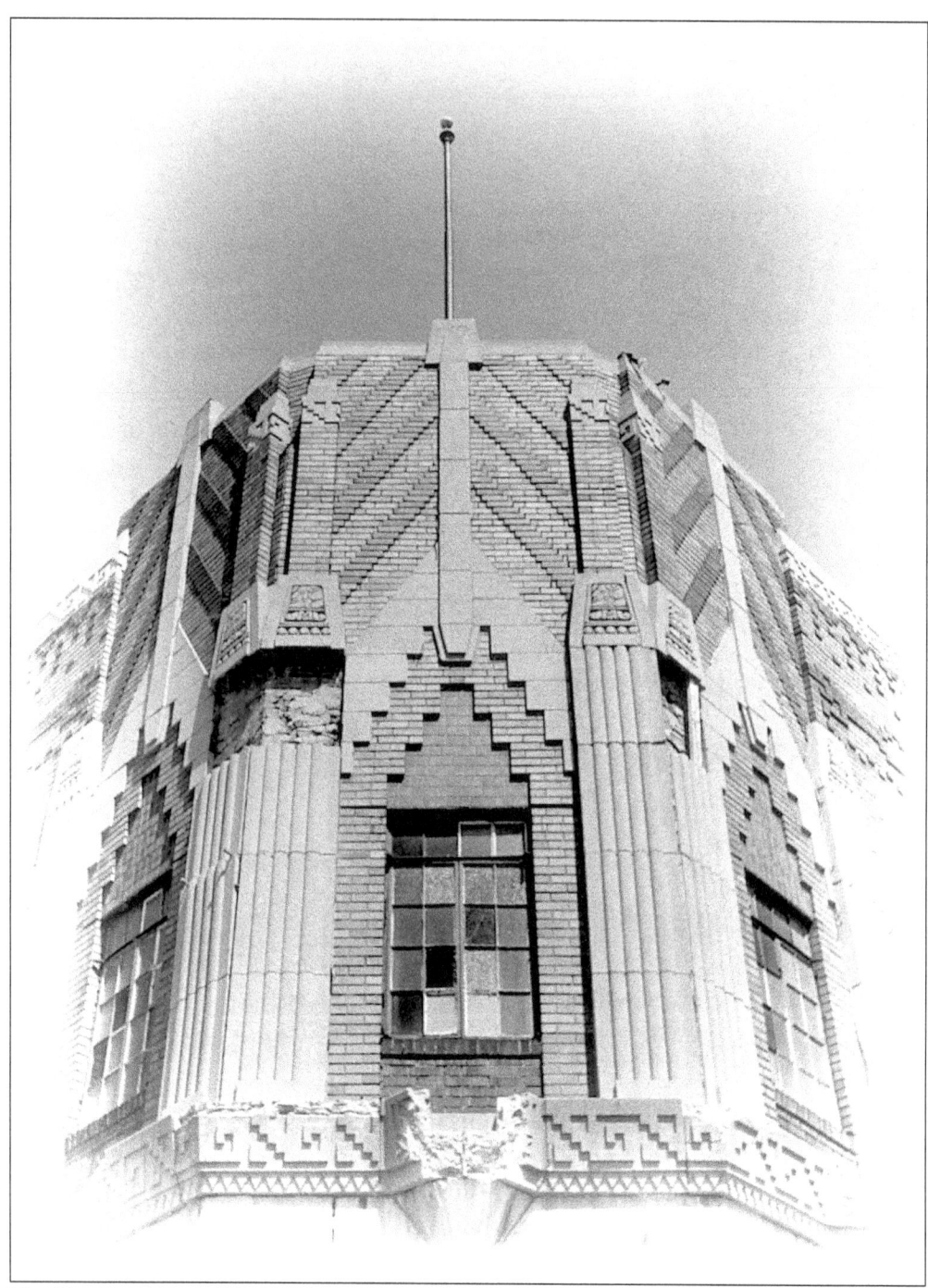

The Vanity Ballroom billed itself as "Detroit's most beautiful dance rendezvous" and it was a rare case of truth in advertising. The Charleston, Prohibition, big bands and swing... the jazz age was realized at the Vanity Ballroom. Built in 1929, it opened just a few weeks before the stock market crashed. Located at the corner of Jefferson and Newport Streets, the Vanity was a destination for eastsiders who wanted to dance to the best big bands in Detroit. (Courtesy Charles Cirgenski.)

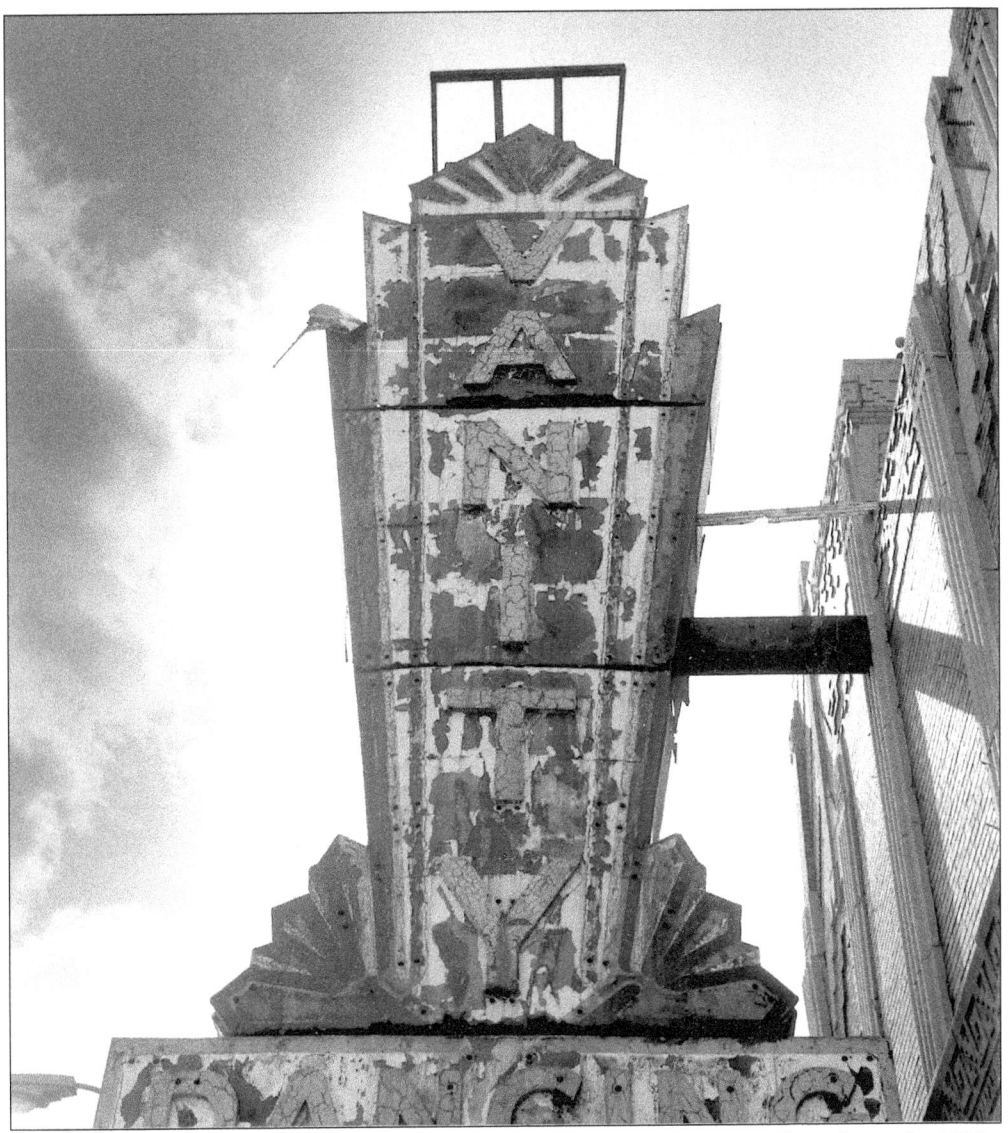
The vertical marquee sign, which read "Vanity Dancing," was removed in the early 1990s. (Courtesy Chuck Cirgenski.)

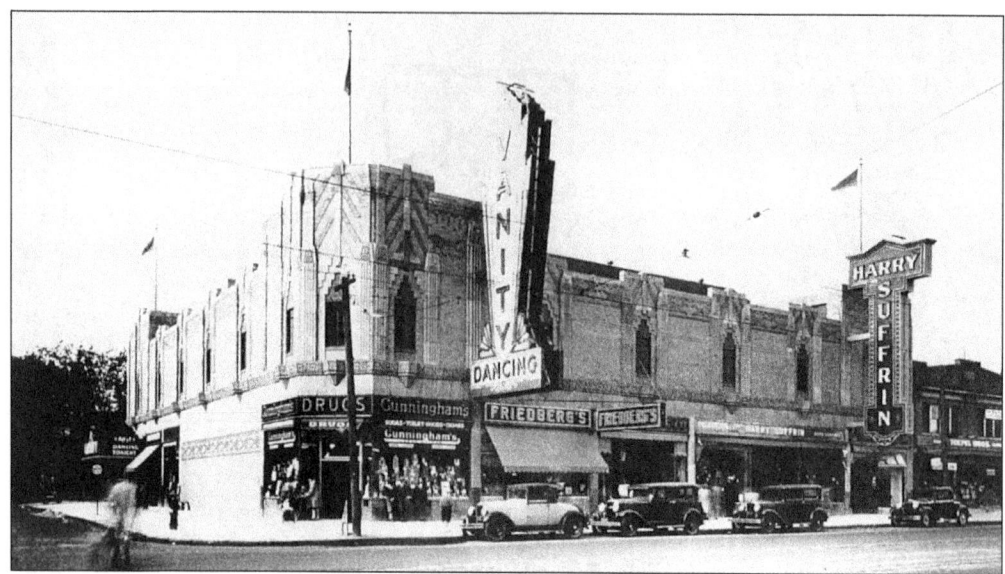

The Vanity's architect was Charles N. Agree, and he designed it in a combination of Art Deco modernity with Mayan Revival exotic. The building's detailing includes the inverted "V" shape called a chevron, as well as the stepped arch reminiscent of the ziggurat pyramids in Central America. The capitals of the pilasters include a representation of the Mayan/Aztec native art, and a frieze of Aztec-derived zigzag wraps around the building. The Vanity Ballroom was on the second story of the building, and the first floor was leased to various retail shops. A Cunningham's Drug Store was on the corner for many years. (Courtesy Richard Bak.)

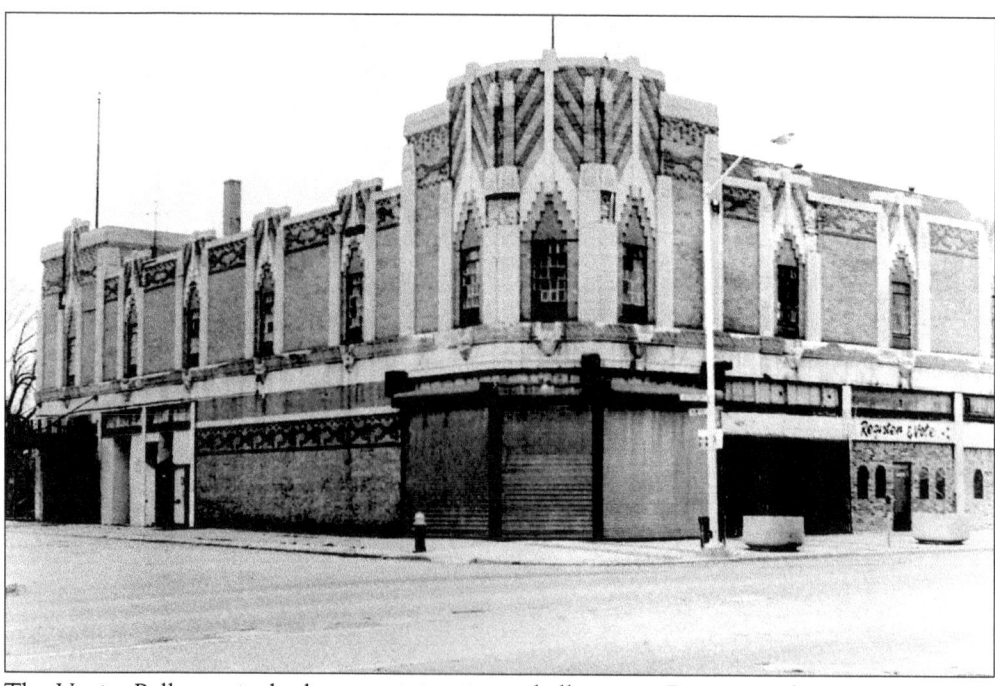

The Vanity Ballroom is the last remaining intact ballroom in Detroit, and it now sits vacant and unused. The Vanity is on Detroit's east side, located on East Jefferson Avenue at the corner of Newport Street.

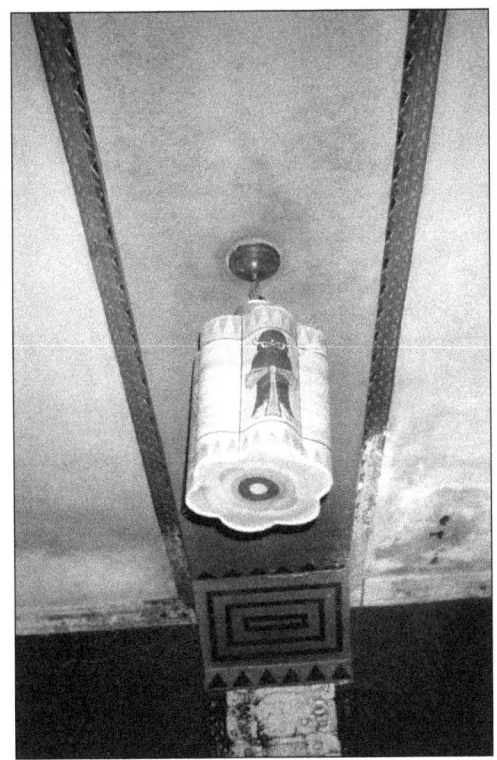 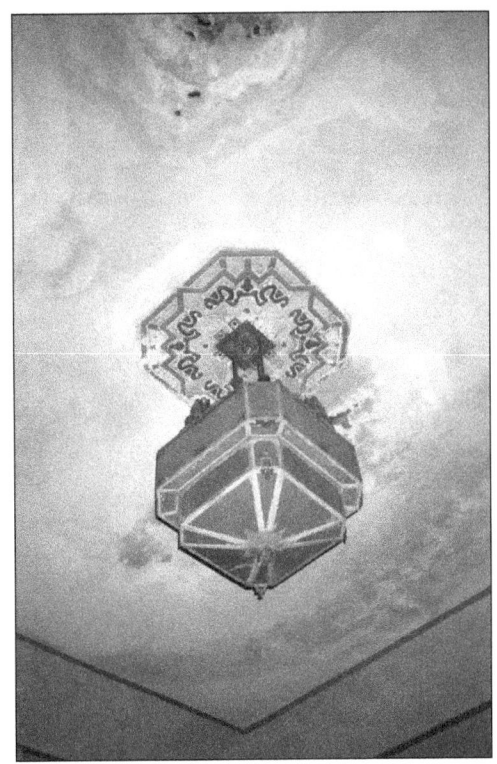

The interior of the Vanity Ballroom was replete with Mayan Revival detailing on every surface. These are some of the hanging light fixtures and a sconce designed in the Mayan Revival style. The water damage to the Vanity Ballroom's plaster ceiling and walls is evident in some of these photos.

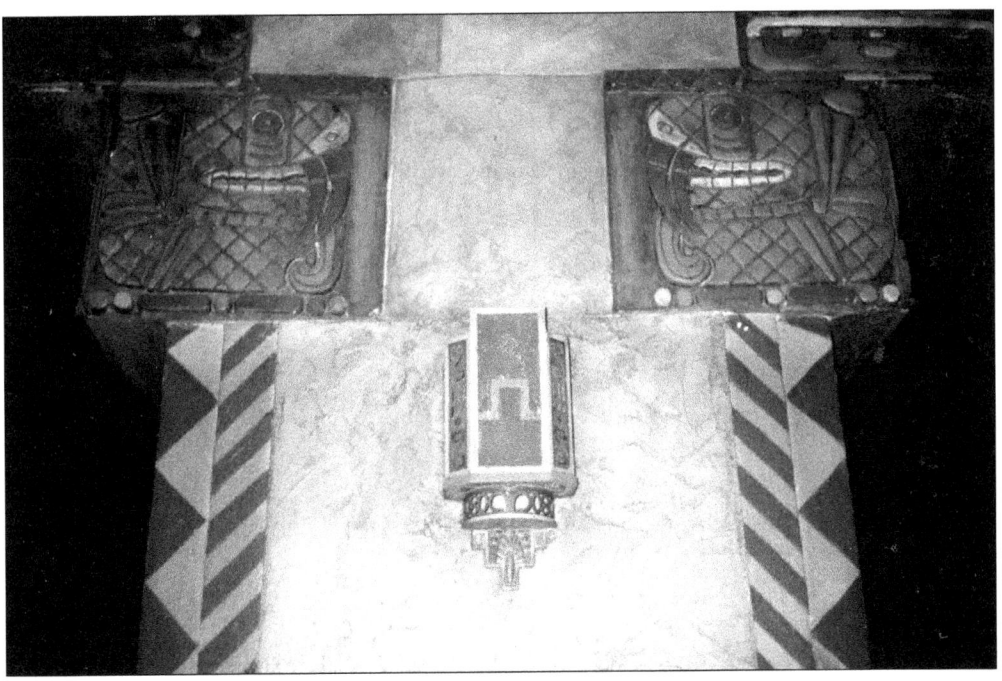

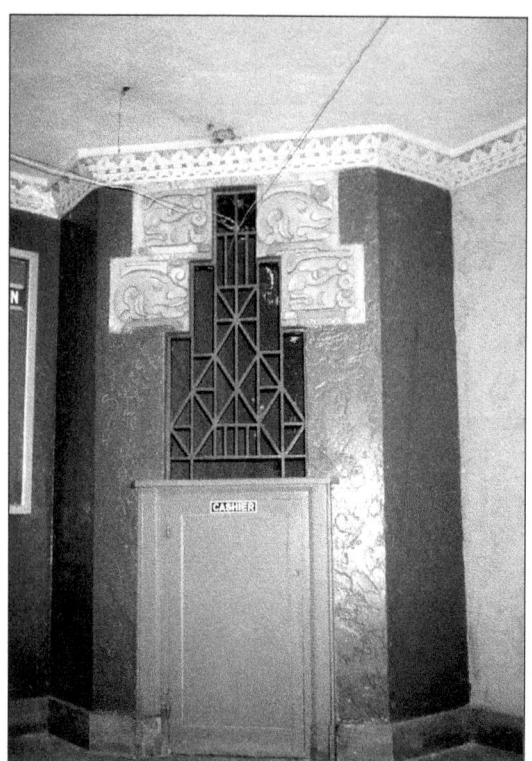

This was the box office where patrons paid the cover charge of 35¢.

These stepped arches surround the dance floor. Vanity Ballroom dance floor was legendary; at 5,600 square feet, it was a "floating" floor, which meant that it was built on springs so that there was a bounce to the dancers' movements.

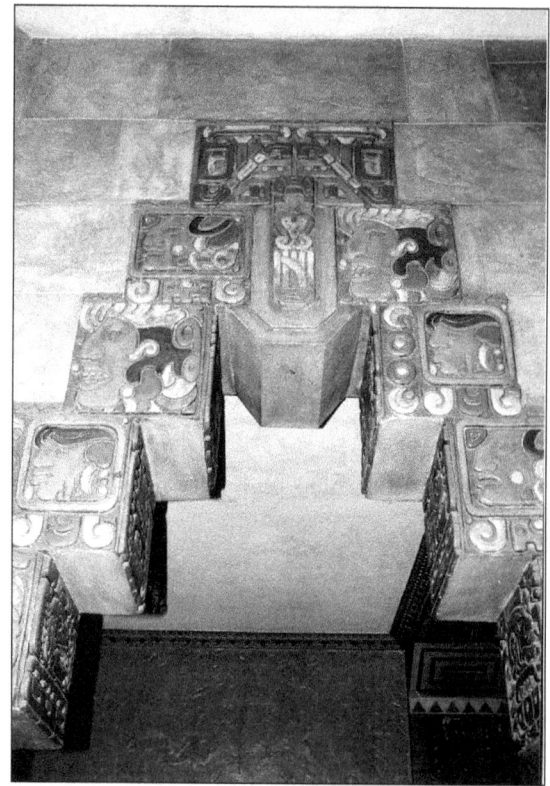

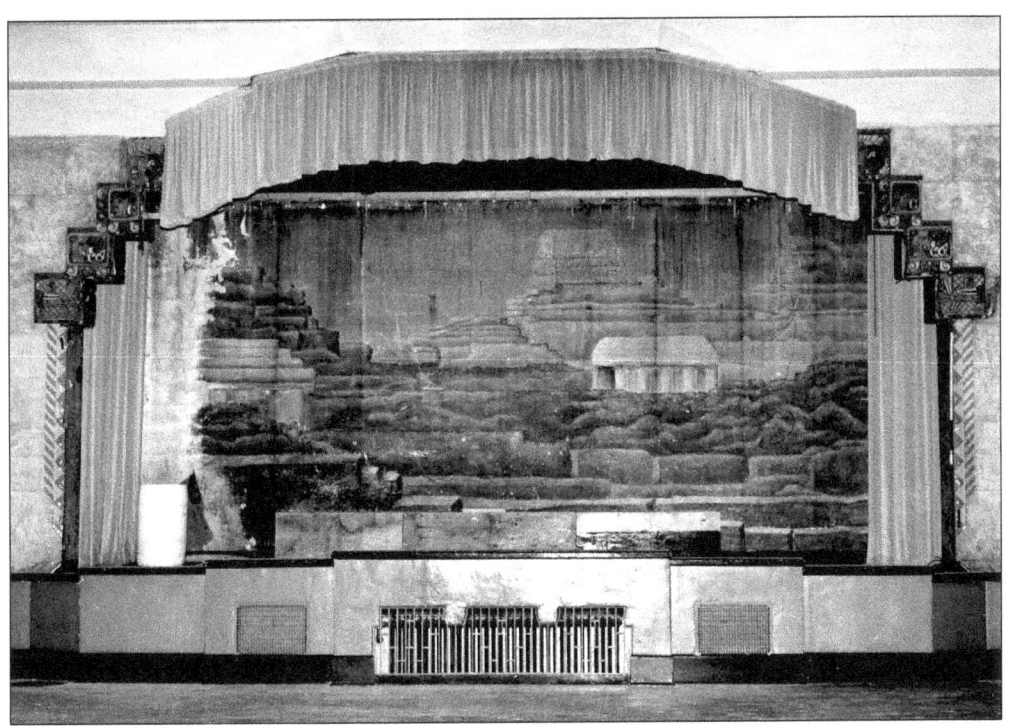

The stage featured a backdrop with a scene representing the Chitzen-Itza ancient temple sites. That stage was the historic site of big band dance music and has hosted stars such as Tommy and Jimmy Dorsey, Duke Ellington, Benny Goodman, Woody Herman, and Cab Calloway.

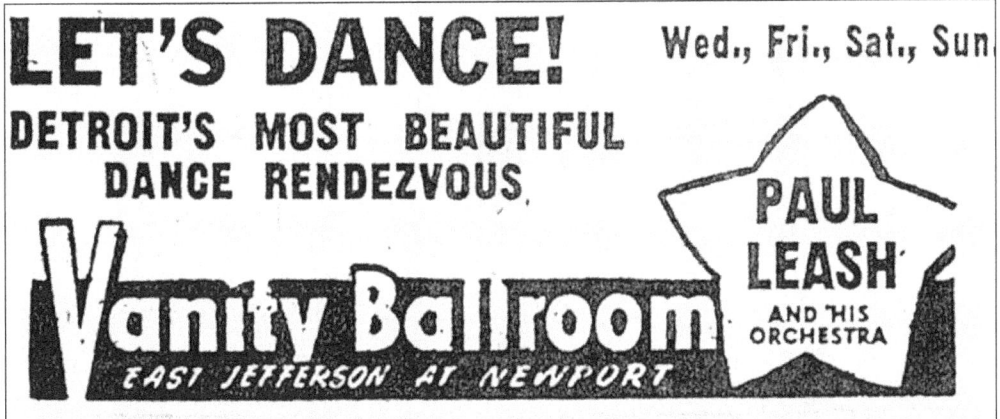

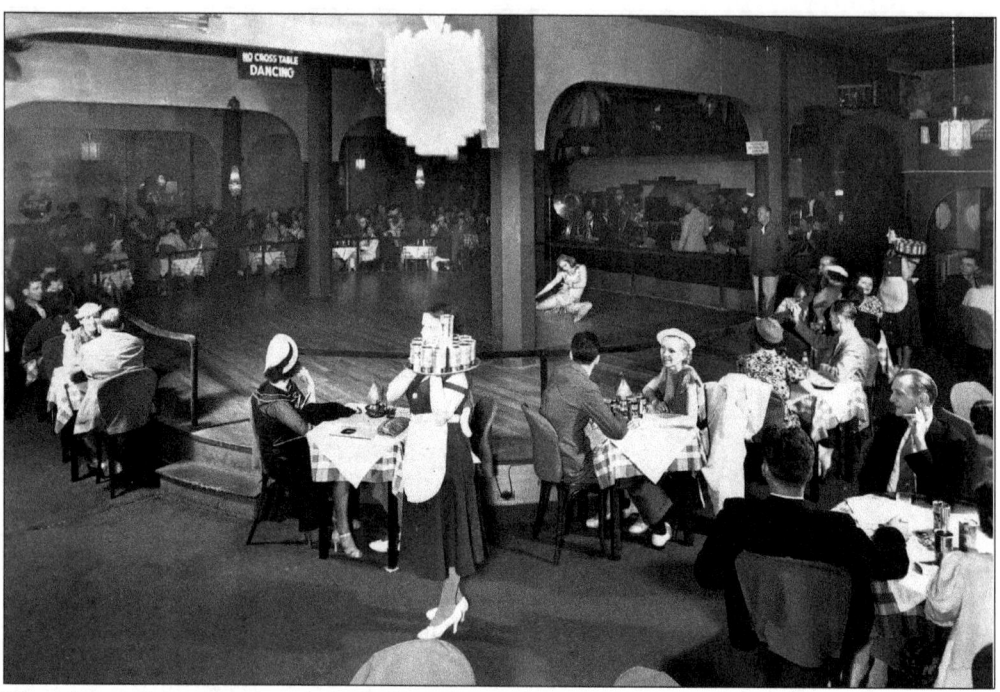

This photo of the now demolished Eldorado Gardens dance hall from 1936 gives us a glimpse into the past ballroom era. (Courtesy Manning Collection.)

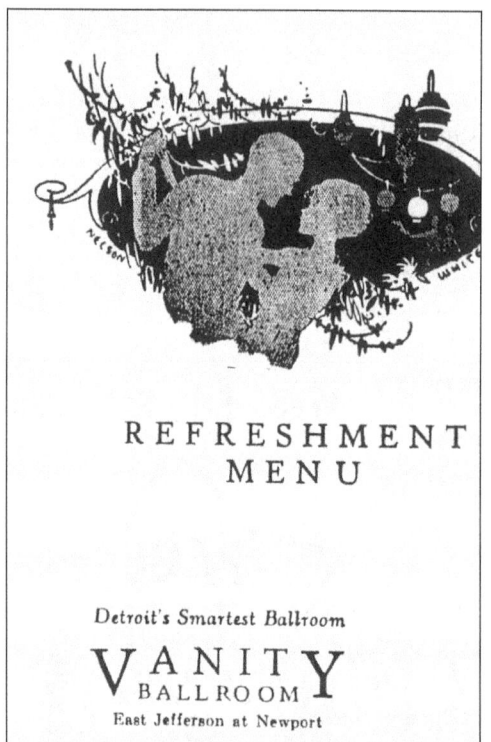

The Vanity did not sell alcohol. This Refreshment Menu lists the beverages available.

Eight
LESSONS LEARNED

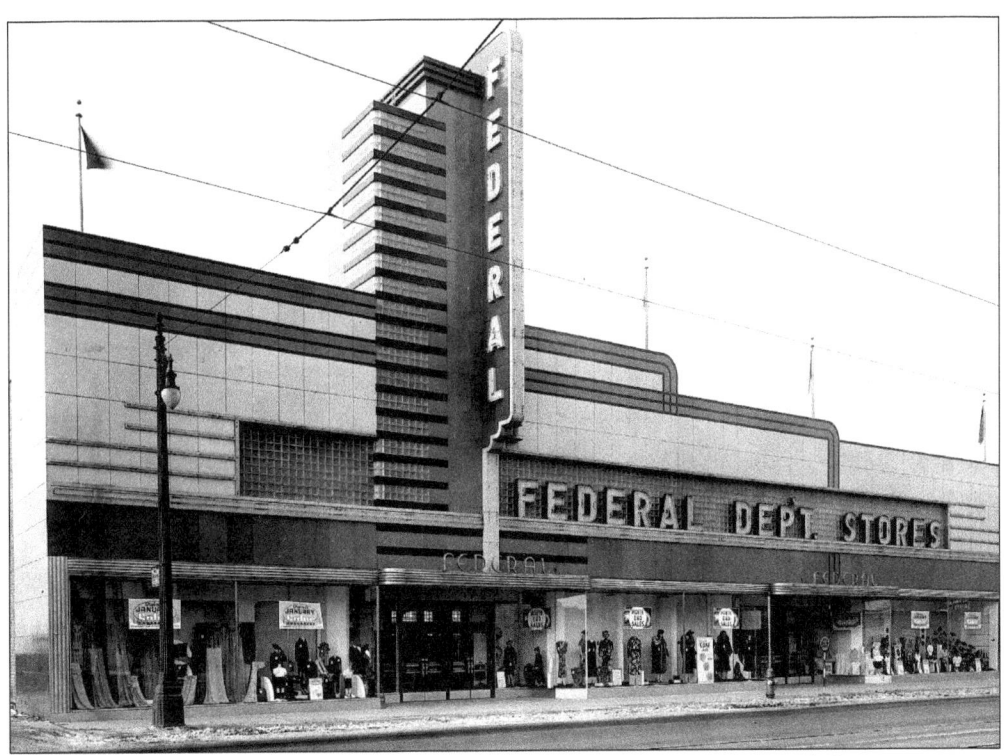

Federal Department Stores were once a common sight all over Detroit and there were many branches, most designed by architect Charles N. Agree. This one on Grand River and Oakman utilized many streamline forms, and Federal stores always used neon on exterior of the buildings. (Courtesy AIA Detroit.)

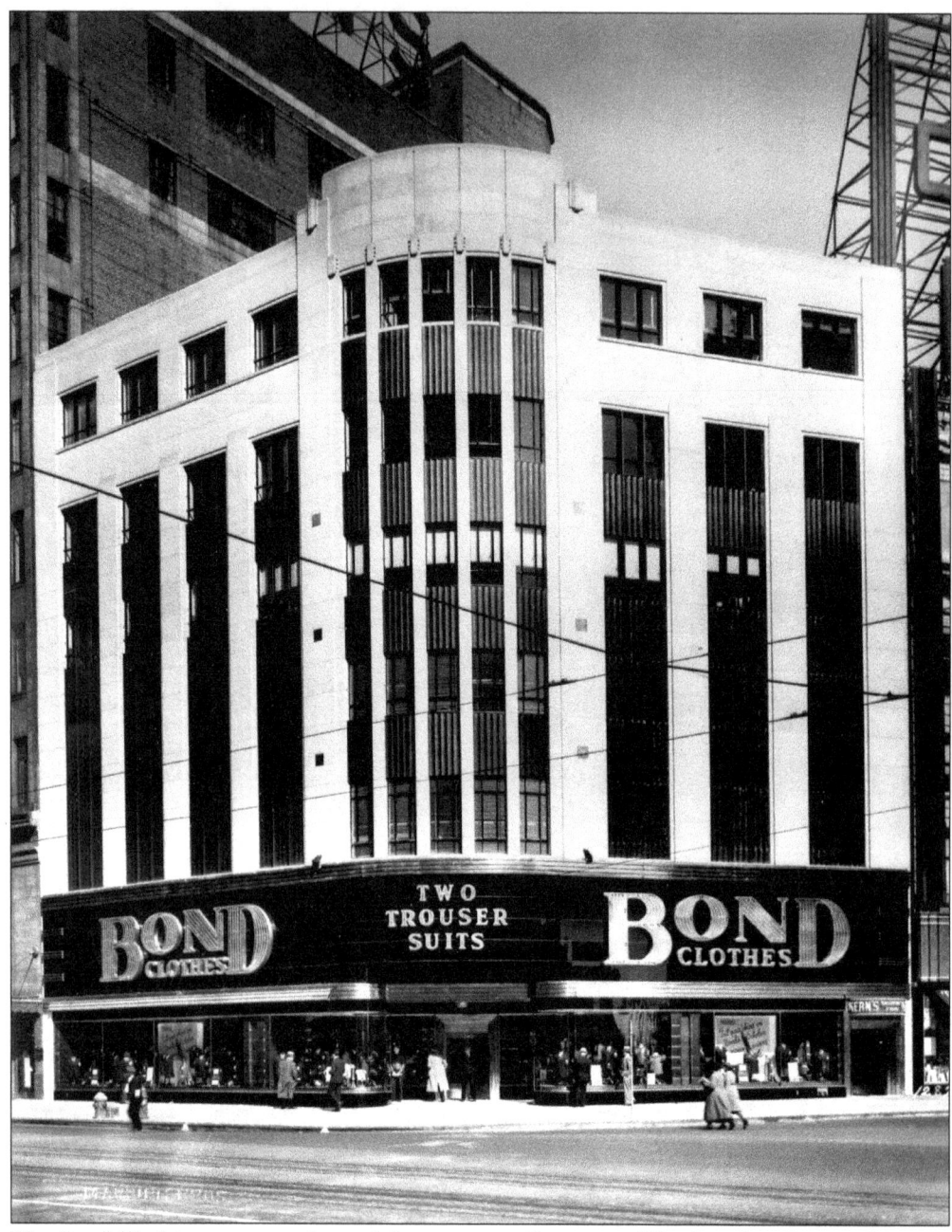

The Bond Clothing store was located downtown in Detroit on Woodward at Campus Martius. The curved corner and aluminum banding at the storefront level made the Bond Store memorable. The building was demolished in 1966, and it is now the site of the new Compuware Company headquarters. (Courtesy Manning Collection.)

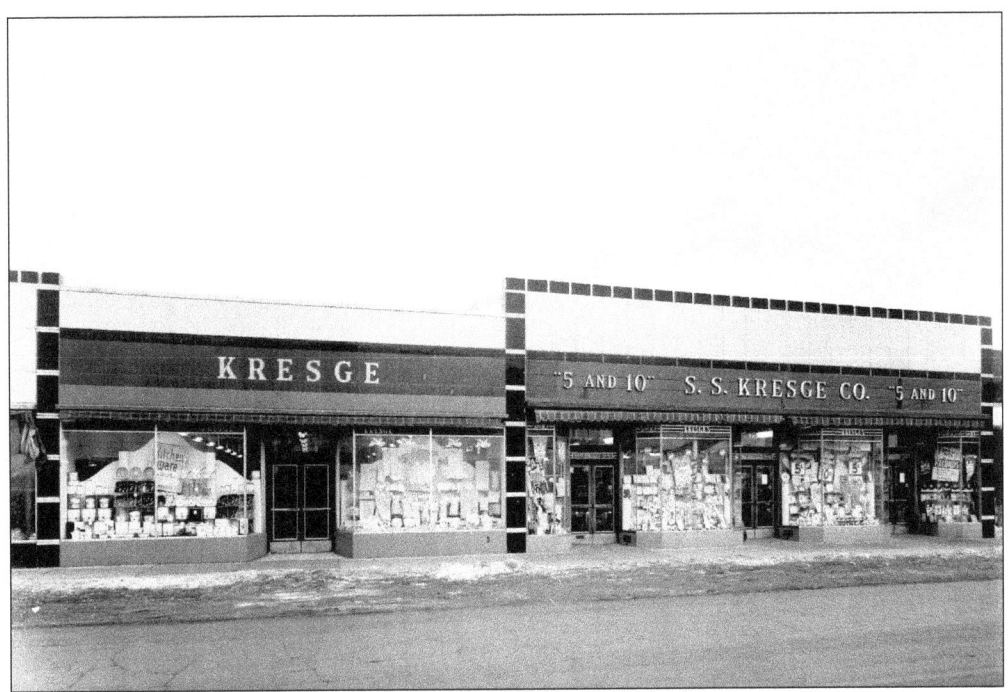

S.S. Kresge Co. stores were common through all of metro Detroit. This one uses multi-colored panels, but most Kresge's stores were known for their "red front" design with a streamlined red Vitrolite background for the Kresge lettering. (Courtesy Manning Collection.)

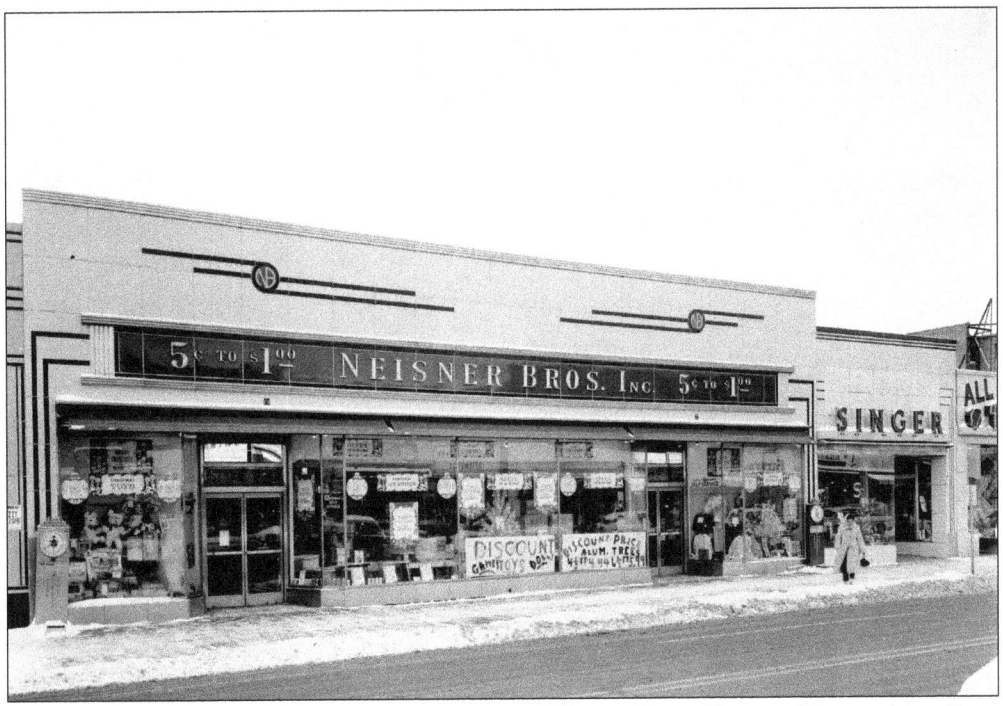

Neisner Bros. stores were the competition to S.S. Kresge Co. in Detroit. Eye-catching Deco details hold the NB initials. (Courtesy Manning Collection.)

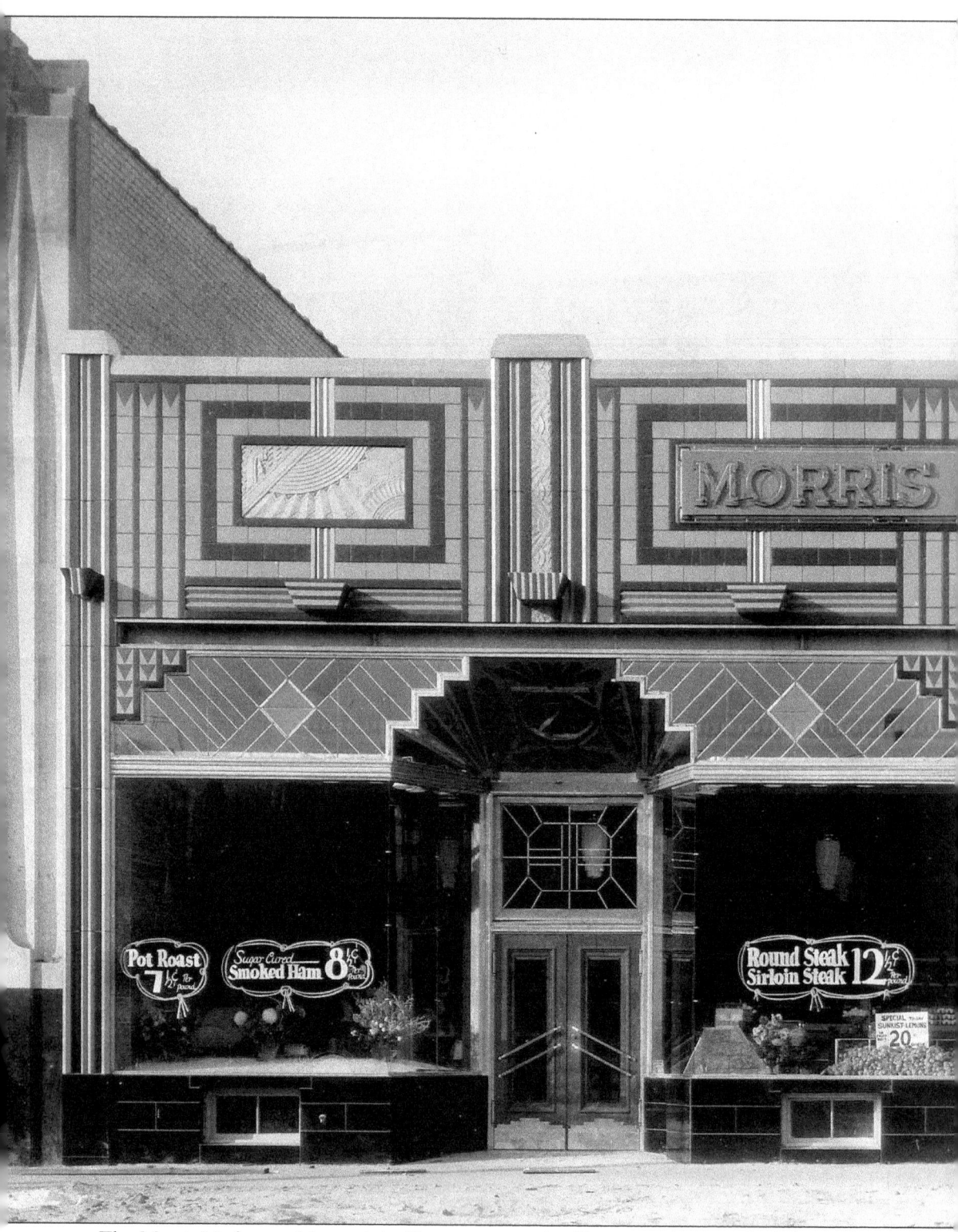

The Morris Market on Livernois in Detroit was an Art Deco storefront to the hilt. Wish we

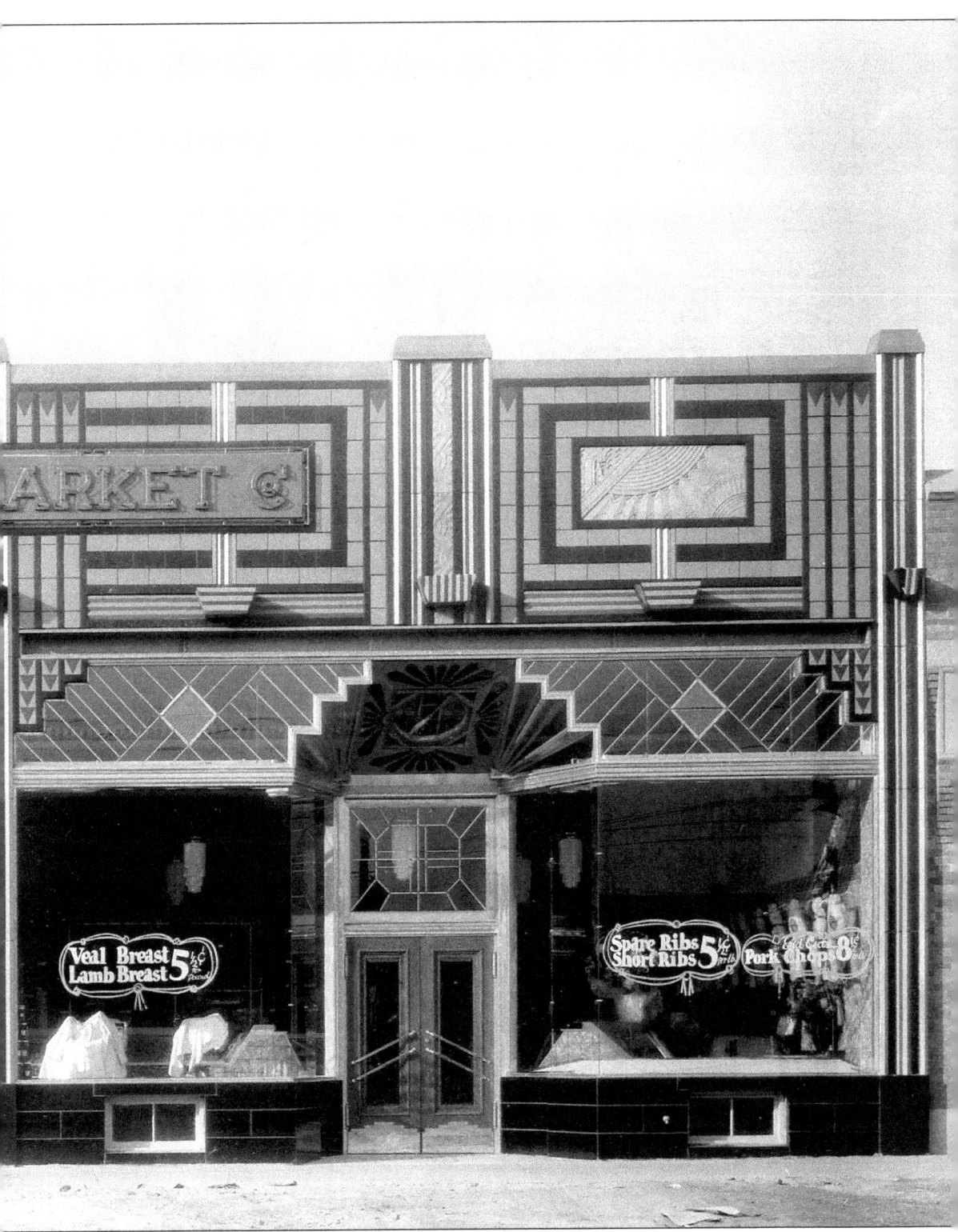

could still go to this meat market! (Courtesy Manning Collection.)

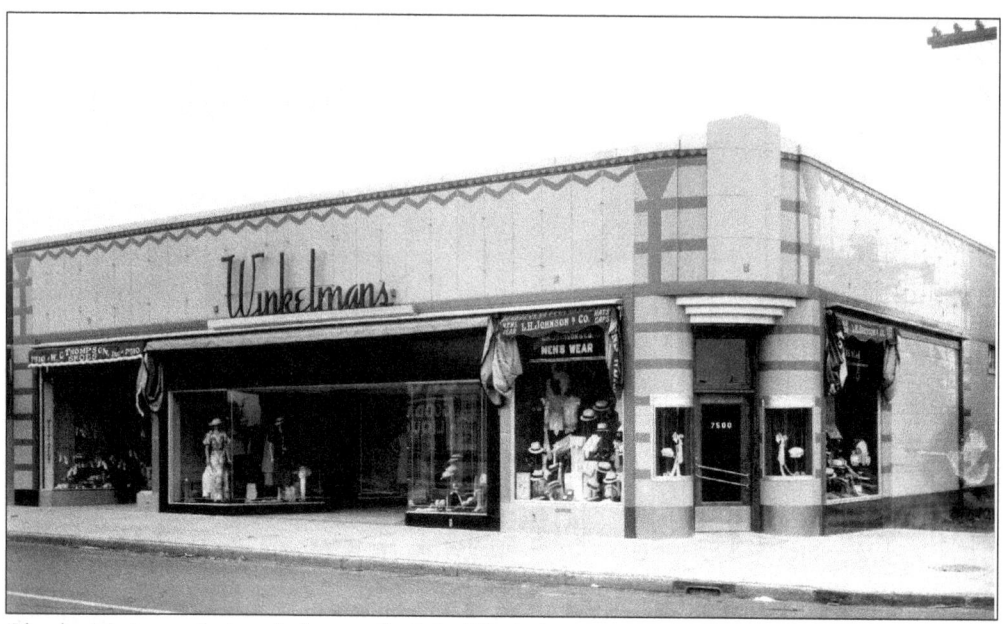

Charles N. Agree designed almost all of the Winkelmans stores in metropolitan Detroit during their growth years in the '30s, '40s, and '50s. This one was located on Six Mile Road and featured multicolored porcelain enamel steel patterns to attract fashionable customers to the store. (Courtesy Manning Collection.)

Charles N. Agree, AIA, was the architect responsible for so many of Detroit's fabulous Art Deco retail buildings and theaters. His work defined the city of Detroit's neighborhood retail districts for decades.

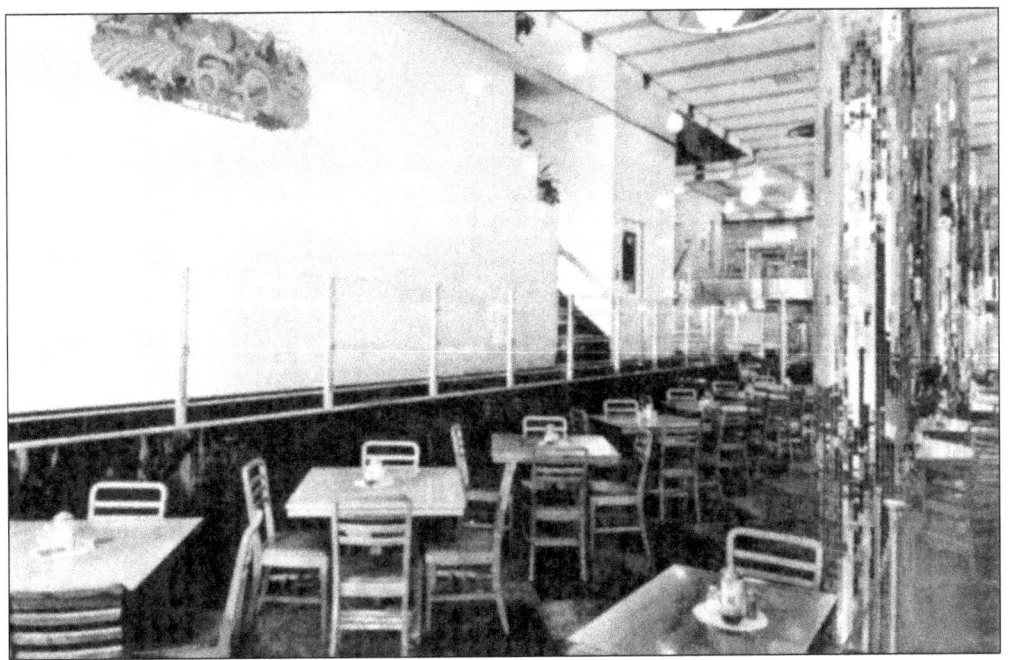

Kartsen's Cafeteria was located on Woodward Avenue south of Grand Circus Park. Kartsen's was a study in contemporary flashiness—mirrored columns competed for attention with the Vitrolite walls and chrome. Note the painting of a Ford farm tractor on the wall. (Courtesy Manning Collection.)

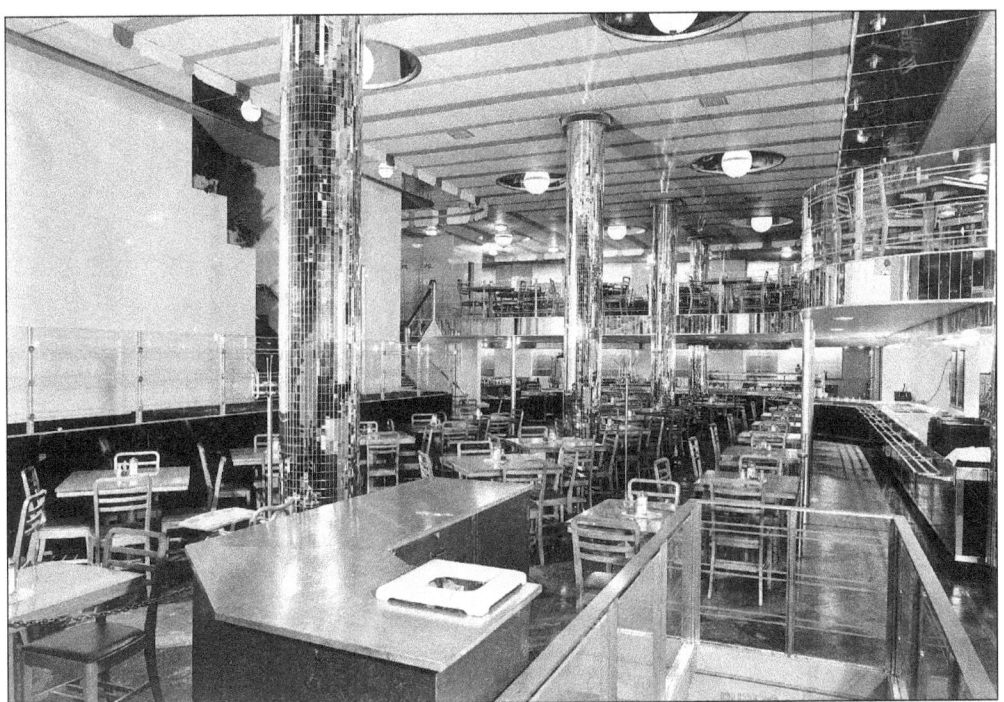

Kartsen's served the thousands who rode streetcars downtown to shop in the many department stores. (Courtesy Manning Collection).

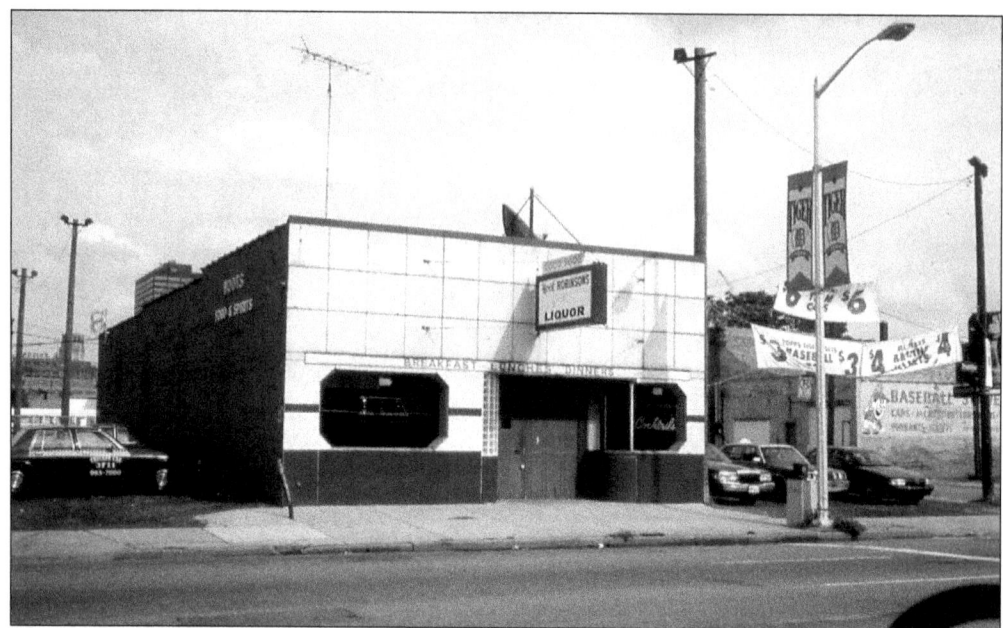

This was once Hoot Robinson's bar located across from Tiger Stadium on Trumbull near Michigan. Originally called the Tiger Cocktail Bar, it was built in 1938. This baseball drinking institution is paneled in porcelain enamel steel—once a lovely combination of oxblood red and cream.

The bar has been closed since Tiger Stadium closed, and the current owners painted it a flat dull brown.

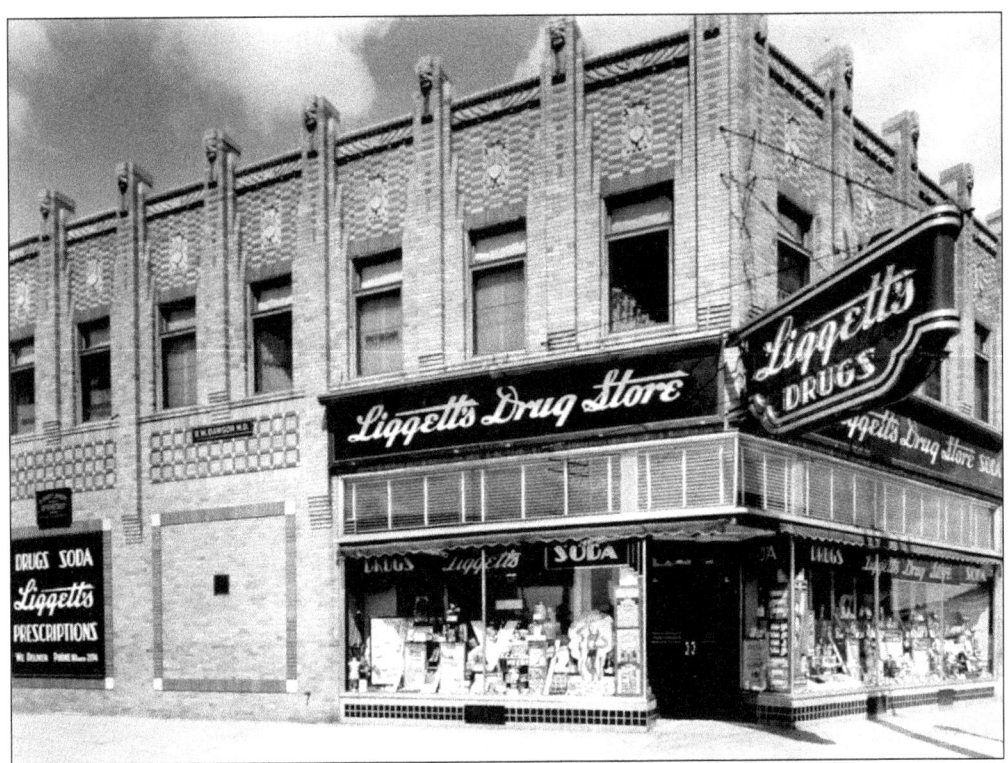

Liggett's Drug Stores were scattered throughout Detroit. Several used this fabulous brick and cast stone detailed design. (Courtesy Manning Collection.)

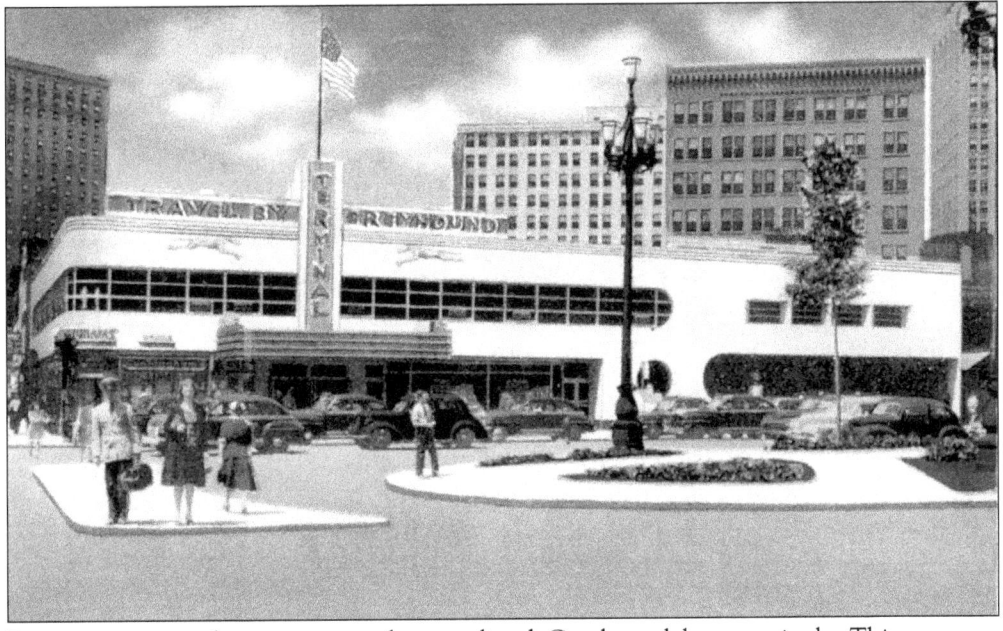

Detroit was once home to several streamlined Greyhound bus terminals. This one was located on Washington Boulevard and Grand River downtown. It is now the site of the Trolley Plaza Apartment building.

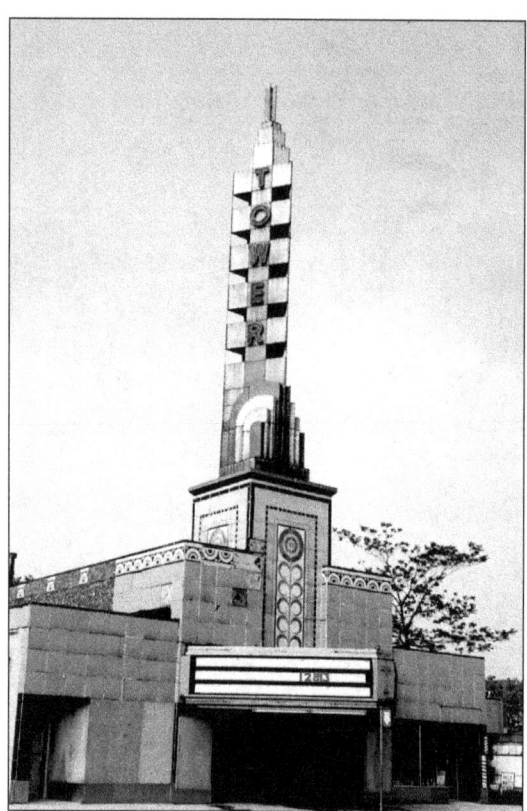

The Tower Theater was on Grand River near Meyers Road in Detroit. This Art Deco confection was built in 1935 by architect Arthur K. Hyde. By 1964 the theater had closed. It is now demolished. (Courtesy Lewis Faieta.)

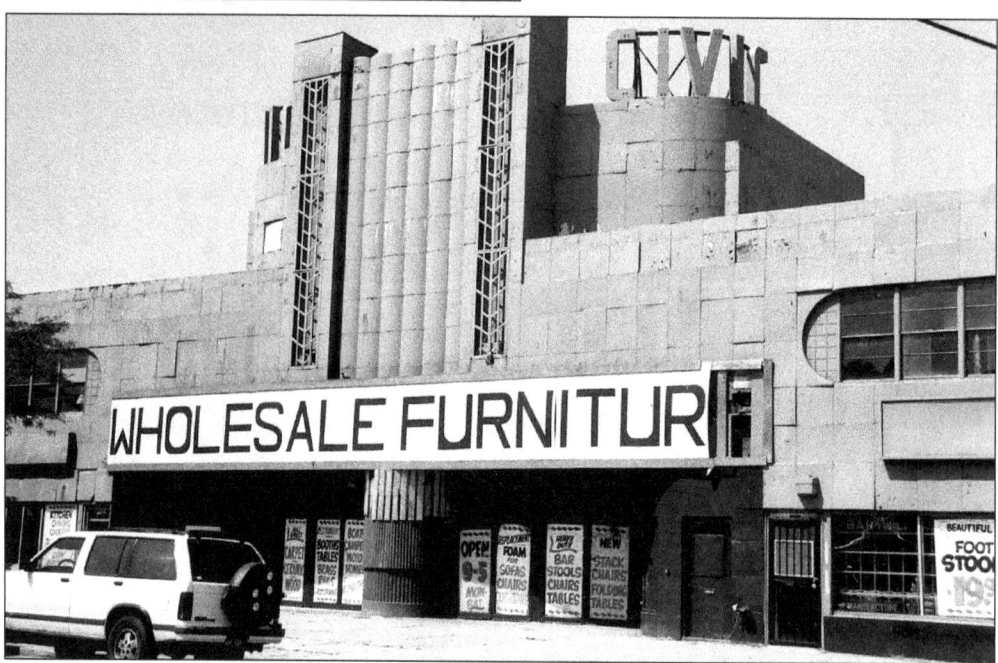

The Civic Theater is on Kelly Road in Detroit. It was built in 1941, and was another large neighborhood theater with 1,445 seats. Today the building is still standing, used as a wholesale furniture store, but has been savagely painted brown and dark green.

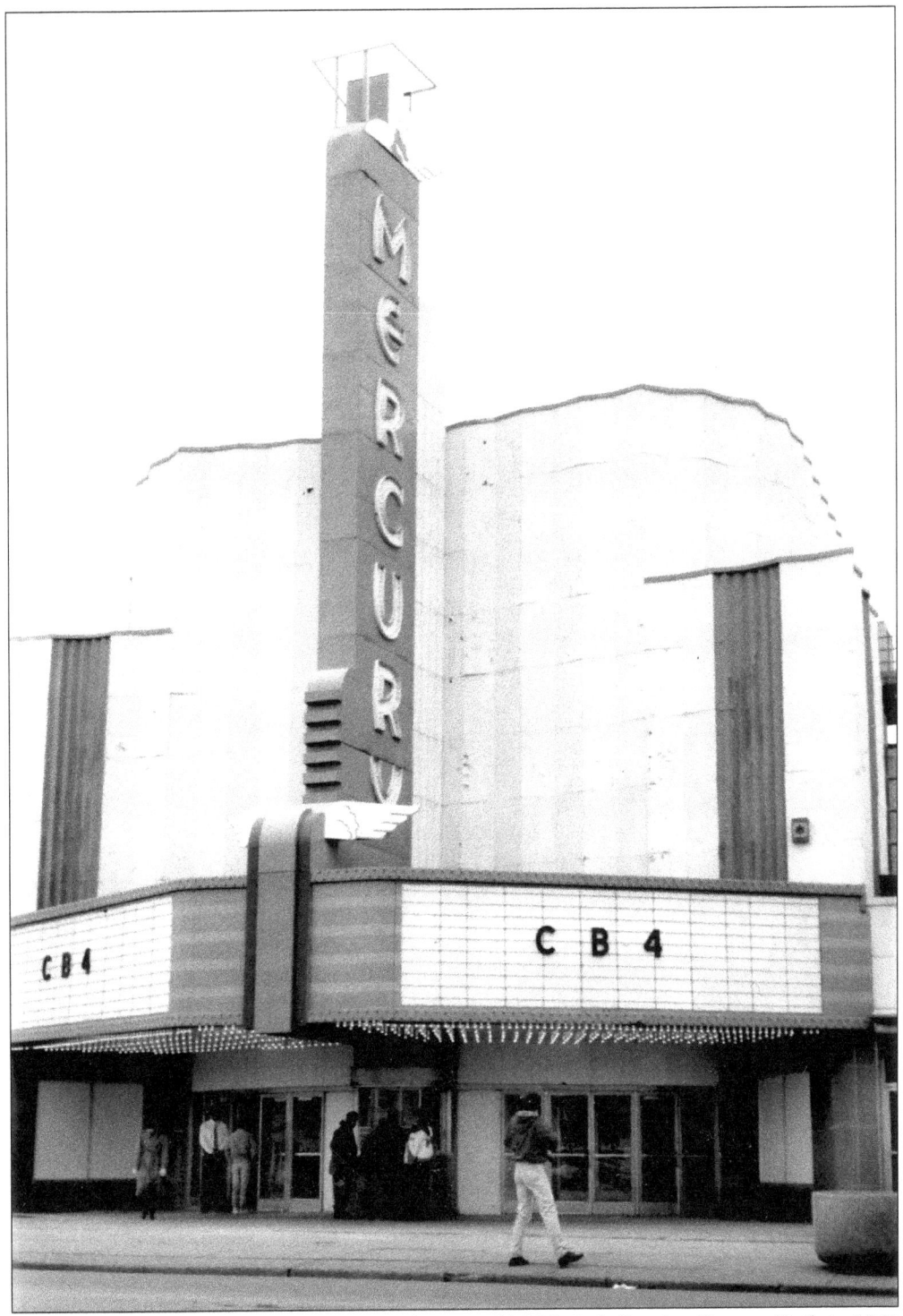
The Mercury Theater was on Schaefer Highway and McNichols Road in Detroit. Built in 1941 by architect Ted Rogvoy, it had wonderful interior wall decorations with mythological and astronomical themes. (Courtesy Michael Hauser.)

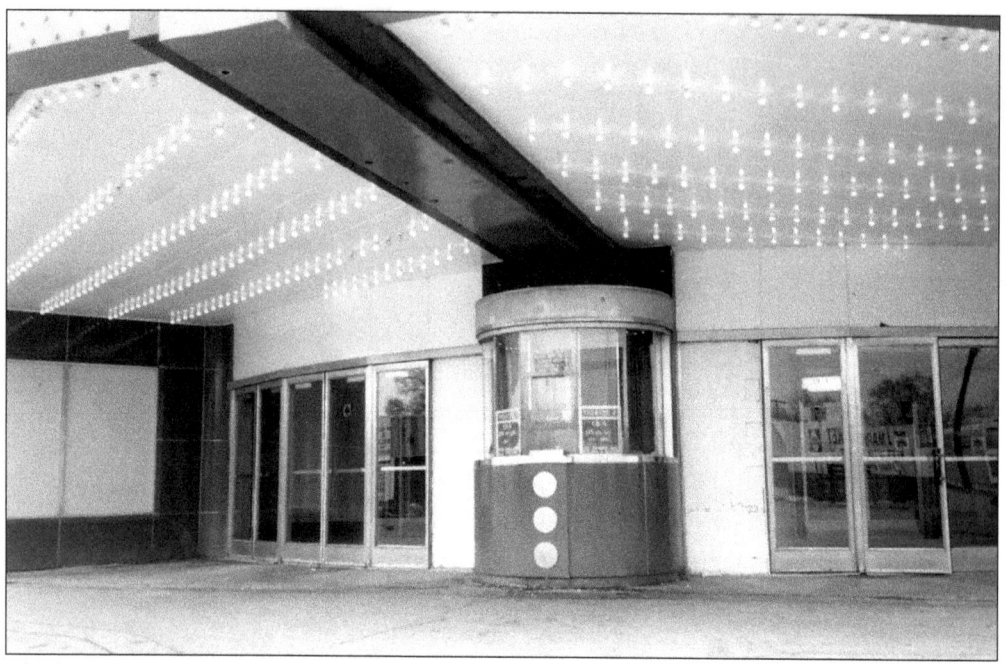
The box office of the Mercury Theater reflected the symmetrical design of the building interior. (Courtesy Michael Hauser.)

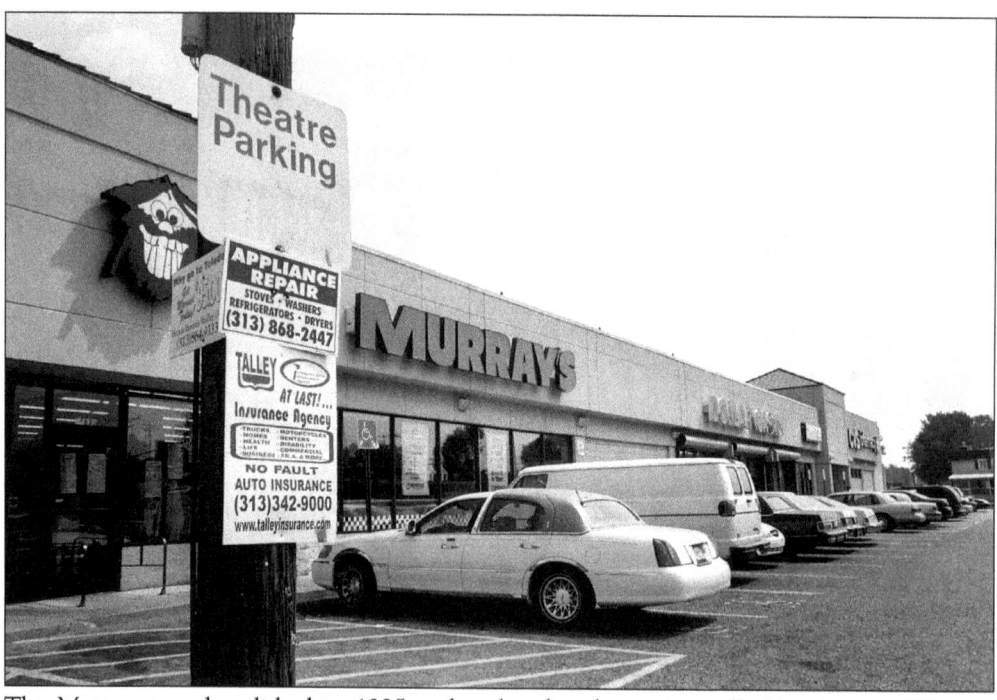
The Mercury was demolished in 1995 and replaced with a strip mall. The sign for "Theatre Parking" remains on the Mercury's site . . . the only reminder of the building's life on that spot.

The Sears store in Highland Park was a landmark on Woodward. It was one of the few cast concrete buildings in the Detroit area. Designed by Nimmons, Carr & Wright in 1938, it was one of the "windowless department stores" they built for Sears across the country, and the first in Michigan. Perhaps most memorable were the huge red neon letters for Sears (in an Art Deco font) at corner of the main entrance.

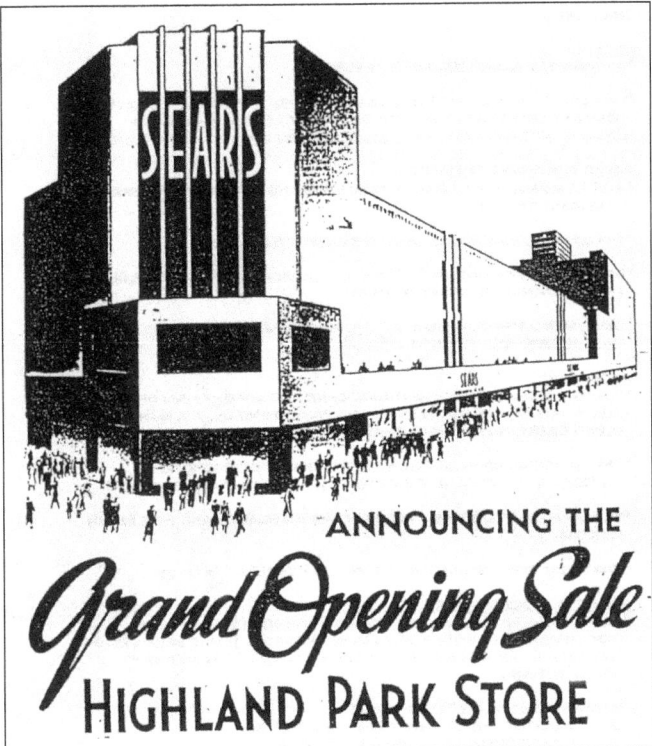

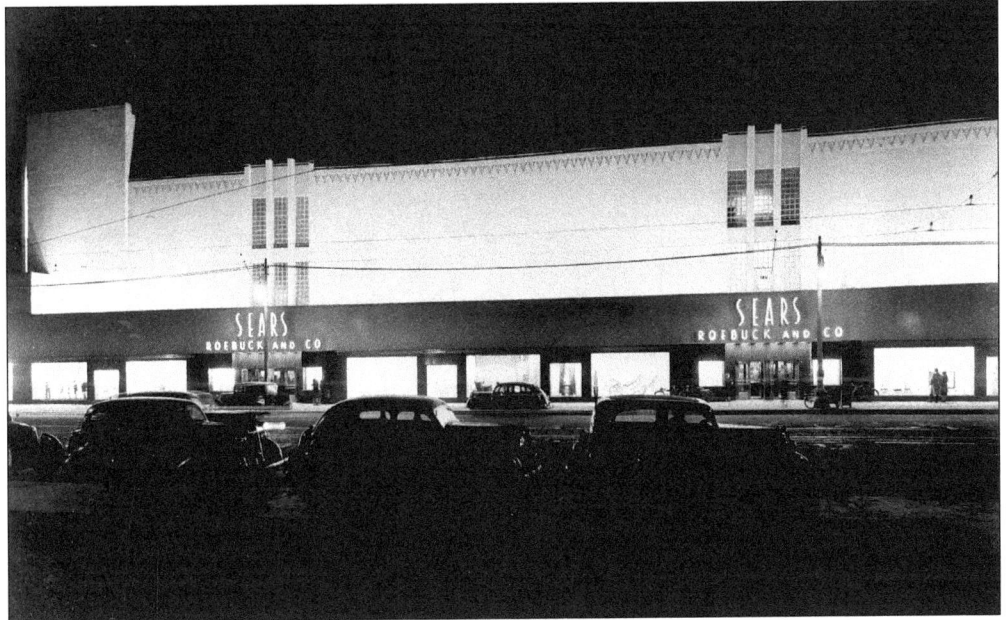

The Sears Highland Park store took up an entire city block. Sears closed in 1992, and was finally demolished in 2001. It marked the loss of an architecturally significant building to the entire metropolitan area. A plan for condos to be built on the site was announced in 2002, but the land remains an empty field today.

This small streamlined building was on Michigan Avenue in Detroit. It is a case of demolition by neglect.

Nine
Religious and Educational Buildings

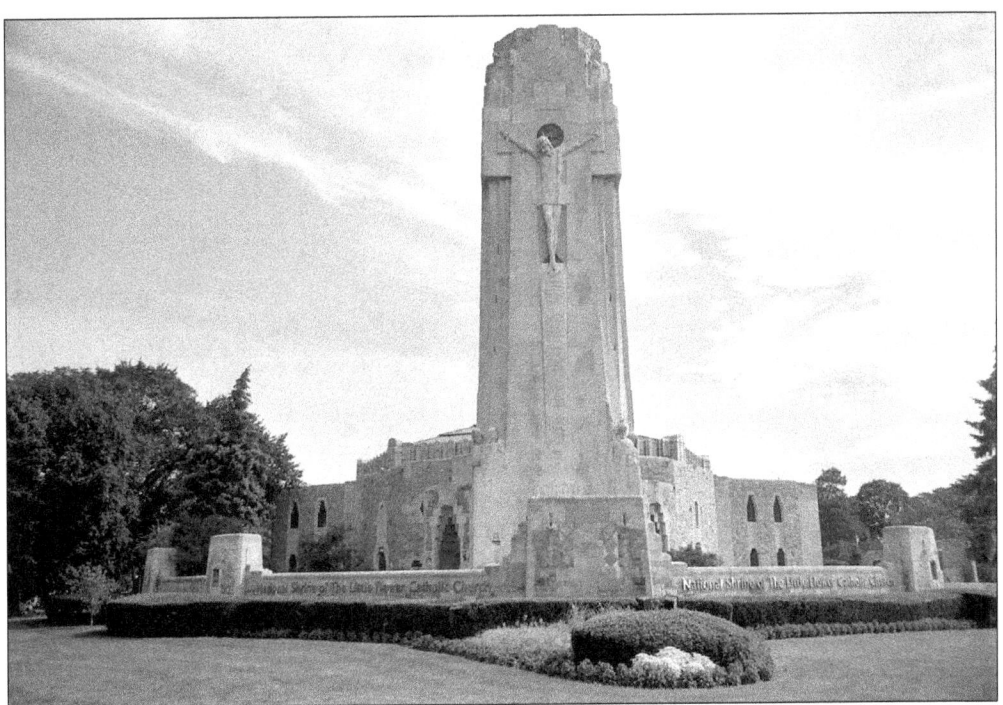

The National Shrine of the Little Flower Catholic Church is located at the prominent corner of Woodward and Twelve Mile Road in Royal Oak, and one of the most significant Art Deco churches in the world.

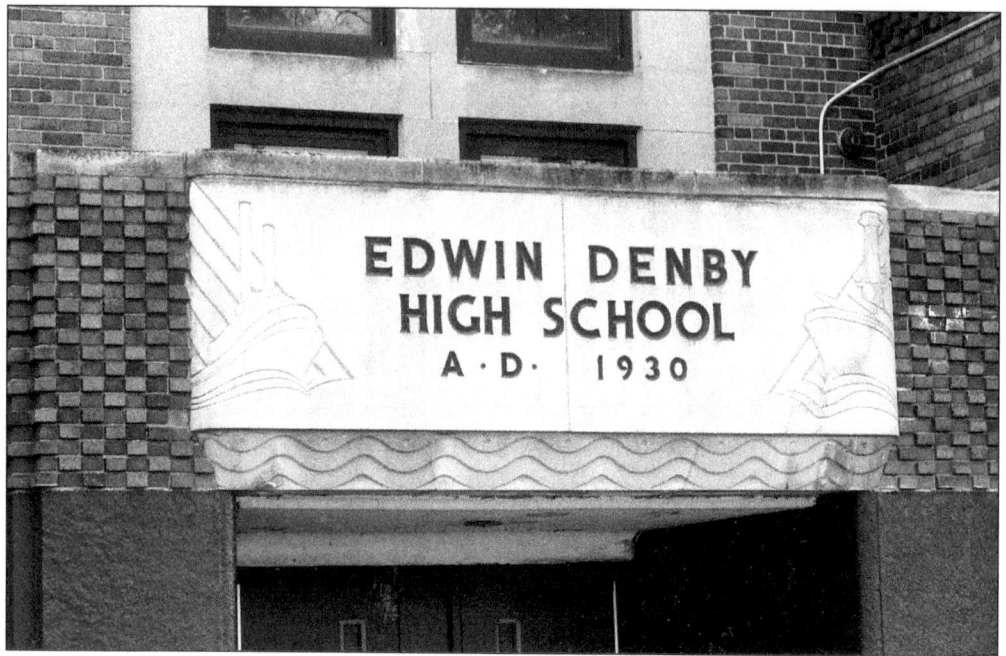

Edwin Denby High School was constructed in 1930, and named for a distinguished Detroiter. Edwin Denby (1870–1929) had a long military career, was elected a member of Congress, and served as Secretary of the Navy.

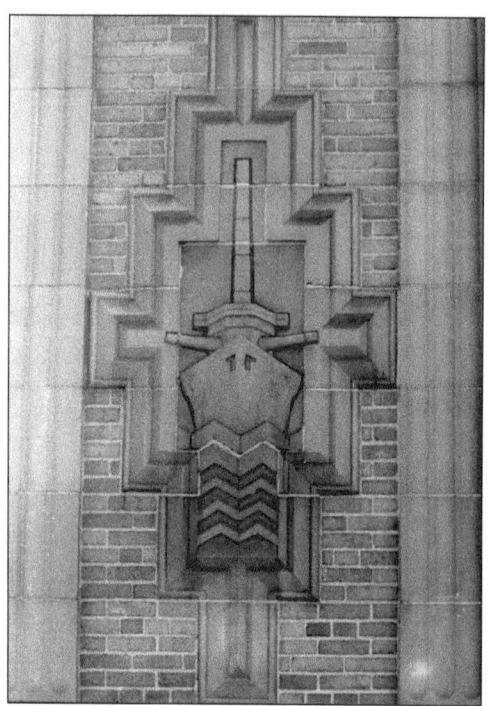

It was therefore appropriate to decorate Denby High School with plaques of military ships. Note the zigzag used to represent the sea. Denby High School is on Kelly Road on the east side of Detroit, and is a twin to Pershing High School on the northeast side of town.

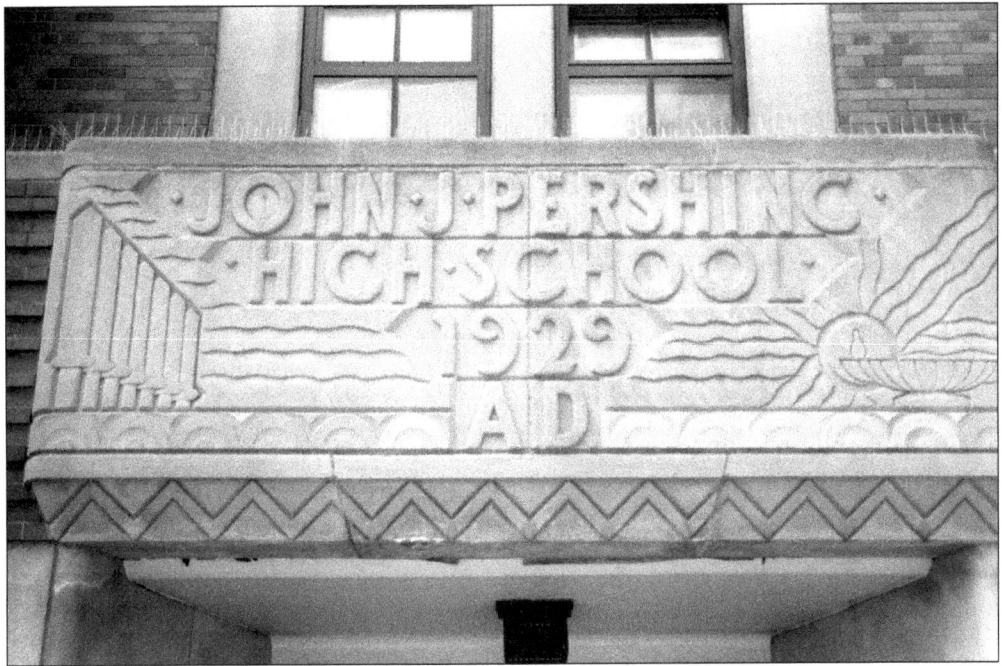

John J. Pershing High School, constructed in 1929, used less military imagery, even though it is named for a military general. The plaque over the door of Pershing uses zigzag Deco designs combined with the traditional lamp of knowledge and industrial smokestacks.

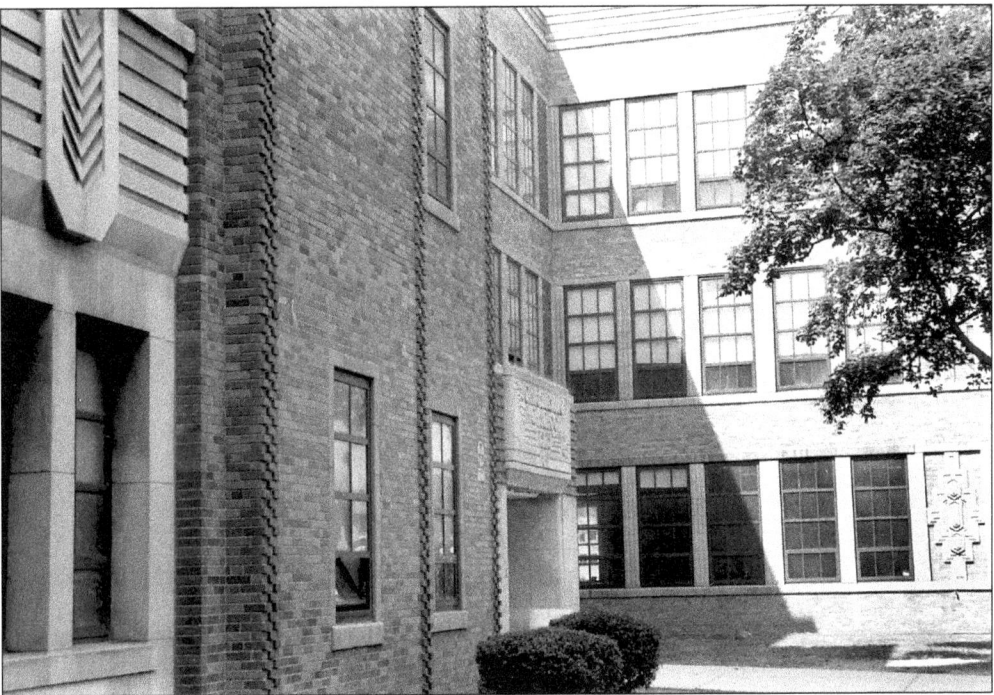

The plan and detailing on Pershing is identical to that of Denby. Pershing High School's cast stone detailing includes the chevron, a popular Deco detail. Both Pershing and Denby were designed by the firm Smith, Hinchman & Grylls.

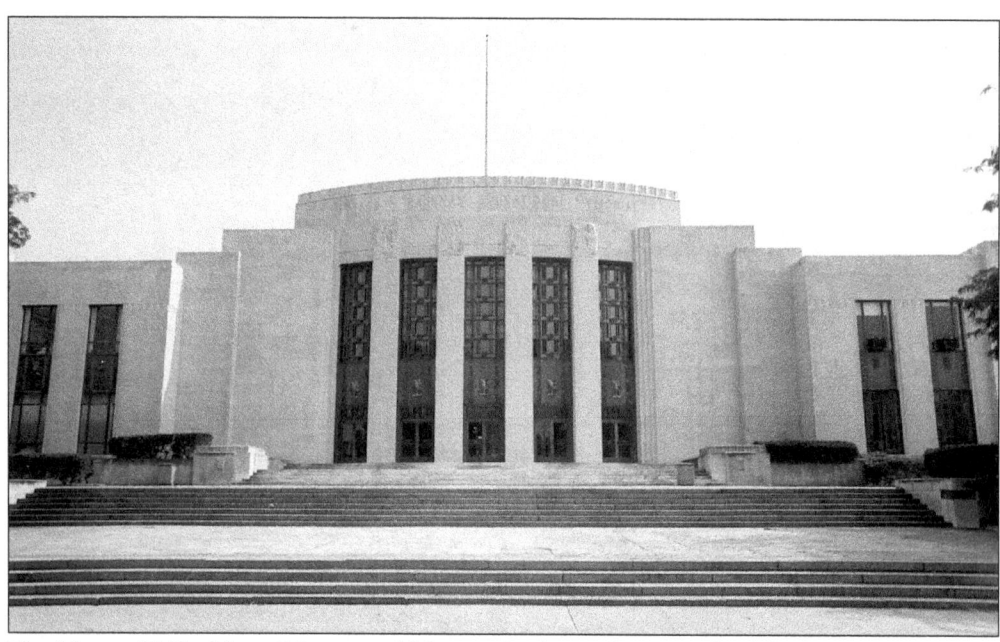

The Horace H. Rackham Educational Memorial is located just south of the Detroit Institute of Arts on Farnsworth and Woodward. This structure was built to house the Engineering Society of Detroit, a non-profit whose goal was to unite and educate architects and engineers in Detroit. Constructed in 1941 by the architectural firm of Harley, Ellington & Day, it was faced with white Georgia marble. The Rackham Memorial building is classified as stripped classic style. The elements of a traditional classical building have been pared down and reinterpreted.

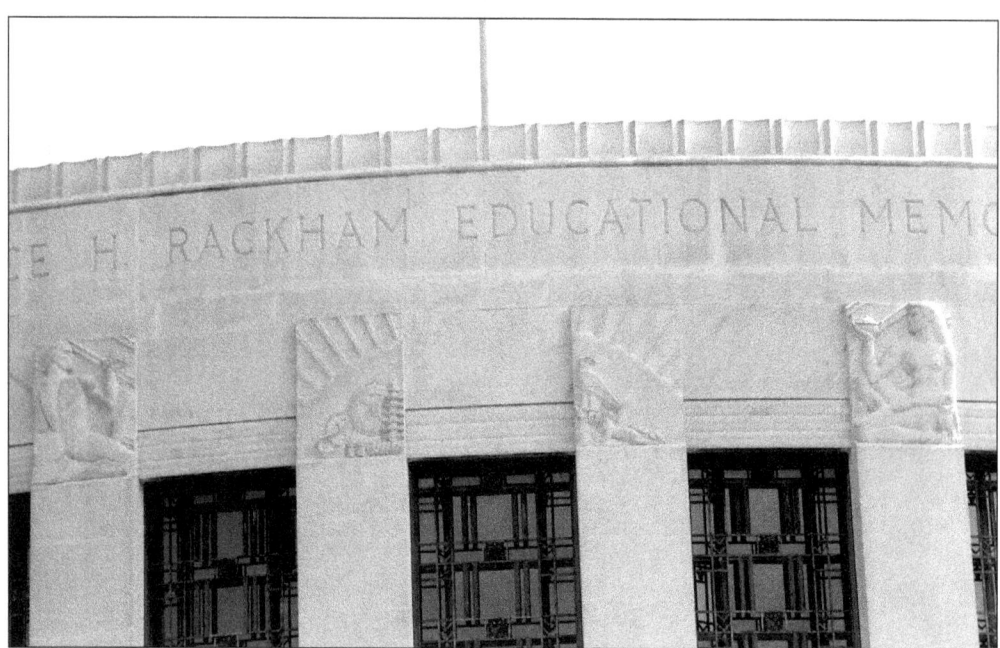

The Rackham Educational Memorial Building's sculptural reliefs were designed by sculptor Marshall Fredericks when he was at Cranbrook Academy of Art. The capitals on the pilasters are all representing a theme related to science, engineering, or education.

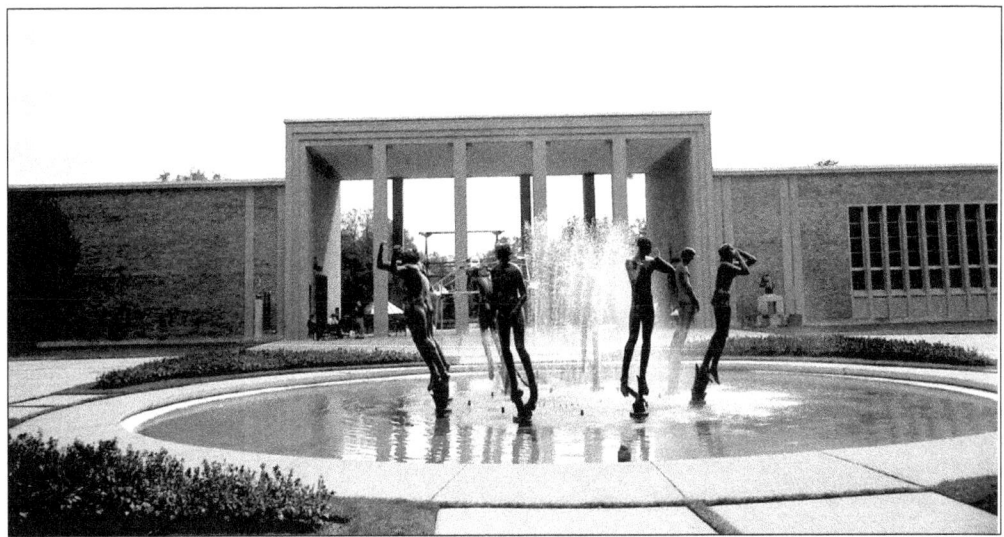

One of the major impacts on the artistic and design community in Detroit was the founding of Cranbrook Academy in Bloomfield Hills in 1925. Newspaper mogul George Booth and his family established Cranbrook on their property. The structure pictured here is known as the peristyle (also called a propylaeum) and it serves as a background for the cross-axial ensemble of the Triton Pool court and the Orpheus Fountain by Carl Milles. The peristyle was designed by Cranbrook Academy's founding president, Eliel Saarinen from 1938–1942. Saarinen was Finnish, and put his own interpretation of Art Deco into the many buildings he designed at Cranbrook.

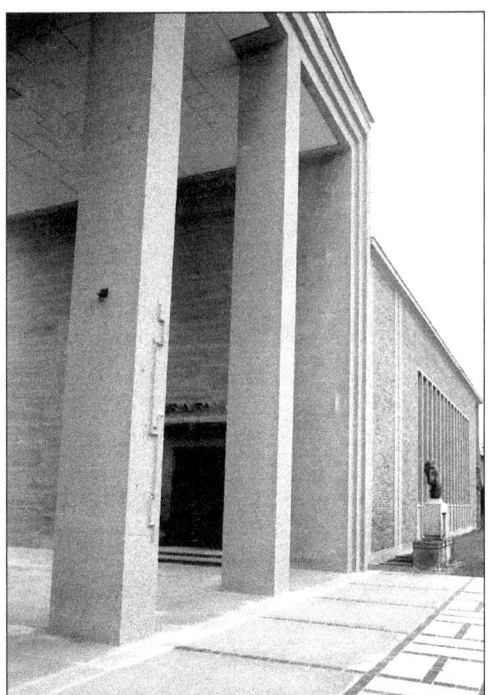
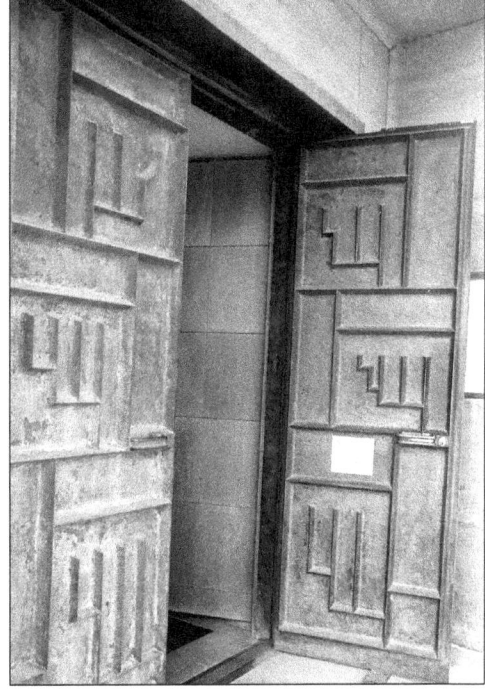

(*left*) On one side of the peristyle is the Cranbrook Art Museum, and the other side holds Cranbrook's library.
(*right*) The bronze doors to the library feature an abstract geometric design.

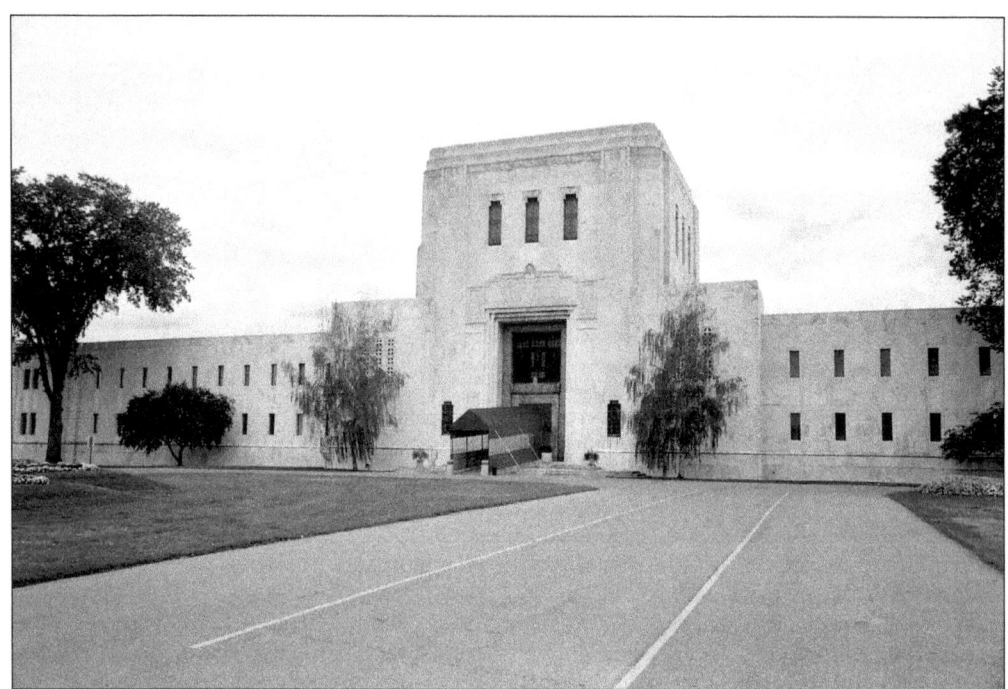

Called the "Temple of Memories," White Chapel Memorial Park is located in Troy and was designed by the architects Alvin E. Harley and C. Kenneth Bell. Again, a stripped classic building which is a stark interpretation of classical architecture.

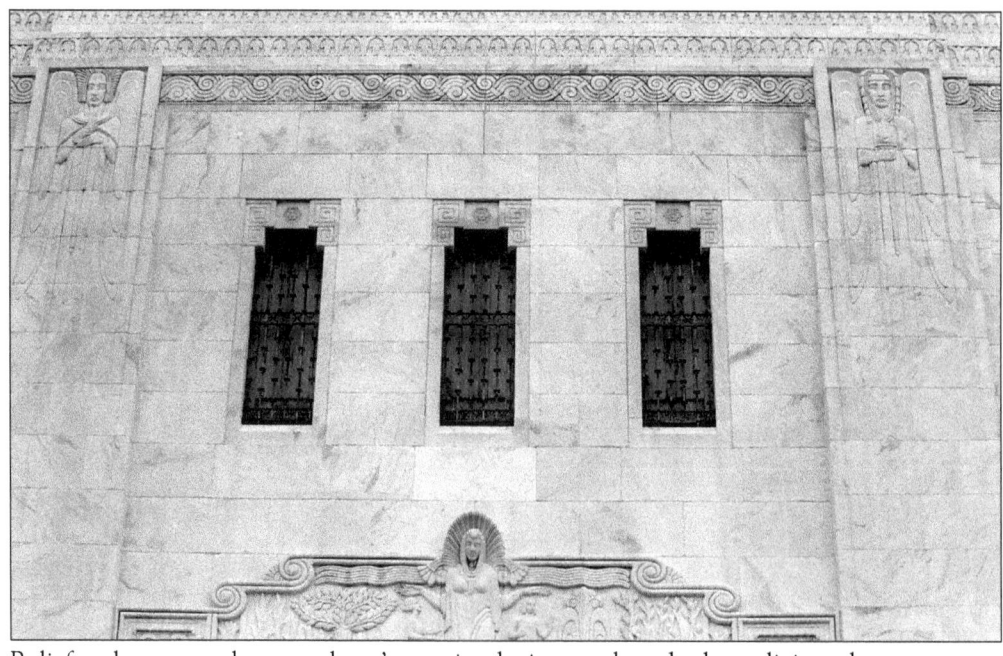

Relief sculptures on the mausoleum's exterior depict angels and other religious themes.

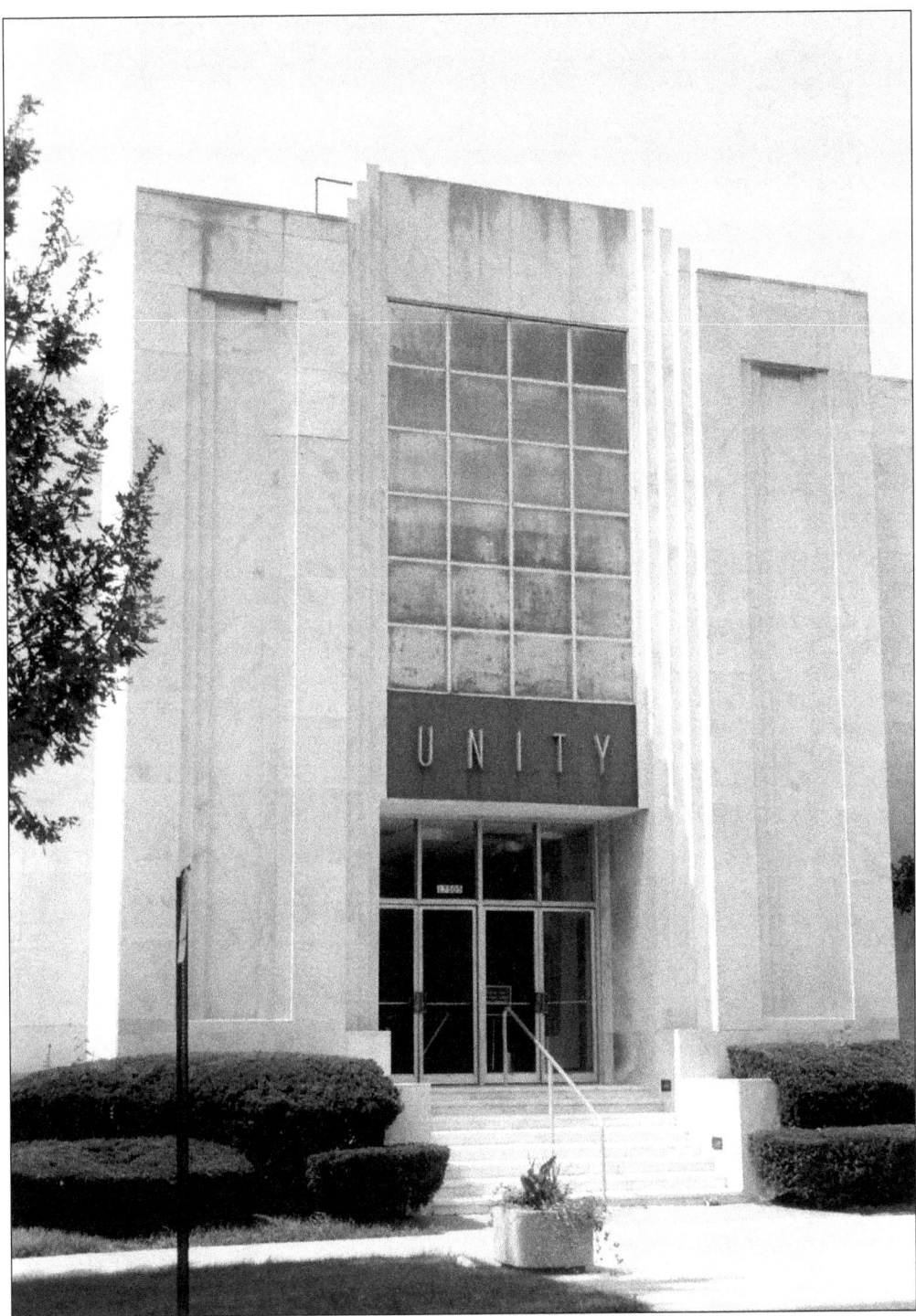

Unity Temple in Palmer Park is another gem in the Palmer Park historic district. Built by Arnold & Fuger architects in 1950, it was a bold departure from the norm of religious architecture of the time. It is more aligned with the International Style, in which a cool sleekness of marble and line are pared down to an almost Bauhaus style.

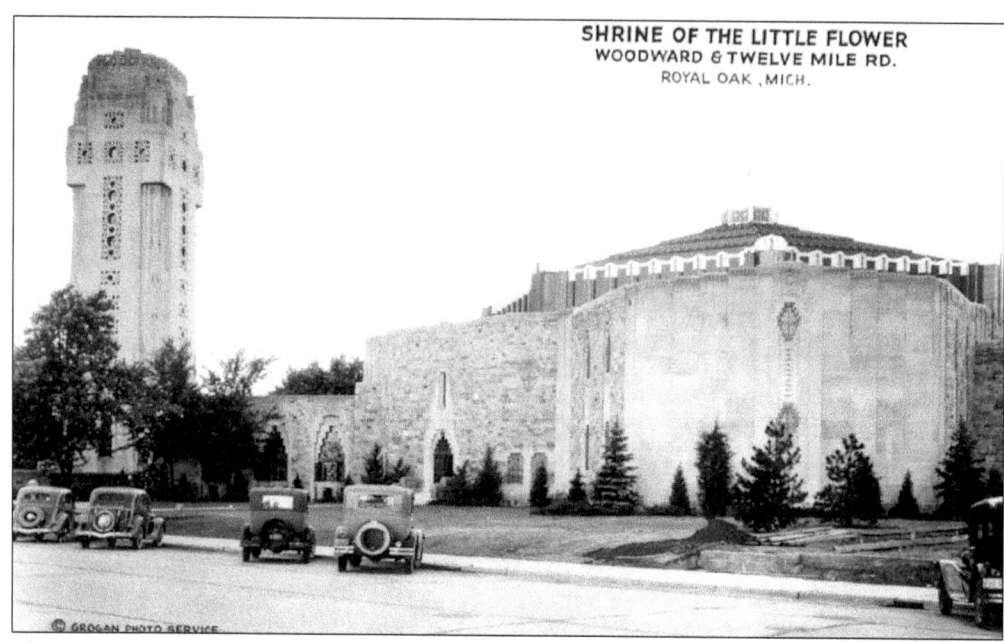

The National Shrine of the Little Flower is one of metropolitan Detroit's landmark buildings, and we take it for granted. New York architect Henry J. McGill was commissioned to design the church tower in 1927. The Shrine of the Little Flower Church would not have been possible if it weren't for the invention of the radio. Father Charles Coughlin, a fiery and controversial 1920s and 1930s radio priest, built the church with donations from across the country. At its peak his show had over 40 million listeners.

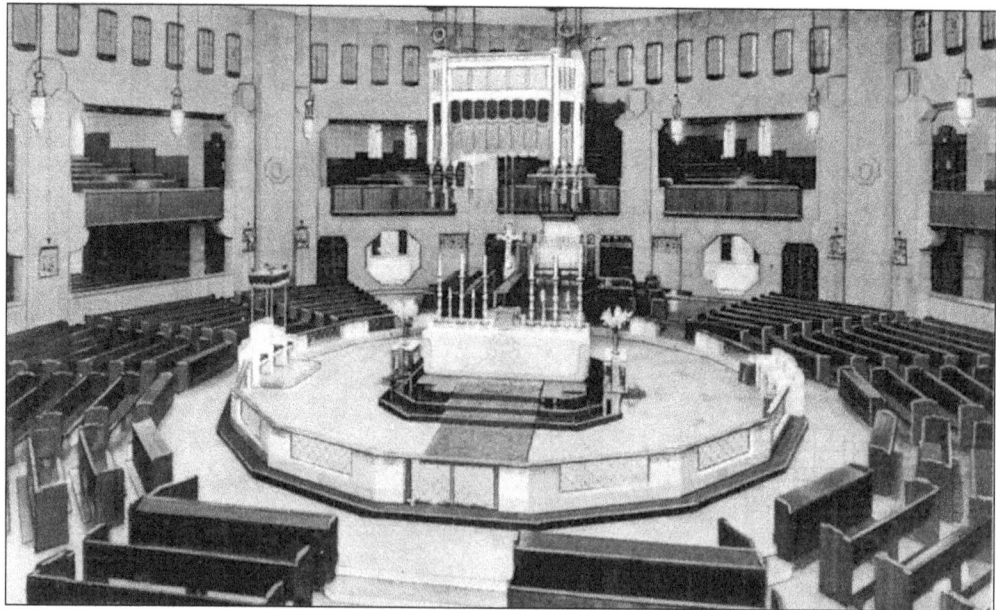

The church sanctuary was constructed as funds allowed, and completed in 1933. It is unusual in that it is without a center aisle, formed as an octagon with seating on all sides of the altar. The church seats 3,000 with majority of the seating on the second-level balcony. Wings containing chapels project from the north and the south, and galleries encircle the entire sanctuary.

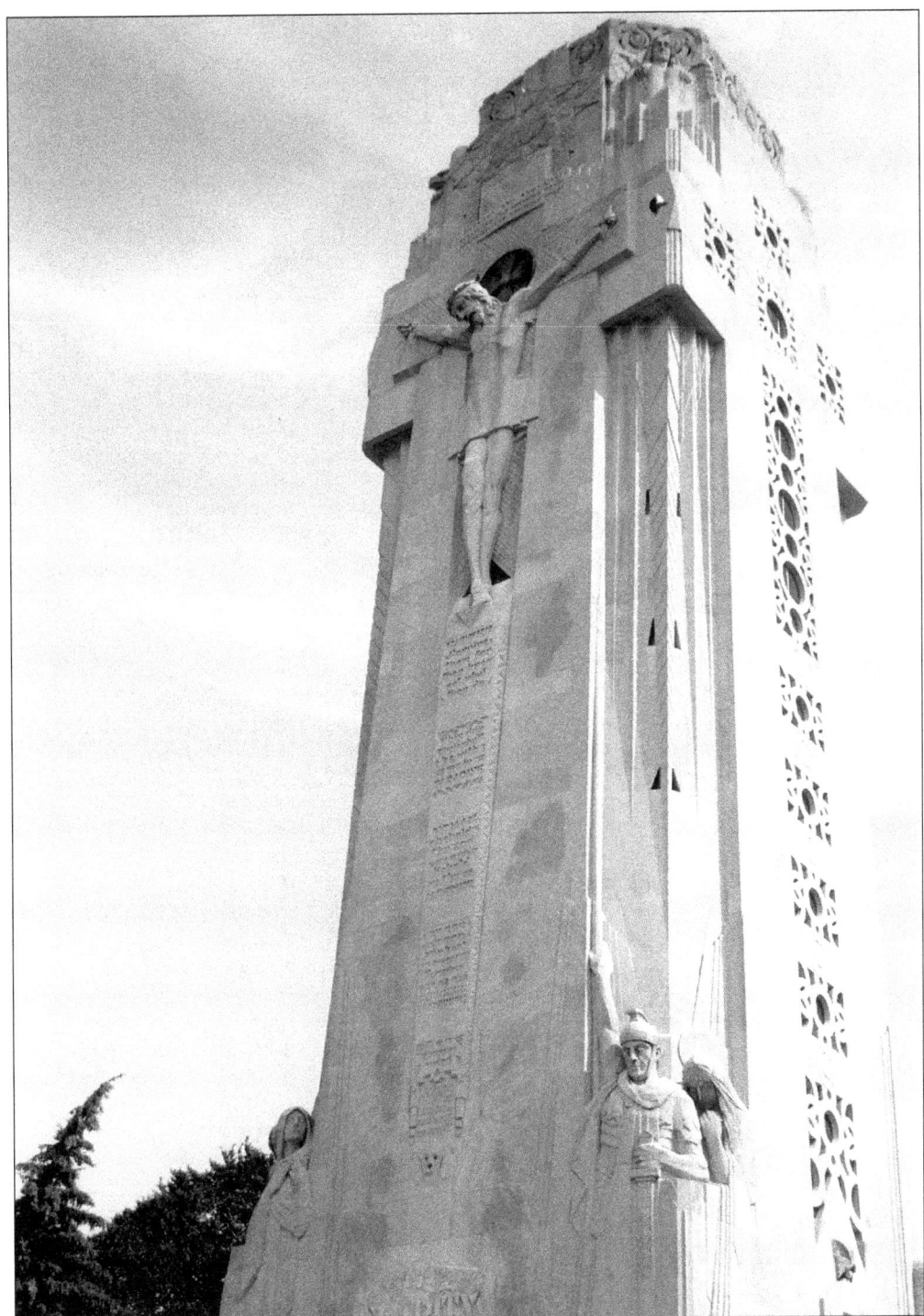

Henry J. McGill designed the square Charity Crucifixion Tower, and the sculpted reliefs are by the renowned Rene Paul Chambellan. Detroit sculptor Corrado J. Parducci did much of the bronze and stone sculpture of the building as well. Behind Christ's head, near the top of the tower and reached by a spiral staircase, is the room from which Coughlin broadcast his radio programs.

INDEX

Agree, Charles N., 88, 94, 96, 99, 105, 110
Bennett & Straight, 91
Berkley Theater, 87
Beverly Theater, 96
Birmingham, 50, 72
Bond Clothing Store, 106
Book, Herbert V., 44
Brodhead Armory, 26, 27, 28
Cadieux Stage, 44
Carrara Glass, 38, 64
Civic Theater, 114
Clinics, 55, 56, 57
Coca-Cola Bottling Plant, 46
Colonial Furniture, 50
Cranbrook Academy, 123
Crane, C. Howard, 89
David Stott Building, 30, 31
Dearborn, 51, 65, 78
Detroit City Dairy, 45
Detroit Public Lighting Department, 43
Donaldson & Meier, 30
Dow, Alden B., 73
Edwin Denby High School, 120
Eldorado Ballroom, 104
Elwood Bar & Grill, 63, 64
Federal Department Store, 105
Fisher Building, 9, 10, 11, 12
Ford-Wyoming Drive-In, 96
Fredenthal, David, 26
Fredericks, Marshall, 122
Frost, Frederick, 68
Giovanni's, 47
Goeschel Building, 39
Greyhound Bus Terminal, 113
Grinnell Street, 41, 42, 43
Grosse Pointe, 59, 67, 73, 75, 76
Guardian Building, 13, 14, 15, 16, 17, 18,
Haas, George J., 24
Hamtramck, 38, 49, 57
Harley, Ellington & Day, 122
Harper Theater, 88
Hazel Park, 54

Helm Building, 45
Highland Park, 45, 64, 83, 117
Hildebrand, Gustave, 27, 28
Hoot Robinson's Bar, 112
Horace H. Rackham Memorial, 122
Hughes, Talmadge, 70
Huntington Woods, 77
Hyde, Arthur K., 114
John J. Pershing High School, 121
Kahn, Albert, 11, 32, 34, 62
Kamper, Louis, 51
Kartsen's Cafeteria, 111
Keego Theater, 97
Lewis, Isador M., 71
Liggett's Drug Store, 113
Lincoln Park, 46, 89
Lustron House, 79, 80
Maccabees Building, 34
Macomb County Building, 24, 25
Majestic Theater, 91
March Mobile Gas Station, 68
Maroti, Geza, 12
Mayan Revival, 16, 18, 81, 82, 100
McGill, Henry J., 126, 127
McLachlan, Jean, 21
Mellus Building, 46
Melvindale, 67
Mercury Theater, 115, 116
Millard Pryor House, 73
Morris Market, 108
Murphy, William H., 21, 22
Neisner Bros. Inc., 107
Noble, Charles, 63
Oak Park, 65, 79
Palmer Park, 70, 71, 125
Park Theater, 89
Parkwood Diner, 65
Penobscot Building, 14, 19, 20, 21, 22
Periera & Periera, 89
Red Knapps, 64
Riverview, 62
Rochester, 64
Rogvoy, Ted, 115
Rowland, Wirt C., 14, 69

S.S. Kresge Store, 107
Saarinen, Eliel, 123
Salvation Army, 47
Schaefer Building, 51, 52
Schley, Cyril Edward, 62, 92
Sears, 117
Selfridge Army Air Field, 25
Senate Theater, 95
Shrine Catholic Church, 119, 126, 127
Simmons & Clark, 53
Simon, Louis A., 48, 49
Strandlund, Carl G., 79
Stratton & Hyde, 26
Tabaczuk, John, 27
Telenews Theater, 92, 93
Temple Bar, 40
Tower Theater, 114
Town Apartments, 69
Unity Temple, 125
Vanity Ballroom, 98, 99, 100, 101, 102, 103
Vitrolite, 38, 53
Vogue Theater, 89
Wabeek Building, 50
Weeks, Arthur L., 78
Weidemier and Gay, 83
West, Robert, 70
Westown Theater, 94
White Chapel Memorial Park, 124
White Tower, 65
Willens Typesetting Building, 37
William Livingstone Lighthouse, 32, 33
Winkelman's, 110
Winter, Ezra, 18
WJR, 62
Woodward Avenue, 34, 35, 55, 56, 85, 86, 111
Works Progress Administration, 26, 27, 49, 58
WWJ, 61, 62, 84
WXYZ, 34
Wyandotte, 59
Yaeger, Edgar, 29
Zisler, Lyle 75